Richard Diebenkorn

Paintings and Drawings, 1943-1976

with essays by

Robert T. Buck, Jr.
Linda L. Cathcart
Gerald Nordland
Maurice Tuchman

Albright-Knox Art Gallery, Buffalo, New York

ALBRIGHT-KNOX ART GALLERY
Buffalo, New York
November 12, 1976 – January 9, 1977

CINCINNATI ART MUSEUM
Cincinnati, Ohio
January 31 – March 20, 1977

CORCORAN GALLERY OF ART
Washington, D.C.
April 15 – May 23, 1977

WHITNEY MUSEUM OF AMERICAN ART
New York, New York
June 9 – July 17, 1977

LOS ANGELES COUNTY MUSEUM OF ART
Los Angeles, California
August 9 – September 25, 1977

THE OAKLAND MUSEUM
Oakland, California
October 15 – November 27, 1977

Table of Contents

This exhibition was supported by a grant from the National Endowment for the Arts, Washington, D.C., a Federal agency.

ISBN-0-914782-07-X

Foreword

Richard Diebenkorn's work has changed considerably as it has evolved over three decades, demonstrating the artist's capacity for continuous self-criticism and awareness rarely matched by any of his contemporaries. This willingness to transform his images radically has been misinterpreted by some art critics who see these shifts as signs of weakness. The opposite is the case: Diebenkorn comprehends the nature of art at its most fundamental as a mutating, vibrant, and even evolving force contrasted to packaged and predictable presentations.

An independent figure who has understandably guarded his personal privacy and artistic integrity carefully, Diebenkorn nevertheless evokes in the art world-at-large reflections and feelings about California more than any other artist. Although he is the best known painter on the West Coast today, a position he has held for some time, Diebenkorn is a painter's painter.

Although his work has been viewed in various single and group exhibitions over the years, his paintings have not been seen in depth for over ten years. In this period, his work has continued to grow in a manner which has caused his name to move to the forefront in international art circles. "Regionalism," mentioned by some in observing past work, certainly has no place at all in discussions of his recent accomplishments which have gained for him ardent admirers, artist and layman, throughout the world. With this exhibition we are pleased to present the most comprehensive show to date of Richard Diebenkorn's works.

I wish to thank the boards, directors and curators of the participating museums who have shared ideas and supported the exhibition from the start. Without their cooperation the project could not have been realized. Generous and understanding lenders are the key to success in any such undertaking and we are grateful for their cooperation. I wish to acknowledge supporting grants for this exhibition from the National Endowment for the Arts and the New York State Council on the Arts. Linda L. Cathcart, Assistant Curator of the Gallery, has worked unstintingly on every aspect of organization. I am very grateful to her for her expert care and work; she has also contributed to the catalogue of the exhibition.

A very great personal pleasure resulting from two years of study and organization for this exhibition has been working closely with Dick and Phyllis Diebenkorn. A gracious and perceptive lady, Mrs. Diebenkorn is her husband's most important supporter and critic. Finally, the artist himself, whose years of creativity speak meaningfully to a broader audience than most of his colleagues can claim, has aided unhesitatingly with every phase of the exhibition. To him, I wish to express my sincerest and warmest thanks as a friend and unbounded admiration as a museum director.

Robert T. Buck, Jr.
Director
Albright-Knox Art Gallery

Acknowledgments

When organizing an exhibition of this size, and over an extended period of time, one owes thanks to many people for support and encouragement as well as for information and assistance.

For over a year, Robert T. Buck, Jr., Director of the Albright-Knox Art Gallery, has given generously of his time, energy and diplomacy, and has provided greatly appreciated support.

It is particularly appropriate that this Gallery should organize a retrospective exhibition of Richard Diebenkorn's works. Three of his finest paintings are in the permanent collection, two of which were generously donated by Seymour H. Knox, and the third by Mr. and Mrs. David K. Anderson, to whom we are indebted.

We are most grateful to Gerald Nordland and Maurice Tuchman for their contributions to the catalogue which are detailed and insightful documents on the periods about which they have written, as well as tributes to their friend, the artist.

The many people who helped me locate works, and who shared their ideas with me, deserve special thanks, in particular Donald McKinney and Patricia A. Gallagher and the Marlborough Gallery staff in New York, Hal Fondren and Eleanor Poindexter of the Poindexter Gallery, the John Berggruen Gallery, the James Corcoran Gallery, Allan Stone and Nicholas Wilder.

My warmest thanks go to John D. O'Hern, Assistant to the Director, for his assistance in researching factual data and otherwise coordinating all aspects of the catalogue. He was ably aided by Serena Rattazzi and Jane Holland, Publications Assistants, and by Gail Wettlaufer, as well as by the staff of the Gallery Library. Paul McKenna of the State University of New York at Buffalo contributed his talents as designer of the catalogue.

Truly deserving of our appreciation are Jane Nitterauer, Registrar, and Alba Priore, Assistant Registrar, for their patient efforts in coordinating loans and shipments of works of art. The preparators and installers proved, as always, to be indispensable and good-humoured throughout.

The exhibition would not have been possible without the assistance of every kind provided by Norma Bardo, who patiently bore the burden of keeping all the details straight and helping all of us; Douglas G. Schultz, Associate Curator, who provided critical support; Elizabeth Burney, Administrative Assistant to the Director, who ably assisted Mr. Buck; and Thelma Snell and Diane Bertolo who helped with the final texts of the catalogue.

Finally, we must all express our deep and heartfelt gratitude to Richard Diebenkorn and his wife Phyllis for their cheerful and continued sharing of ideas and information.

Linda L. Cathcart
Assistant Curator
Albright-Knox Art Gallery

4

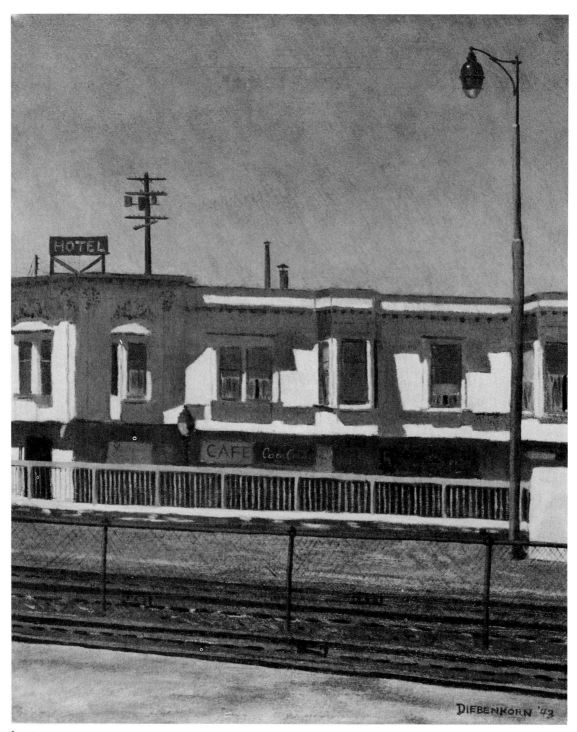

fig. 1

Diebenkorn's Early Years

The remarkable achievement of Richard Diebenkorn in the late forties and early fifties may surprise even knowledgeable observers of advanced American art of that period.[1] Only California-based collectors such as the Gifford Phillipses, dealer Paul Kantor, and the farsighted director of the California School of Fine Arts, Douglas MacAgy, knew that Diebenkorn, who was only in his mid-twenties, "was doing things that weren't being done in New York at all."[2] In large part this neglect is due to the absence of a substantially supportive system of criticism and patronage in California during that period, and to the indifference and/or chauvinism of the New York art community with regard to artists outside the city. The Phillipses, who were then acquiring works by Rothko, Motherwell, and Baziotes, along with those by Diebenkorn, repeatedly encountered an utterly blank response when they tried to elicit New York interest in the West Coast artist. To be sure, Diebenkorn could have availed himself of the promotional possibilities in the East, but he was, and is, fundamentally, an artist of the West. Further, he is a private and independent individual who would not intrude on the historical stage wherever he chose to live.

Richard Clifford Diebenkorn was born in Portland, Oregon, in 1922. Two years later his father, a successful sales executive, moved the family to San Francisco. An only child, solitary by circumstance and by disposition, Richard responded to the poetic yet highly disciplined nature of his grandmother, Florence Stephens, who occasionally lived with the family. Mrs. Stephens had returned to school at age thirty-five to study law; during World War II took on twenty-eight cases defending German-Americans whose civil rights had been violated and won them all; retired to travel, paint, and write poetry; had her short stories published; and ran a book review program on San Francisco radio. She also devoted herself to the cultural edification of Richard, who spent his summers alone with her and was obviously adored. She knew "absolutely which books at which time"[3] to give him – Arthurian legends one year, English history the next – thus feeding the boy's imagination for five summers while he was in grade school. The illustrators Howard Pyle and N.C. Wyeth entranced him too, particularly Pyle, whom he already perceived as the "more austere and harder" of the two. Even then Richard had the notion of being an "artist," which meant to him that he would "paint and draw for a living," but this was only a vague idea. He made his first oil painting, remembered as a "surrealist landscape, bleak and simple, with a cube for the sun and moon – a bit forced." He was encouraged to draw by the family cook, who gave him art supplies. When Richard told his father about his desire to make art for a living, Mr. Diebenkorn demurred. The artist remembers arguing that since "I have this gift of drawing shouldn't it be taken seriously?" His interest in art was no more encouraged at Lowell High School – the school for bright and talented children in San Francisco. He recalls that art – or at least modern art – then seemed to be an "effete activity," often outlandish or foolish in appearance ("paintings of rope, people with outsize feet"). Diebenkorn, who identified with illustrators of adventure, says that although he "didn't want to be different – I *was*." "I drew at home, not at school – and I was not about to become an *artiste*."

Both father and son did agree on his enrolling at Stanford University, which he entered in 1940. After the country

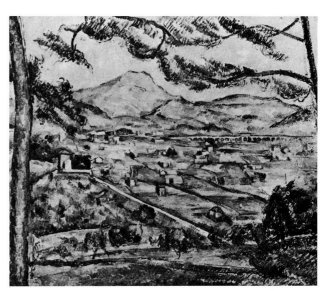

fig. 2

went to war and it became clear that Richard would be in military service, it became easily acceptable for him to become an art major. During the first two years at Stanford, however, he plunged into other studies, acquiring a lasting passion for music, literature, and history; at this time "it was mostly the world of writing that opened up – Faulkner, Hemingway, Sherwood Anderson." During this period he also met Phyllis Gilman, whom he married before entering the Marine Corps in 1943.

In his third year he studied with Daniel Mendelowitz and Victor Arnautoff in Stanford's art department. Mendelowitz had studied with Reginald Marsh and expressed deep appreciation for Charles Sheeler, Arthur Dove, and Edward Hopper – one of several points of ready contact between teacher and student. Although Mendelowitz's interests ended with Cézanne, save for these earlier Americans, he did take his student to lunch at Sarah Stein's house in Palo Alto, affording Diebenkorn an intimate first view of Matisse and Picasso and Cézanne. Cézanne "rapidly became ever more marvelous" for him, largely through reproduction (he carried a Cézanne book in his Marine seabag).

The 1943 painting of *Palo Alto Circle* (fig. 1) evinces Diebenkorn's longstanding interest in Hopper, but in a fascinating way it also anticipates his own style. This is an exquisitely painted work for a provincial student of twenty, rendered with a delicate touch. There are personal elements that are utterly foreign to Hopper's way of seeing, such as the coincidence of the upper edge of foreground fence with the bottom strip of background railing. This device, fusing spatially separated planes into one flat surface, is a remarkable invention for a student, and would have been even if Diebenkorn had known Cézanne well at this time. Not long after, when Diebenkorn saw the renowned Cézanne landscape *Mont Sainte-Victoire* (fig. 2) in Washington's Phillips Collection, in which the foreground branch echoes and thereby joins the distant mountain contour, he must have appreciated the confirmation of his own intuitive approach. In *Palo Alto Circle*, the foreground fence tilts forward, away from the row of houses while seeming to be parallel to them, another indication of a post-Hopper spatiality, albeit

embryonic. The artist's abiding passion for strong clear sun-light, indeed for specifying a distinct time of day and an actual place, is already apparent in the inventive shaping of shadows and forms on the facade. His use of the high over-hanging light fixture on the attenuated post foreshadows future paintings and styles in which form placement frequently appears. Another clue to future works can be found in the configuration of a vertical slash between two rectilinear shapes which appears in three of the curtains, the jambs between windows, and elsewhere. Seen here in a representational format this gouging of forms, emphasized by contrasted shades, has continued throughout his abstract phase. This configuration takes on associational and actual meaning in the abstractions and is a vital part of the iconography of Diebenkorn's art.

After enlisting in the Marine Corps Officer Training Program in the summer of 1943, Diebenkorn was transferred from Stanford to the University of California at Berkeley. Since enlisted men's talents were then notoriously disregarded, it is astonishing that he was assigned to specialize in art by the marine's programmer. Diebenkorn spent a semester of duty at U.C. Berkeley, where Hans Hofmann's aesthetic legacy was being passed on by the painter-critic-teacher Erle Loran. Diebenkorn studied with Loran, Worth Ryder, and Eugene Neuhaus. After the more relaxed atmosphere at Stanford he felt he was now acquiring a "real education, quite a shock, and a good one," from Loran's "almost militantly intellectual probing," and that it was a "nice preparation for seeing good paintings in the East." Soon assigned to a base thirty miles from Washington, D.C., in Quantico, Virginia, Diebenkorn made carefully rendered portrait

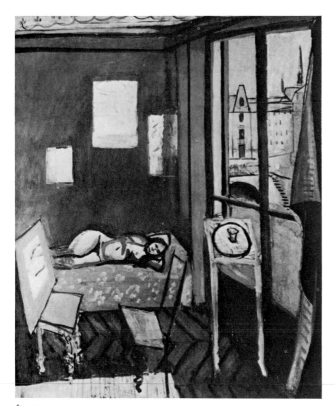

fig. 3

drawings of his fellow marines, and – after being ordered to draw animated maps, which he "never could do because I couldn't make absolutely smooth washes" – he was permitted time to pursue his own painting.

He frequently visited The Phillips Collection "as a kind of retreat from service. I looked at the paintings of Matisse, Picasso, Braque, Bonnard. . . . It was sort of an art school thing for me."[4] No painting had greater impact upon Diebenkorn in this period than Matisse's *The Studio, Quai St. Michel* of 1916 (fig. 3), in the Phillips. It was for him an endlessly fascinating picture, and it affected him continuously during the next two decades. Its appeal rests first in the candid way in which Matisse allows the viewer to see the artist's painting process. For example, he has not hidden the trial-and-error method by which he arrived at the eventual placement of the three whitish gray paintings on the wall. Nothing is more characteristic of Diebenkorn's fundamentally empirical way of continually probing for visual correctness than what is implied in this passage. The emphatic contrast between indoor and outdoor space in the Matisse (a device the French artist took from art history and made important again in modern art) must also have impressed the younger artist. This contrast, which allows a painter to emphasize the tangibility of space and evanescence of light, was deeply congenial to Diebenkorn, who would later fuse not only interiors and exteriors, but also still lifes with landscapes with figurative elements. (After 1955, when he adopted figuration, this became overt.) Note in this regard how Matisse has treated the sensuous reclining nude: on the canvas depicted at lower left she appears as an abstract landscape, while at the right her other potential aspect – that of geometric form – is suggested by the glass and tray. Also striking to Diebenkorn, although he could not immediately absorb the insight fully, was the relationship between the painting's edge and the interior parallel planes – the ceiling and wall molding, the uncurtained window with almost a dozen repetitions of long parallel lines that enter the room from outside, so to speak, by lining up with and incorporating interior objects. He soon responded to this potential for paralleling the picture edge. In unpublished private notes written from 1965 to 1972 Diebenkorn made the following observation: "One of the stylistic features after World War II, between 1948-50, was the concern with the framing edge. There was historical precedent for this but new was to use it directly as a dynamic aid in forming space." The young Diebenkorn's potential ability to fully integrate line with shape, form with color, and keen observation with frankly abstract formal handling could not have been better served than by Matisse's painting. In it brilliant original observations occur simultaneously with inventive formal distortions; the very quality of transparent glass is rendered a different way in each of the four panes.

The painting may also have held strong psychological significance for the young Diebenkorn, for this is an unusually evocative Matisse: the three canvases depicted on the wall can be read as symbolic of a family triad. The large central rectangle bears a geometric, near-human image; the next largest canvas, placed below and to the right as in a posed photographic portrait, suggests "female" impulses of rhythmic energy (interestingly this form is bisected by light, as is the reclining nude); the smallest canvas is rather a *tabula rasa*. The psychological quotient is multiplied by the empty chair of the painter, token of the invisible but palpable presence of the artist in the interior.

In 1944-45, Diebenkorn also studied the A.E. Gallatin Collection on loan to the Philadelphia Museum of Art and perused a catalogue of it for years. It is curious that the first reproduction in the catalogue, Cézanne's *The Balcony*, depicts an inside-outside format, as well as a sensitive play of post and lintel lineups with the picture edge, concerns we have encountered in the Matisse. Of further interest is the single Gallatin Matisse *Interior at Nice*, 1917-18 – yet another example of this deeply meaningful format. In the Gallatin collection Diebenkorn was also taken with Arp's biomorphic torn collages, foreshadowing as they do de Kooning's work of 1948 (which also affected Diebenkorn), and with Klee's *Christmas Picture*, 1923 (fig. 4), with its whimsical use of arrows, letters, and numbers and certain quasi-geometrical configurations that assume different meanings dependent on their context. Specially interesting is the crevice between linear bristle-like flanking areas; this configuration alternatively suggests a nose, a mouth, an eye, sexual parts – both male and female – and non-objective passages. There are several marvelous Miró paintings, including *Dog Barking at the Moon*, 1926, and *Painting (Fratellini)*, 1927, both of which use humanlike abstract shapes that would emerge in Diebenkorn's own work. Miró's *Object*, 1932, might be a source for the fetishistic object-making episodes that have occurred at three points in Diebenkorn's career.

Around this time Diebenkorn also chanced upon two copies of *DYN* magazine and "saw pictures of paintings that were a new breed of cat to me altogether."[5] These were by the emerging New York-based painters then working in a Surrealist ethos. Recently, while leafing through these copies again, Diebenkorn remembered his interest in Robert Motherwell's *The Room* (again an inside-outside theme), for its "frankly media" presentation (fig. 5). "This, at a time when I was looking at French modernism, hit me kind of hard. It related curiously to that and yet it wasn't that," he later recalled.[6] In 1976, he added, "There's a whole generation [deliberately] left out by Motherwell, for example, Dove." Diebenkorn enjoyed the "immediacy" of *The Room* – its quality of "being, in itself," in distinction to the tone of an earlier Motherwell in the same issue of *DYN* which has more "reference" in it. With its "blots and scratches a new smell came off the page." Diebenkorn pointed out in the same issue an early Baziotes that had intrigued him (fig 6); an image that can be related to Diebenkorn's youthful painting of a solitary figure (fig. 7), a brown, gray, and khaki-colored painting redolent of war and combat fatigues. He sensitively combined stylistic devices adapted from the two-inch black and white reproduction of Baziotes' work with certain inventions like the overlapping thumb/phallus and the probe into negative space that now appear prophetic of his later work.

Diebenkorn was slated for combat in Japan when the atom bomb was dropped. After being released from the marines he returned to California later in 1945. One of the few paintings to survive from this period, made shortly after his return, is *Untitled*, 1945 (fig. 8), which reveals the influence of Motherwell in the purely formal use of striping and splattering. Underlying the structure of the picture as well as its fundamental imagery are Picasso's Cubism of 1911 and the metaphysical distortions of the thirties. The influence of Schwitters, also encountered in the Gallatin collection, may be detected in the use of spatial compartmentalizing and assertive, almost objectlike textures. In this early attempt at abstraction the figurative attraction still dominates,

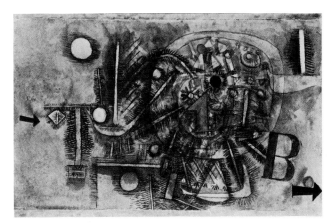

fig. 4

resulting in the creation of a personage – helmeted, warriorlike.

In January 1946 Diebenkorn enrolled at the California School of Fine Arts in San Francisco. His teacher was the painter David Park, eleven years his senior, who became his close friend and mentor. Except for the time Diebenkorn spent in Albuquerque and Urbana, Park remained his brotherly confidant until his death in 1960.

The school, under the leadership of Douglas MacAgy, was quickly becoming, along with Black Mountain College in North Carolina, the leading experimental, energy-charged art school in the country. With other GIs of his age "searching and fumbling around" as he was, Diebenkorn set to work in earnest. Elmer Bischoff, who was already teaching at CSFA when Diebenkorn enrolled, recalls that he was regarded right away as "a star among students, with marked capacities" that earned him "mutual regard among all the faculty members." Curator John Humphrey, then a preparator at the San Francisco Museum of Art, remembers his characteristic "weight of reserve." Diebenkorn soon won the Albert Bender Grant-in-Aid, a fellowship designed to encourage young California artists to travel east and be exposed to the art in New York. In the fall of 1946 the Diebenkorns along with their infant daughter settled into a studio in Woodstock, New York. For a sun-loving Westerner it was a grim snowbound winter, but he worked from 6 a.m. to 10 p.m. every day, "teaching himself how to paint." There were a few trips to New York City, including one to the Kootz Gallery to see what was going on, and visits with neighboring artists at Woodstock including sculptor Raoul Hague and painters Judson Smith and Mel Price.

Park had urged Diebenkorn to look at Miró, and the student now "ploughed into him," assisted by a book of reproductions which he analysed studiously and by visits to The Museum of Modern Art where he saw *Person Throwing a Stone at a Bird*, 1927. From Miró he learned to curve a large shape, to give it whimsy and evocativeness; the sense that shapes are being stretched to the breaking point in Diebenkorn's work comes from Miró. Primarily, however, it was Miró's color, in its "weight and opacity and somberness" that affected Diebenkorn and permanently enlarged his pictorial vocabulary.

David Park's influence is acknowledged in the small picture called *Advancer*, 1946-47 (fig. 9), which is an allusion to radar receivers. Diebenkorn credits Park's "personal variation on Picassoid double portraits – more personal than

fig. 5

Gorky's" adaptation as the stimulus for this work.

These and other Woodstock images pertain directly to Picasso's *Guernica*, specifically to the spikiness of form and the electric light bulb image of the 1937 masterpiece, and to a sort of "beast" imagery provoked in Diebenkorn's and many artists' imagination at the time[7] by Yeats' poem "The Second Coming." In the paintings the beast is often identified with technological apparatus – especially signal systems like radar. (The anvil and wrench which appear continually at this stage, can be traced to his vivid recollections of an ironsmith during boyhood summers with his grandmother at Woodside, California.) When the Bender grant money ran out in the spring of 1947 the Diebenkorns drove home, not without a feeling of relief. A personal loan helped support them and the family (there was now a second child) until September 1947 when MacAgy offered Richard a teaching position at the CSFA. This marked the beginning of a teaching career that was to span over two decades. On the West Coast teaching was then regarded as an honorable calling, unlike New York where it was perceived as hardly more honorable than doing commercial art. And teaching at CSFA in the forties was a singularly sharing experience, with great interchanges among the faculty and between professors and students as well. (To be sure, a senior faculty member like Clyfford Still was at great remove from a junior like Diebenkorn.)

John Hultberg, who took a class with Diebenkorn in 1948 (and whose work then as a brilliant student distinctly affected Diebenkorn) recalls that "the idea was to break all the rules." We "drew the nude á la Matisse" in Diebenkorn's class, "other teachers preferred Picasso." "Everyone talked about how to get abstraction and the image simultaneously . . . and how to get the human element, comic or tragic, but also keep the religion of pure paint, how to get to the human but preserve the intensity of non-objective painting: Diebenkorn bridged both."

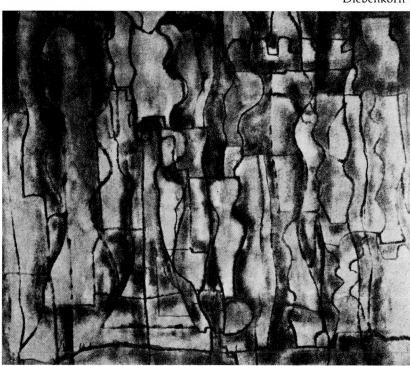

fig. 6

The work of students and teacher appeared together in a now rare book titled *Drawings,* published by Eric T. Liden at Mill Valley, California, in 1947. Edited by Frank Lobdell, the volume of offset reproductions of tusche drawings on cheap paper includes works by Hultberg, James Budd Dixon, Walter Kuhlman, George Stillman, and Lobdell, in addition to representing Diebenkorn, whose three drawings exhibit a striking fluidity and sureness, conceptually well in advance of his paintings.

"There was a strong feeling of self-sufficiency" in the air, "not without chauvinism," recalls Bischoff, who became and remains a close friend of Diebenkorn. "Going to New York would have been a commercial thing to do." There was an underlying conviction in the power of art to communicate to large masses of people as a sort of Esperanto which was related to the trust and belief in the political system during the forties. "Struggle must be made and something beautiful must be made" – this phrase was tantamount to a slogan. Other characteristics have been summarized by Bischoff: the "conclusiveness" of a work had to be stressed; the "raw materials of art, their range, the tones of forms and imagery connected to rawness" should be fully realized in the picture; "the complexity of yourself being poured into the painting is the issue" – the success of a painting was in direct ratio to how much of yourself you got into it. Painting had to be

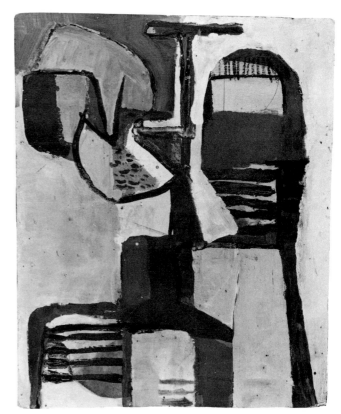

fig. 8

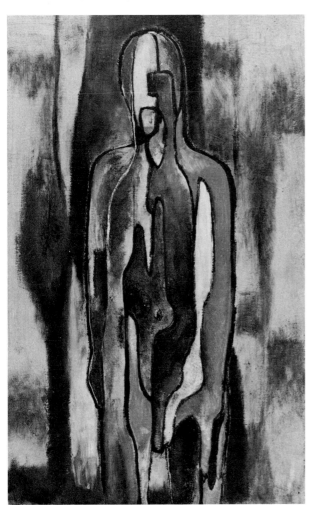

fig. 7

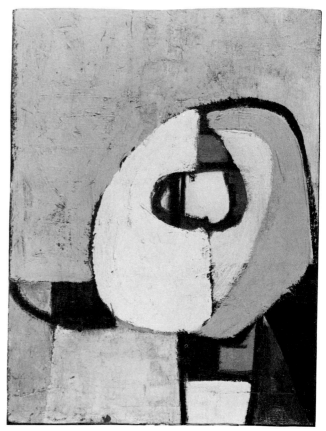

fig. 9

highly moral – a variant on the "toughness" ethic then current in New York. According to David Park, paintings must not be "easily come by," but "must be hard-bought," they "shouldn't be soft." This generally meant that a painting should reveal its own agonized history, the evidence of struggle with a simultaneous disdain for elements that tend to please. Not surprisingly, the pigments selected often "were not Winsor-Newton" but house paint, and stretcher bars had a homemade look. Although his paintings appear elegant enough today, at that time, as John Hultberg noted recently, Diebenkorn wanted the pictures "to have a bad effect, to be ugly up close – at a distance it won't look bad." In this context Hultberg recalled that Mark Rothko once brought into his class – during one of the two summer sessions he taught in 1948 and 1949 – an original Dubuffet painting to show that "art could hurt."

In self-critical sessions Bischoff, Park, Lobdell, and Diebenkorn shared the belief, no matter how vaguely expressed, that they were working "under one ism," but they actually worked quite differently. (Diebenkorn had an independent relationship with artist Edward Corbett, a brilliantly gifted painter. They were "staunch admirers of each other's work," but in Gerald Nordland's words "didn't have as much to give each other personally.") "Park worked in one area adding colors to it," comments Bischoff, "while Diebenkorn had this marvelous line, halfway between calligraphy [relating to Smith] and color [Park] as his way of painting"; "just in a combination of lines, their handling was filled with action, vitally alive – it didn't even need a configuration, an image." He "would worry and fuss the line, to loosen it up, when you watched him draw he looked uncertain – contrary to Hassel Smith, he never looked as if he could make a perfect circle – but you'd never know it from the end result, which looks so certain." The "light touch of Matisse" was Diebenkorn's: this "was an obstacle for Park, for whom brevity was not moral, morality being tied to blood, sweat and tears. . . . Park would chide and ride Dick about this. . . . Dick was much quicker than Park or I, with perception of a future chain of activities, while others might struggle, placing forms here and there before there was a final synthesis. . . . he would quickly utilize a happening on a canvas, the action might be lean but it was the right thing and it would have been accepted as the right thing; whereas Park would have demeaned it." Color "was basic" to all of them, "to determine structure, pulling the whole together; resolution of the canvas could take place on color grounds – proportion played a role, but color alterations could do it." The artist "objected to tonality or cast, and sought neutrality, to allow a full range of color to operate, each playing their role"; "neutrality suggests noonday light, as Dick's use of colors suggests high noon on a clear day, with hard clear blues, greens or reds going across the color spectrum, each with full resonance. . . . Dick's color gave the impression of atmosphere even more than Matisse – in this way he departs from Rothko in a direction toward Matisse." Diebenkorn "could make a fast transition, if color is modulated, from where color is hitting to where color isn't hitting, and maintain marvelous vibrancy; he could give the sense of form going into shadow, form going away from light, then hit by light. He retained a love for abrupt transition where we indulged in slower modulation." While de Kooning's line is a continually exploding charge, Diebenkorn's line wanders and meanders; but compared to those of his California peers, one realizes that it is actually supple, a

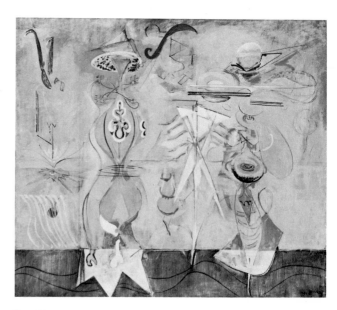

fig. 10

malleably energetic flow that can race or crawl, encapsulate a form neatly or dissolve suddenly, dazzlingly.

The sense of sharing and real interchange among these artists in the forties, the aspect of mutual adventuring, self-exposure, and support, stands in contrast to the air of historical self-consciousness and competition then developing in New York.

Diebenkorn interacted with two groups of friends: the older ones – Hassel Smith, Bischoff, and Park – were teachers at CSFA; the younger were students. From both sides came tonic criticism of Diebenkorn's work. After his return from Woodstock, it was regarded as "too stiff" with "baggage that was overstructuring" and overly derivative from Cubism. Clyfford Still's presence at CSFA was critically important to many artists there, though perhaps less to Diebenkorn who saw him only two or three times in rather tense circumstances. Nevertheless the impact of Still's exhibition at the California Palace of the Legion of Honor in 1947 was "immense" and is apparent in many of Diebenkorn's paintings, whether stemming directly from Still or coming through painters such as Lobdell who had absorbed a great deal from Still. In much the same way one can point to the pervasive influence of the New York School ethos and Surrealist ideas upon virtually all the artists in this circle who then influenced each other with their individual interpretations. But the particular impression made by single works, more upon Diebenkorn than the others, can be documented. Diebenkorn remarked to Gerald Nordland that a visit to the San Francisco Museum of Art "was worthwhile just to see the Rothko" painting *Slow Swirl at the Edge of the Sea*, 1943 (fig. 10), that extraordinary large canvas – 76″ x 85½″ – so admired by artists in the forties (it was later traded back to Rothko). A work of utterly convincing abstraction, its subtlety and lyricism has a strong connection with his emerging sensibility and helped corroborate Diebenkorn's inclination toward abstraction. ("It was square somehow to look at anything and draw it . . . and I was behind this emotionally," he remarked in 1963.[8]) To become more pronounced later in Rothko, and in Diebenkorn, is the tripartite conformation of *Slow Swirl*; in regard to Diebenkorn

it is important to note the tremendously vivid impression made upon him as a boy by a set of picture postcards of the eleventh-century Bayeux Tapestry, which is triple-banded.

Another painting at the San Francisco Museum of Art that Diebenkorn and all the serious painters studied is *Enigmatic Combat*, 1936-37 (fig. 11), by Arshile Gorky, who had had his first major one-man exhibition at the Museum in 1941. With its surprising all-over lavender hue and the easy way bird shapes and anatomical allusions merge into abstraction, one can understand Diebenkorn's positive response to the picture.

Jackson Pollock's formidable *Guardians of the Secret*, 1943, measuring over six feet wide, was influential for certain San Francisco artists, including James Budd Dixon. Diebenkorn knew the painting but was less affected by it than one might expect. Diebenkorn's paintings, whether abstract or figurative can invariably be traced to configurations of observed forms, while Pollock's are fused with the subconscious. A modest Picasso in the San Francisco Museum of Art, *La Cruche Fleurie*, 1937, with its "lovely gentle pastel colored" flowers, "toughened and made biting" by the touches of black is closer to Diebenkorn's sensibility.

Finally, one may mention that Diebenkorn alone was interested in reading Clement Greenberg's art criticism in *The Nation* and *Partisan Review*. He admired it because it read "like painters talking."

fig. 11

fig. 12

From these sources and from the generally liberating tone
at CSFA, Diebenkorn's paintings became more fluid; the
surfaces began to breathe, lightning flashes of orange and
other hues replaced primary colors; war-haunted imagery
faded; and a gradual openness to organic imagery emerged.
"I thought I was being non-objective – absolutely non-
figurative – and I would spoil so many canvases because
I found a representational fragment, a Mickey Mouse . . .
back it would go to be redone." It is difficult now to grasp
the problems faced by the West Coast painters of the forties
who wanted to use organic shapes while making abstract
painting. "It was impossible to imagine doing a picture
without it being a landscape; to try to make a painting space,
a pure painting space, but always end up with a figure against
a ground." The escape route offered by geometrical painting
was "not acceptable in the Bay Area." Indeed, "one tried
to fight off near-geometry coming into the work, to push
it out," for geometry "equalled sterility," and was an
earmark of "intellectual" painting. Bischoff recalls that use
of a straight-edge was absolutely forbidden.

Diebenkorn had a one-man show at the California Palace
of the Legion of Honor in 1948 (fig. 12). Rooted in Cubism,
the newer work inclined toward the organic or the bio-
morphic. Ambiguity and amorphousness replace "abstracted"
seascapes and sailboats and other figure-ground based
images such as those in *Composition*, 1948 (fig.13).[9] The
results in 1947 could be "embarrassingly out-of-scale," a
large shape might be "too assertive or have too much pres-
ence for its mate," but at other times a "yin/yang relationship"
would successfully allow the desired "ambiguity" as in *Untitled
No. 22*, 1948 (fig. 14). These were concerns of artists close to
Diebenkorn. His *Painting II*, 1949 (fig. 15), reveals charac-
teristics typical of the time: very thickly painted orange
surfaces, coruscating dashes of pigment crackling (or
sometimes cracking) through the surface in the manner of
Clyfford Still, and a lateral stretching of form and textured
surface toward the picture edges, with effects produced by
painting wet-on-wet frequently encountered. "A moving
mass, not quite porous, not quite solid," in Gifford Phillips'
words, was seen in much San Francisco painting then.
Bischoff adds that the forms commonly were "lop-sided, but
geometric, able to provide multiple connotations." The
particular imagery of "pendulous high hanging" animalistic
shapes at the top of the canvas relates Diebenkorn to Hassel
Smith. A special affinity with Smith led the two artists to
decide to show together at the Lucien Labaudt Gallery in
San Francisco in 1949. In Diebenkorn's *Untitled*, 1949 (fig. 16),
one of the pictures in that exhibition, there is a new land-
scapelike light, a loose calligraphy with yellow streaked
boldly, directly from the tube; this was directly inspired by
a passage in a letter Vincent van Gogh wrote to his brother
Theo in which he described his use of such a stroke.
Reminiscent of Rothko here is the mauve-black configura-
tion of resting soft-edged square patches, but the Phillipses
point out that Diebenkorn's painting is more solid and
opaque; when Diebenkorn painted thinly, like Rothko, there
is much more incident. Diebenkorn is now glad that he did
not destroy the picture, which the red-flecked animal image
might well have caused him to at that time.

The impetus in those years, from figure/ground to field
imagery, is most strikingly realized in *Untitled*, 1949 (fig. 17).
This is a remarkable work of the time, directly in advance of
important American art. It also anticipates Diebenkorn's
move from California to New Mexico so graphically that

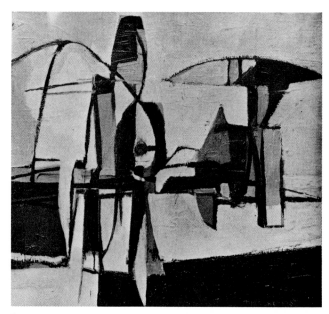

fig. 13

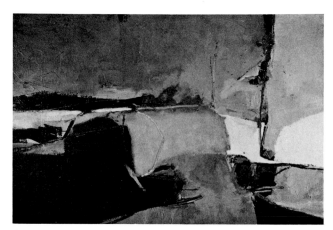

fig. 14

close observers of Diebenkorn, including the owners of this
painting, believed for years that the picture had actually
been made in the Albuquerque environment, so suggestive
is it of the future landscapes. The picture may relate to con-
temporary paintings by Hassel Smith, Mark Rothko, and
Edward Corbett, but its brilliant bold lyricism sets it apart
as a work proceeding from its own ancestry. Characteristically
"Western," noted curator Walter Hopps, is its "softness, the
blending and staining allowing a different attitude to the
picture plane" from what is common in the East; and he cites
the influence of the San Francisco ambience on Mark
Rothko in the "reinforcing of his moves into non-objective
painting." Atypical, however, of Rothko's work is Dieben-
korn's linearity; his edges are conceived as line work, not
blurred shapes.

In regard to Western-Eastern considerations, Ray Parker made the following observation several years ago: "There was a lot of paint slinging [in San Francisco], a lot of energy, a tremendous amount of directness in that way, but it pertained to surfaces rather than to any kind of intervals and distribution of rhythms, of accumulations or dispersals or the flow of activity."[10] In *Untitled*, however, Diebenkorn joined the surface lyricism with definite planar structuring.

It was the "look of the place," seen perhaps in magazine photographs of the Southwest, that triggered Diebenkorn's decision to move to Albuquerque. With the G.I. Bill he could have chosen any school for continued studies, but in January 1950 he enrolled at the University of New Mexico. The sparseness of desert landscape was quickly assimilated into the forms and dry surfaces of many of his paintings. "An almost linear lineup of light into clear flat planes," in writer Kenneth Lash's words, typified the region, and subsequently, Diebenkorn's handling of space. A sense of aerial landscape is frequent; this could have been suggested by views from Albuquerque, a mile-high city, and from the speedy drives to many mesas in the vicinity; also, Diebenkorn's first civilian airplane flight was taken in 1950 from Albuquerque to California. Strictly internal aesthetic concerns were even more important in determining the new look of the canvases – a lateral thrusting and a sense of flattened forms stretching outside the picture edge, observed first in pictures from 1949 revealing perhaps the influence of work of Hassel Smith, become dominant.

Sculptor Paul Harris, a fellow graduate student, recalls Diebenkorn in New Mexico as being "so much ahead" of everyone, including faculty, but being "humble, trying to play it down." There was a "kind of formality about him, like T.S. Eliot," who had long been a favorite writer. He "liked things that were ugly – buildings that were awkward, and opposed them to French things;" a "true intellectual, with an artist part in him that was equally strong – when he starts to paint the thinking part doesn't inhibit him – there was a shared power." He would often refer to "sparseness," and would urge "not to put anything into the canvas if you didn't need to." "Don't be afraid of empty space." That these sentiments are directly reflected in many Albuquerque paintings is evident, but another comment of Diebenkorn's may be slightly more surprising in light of the "advanced" nature of his work in the early fifties: "I'm really a traditional painter, not avant-garde at all. I wanted to follow a tradition and extend it." Diebenkorn and other people talked about "annihilating the image," – "if you get an image try to destroy it." There was a sense of "a real crusade," about extirpating "prettiness," guarding against "heavy stuff," against "imitation" and anything "false to painting" – and concomitant stress on basic inexpensive materials made with simple tools, "a real painting is paint and canvas." Never be "charming" or "ingratiating."

A "breakthrough" was experienced by Diebenkorn in *Miller 22* (fig. 18). There is an improvisatory quality here that would have been impossible in San Francisco, where a looping line – especially a line that did not delineate a shape, but actually seemed to have only an arbitrary relation

fig.15

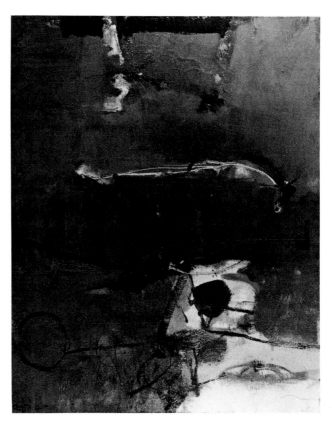

fig. 16

to it – would have been regarded as frivolous. Spontaneity of this sort might have been thought of as appropriate to theater rather than painting. Diebenkorn's move out of the Bay Area at this time was necessary to allow him space to breathe. A burst of energy informs the Albuquerque paintings. Often, as in *Miller 22*, there is a matching of landscape – sometimes suggesting a map of the U.S., or aerial views of ploughed fields – with a still-life perspective, ultimately deriving from Cézanne's combination of the table top and Mont Sainte-Victoire. This is seen in Diebenkorn's work in the notched, cut-out elements at the sides, and in anatomical, particularly sexual, forms. (The first eighteen months at Albuquerque were spent in a ranch environment, where the sex life of animals was something new to observe.) In this stage, identifiable shapes are used and then made multiple in association (pig-map-breast-mesa), but simultaneously toned down or disguised, often by actually painting on the canvas from several directions, as the brushstrokes and the

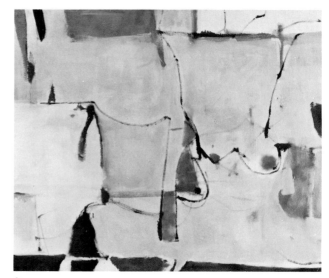

fig. 18

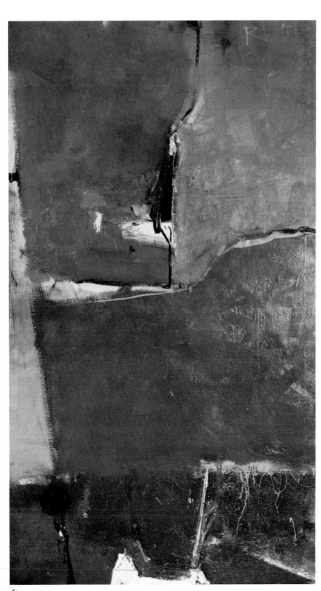

fig. 17

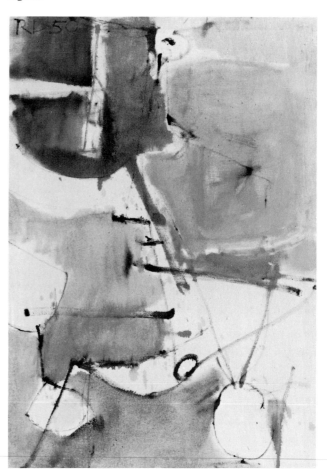

fig. 19

fall of spattered paint clearly indicate he did. This disguising is evident in *Untitled*, 1950 (fig. 19), when turned upside down. Often Diebenkorn develops here his characteristic long meandering line, a confident rhythmical stroking that can traverse seemingly great distances, define a shape, then go free, quicken and thin out, lurch and slow to a halt. It has a character and an intention quite unlike the lines of any of his contemporaries.

In other early paintings done in Albuquerque, different aspects of Diebenkorn's complex personality emerge. For example in *Untitled*, 1950 (fig. 20), with a nod to Matisse's *The Red Studio* in the unification of the picture by one line, Diebenkorn consciously allowed a rather literal lamplike drawing and a humorous head shape associated with the comic strip character "Henry" to dominate: "objectness would occasionally pop up again so I would accept it – and exaggerate it." It was a matter of "discovery of shapes through a negative or backward process; ordinarily one presents the object – here you achieve the same by painting the ground."

The artist's quirkily allusive line, his shorthand gesticulations filled with verve and humor can be traced in part to his affection for poetic cartoonist George Herriman's *Krazy Kat* comics, an anthology of which he bought in Albuquerque. This classically imaginative strip set in the New Mexico or Arizona desert contains whimsical depictions of the terrain – sagebrush and tumbleweed, mesas and bluffs, rocks and trees – that often parallel Diebenkorn's forms. The comic strip backgrounds are comprised of a repertory of irregular shapes and linear fantasies. There are "all-purpose" forms that can stand for an eye, a mouse's head, ears, flora, a bull's eye, a building perched on a hill, or a peephole, and these are presented as a family of transformational elements. Also suggested in Diebenkorn's paintings are the frequent fanciful variations of X-shapes, encircled, bent, rendered light against dark, then reversed, and continually dispersed through the strips as counterpoints to the narrative and as visual exclamation points.

The extreme receptivity of Diebenkorn at this moment (he had just written an art historical term paper on Dada), whether to previously undeveloped areas of sensibility such as humor or to the use of spontaneous pictorial devices, was extended to the work of Willem de Kooning, which he knew only from reproduction. Diebenkorn saw de Kooning's 1948 black and white paintings in an issue of *Partisan Review* that year. Although a painting such as *Untitled*, 1950 (fig. 21), is admittedly in debt to de Kooning, the distinct voice of the far younger artist (Diebenkorn was 28; de Kooning, 44) rings clear: the upper black area spatially resists the allover fragmentation of a de Kooning; it is evocative of an animal, just as other forms suggest humanoid or animalistic figures engaged in mock battle. Diebenkorn's execution is far less suave, more searching and tentative, yet confident and accepting of itself.

Diebenkorn "didn't have the color blue on [his] palette because it reminded [him] too much of the spatial qualities in conventional landscapes"[11] at around this time: *Albuquerque No. 4*, 1951 (fig. 22), benefits from this in its splendidly rich coloration. The pink coloration typical of Albuquerque recalls the "fleshy" pinks in de Kooning's contemporaneous *Woman* series but actually reflects the red dust of New Mexico and the effect of Southwestern light on adobe houses. Emblems, cryptic signs, and alphabet letters make their appearance at

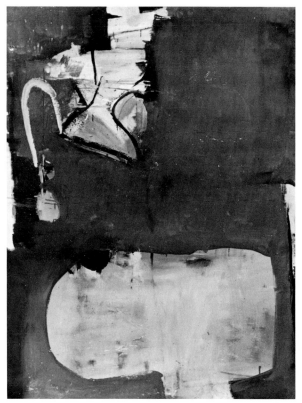

fig. 20

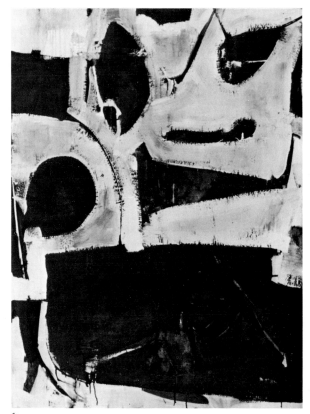

fig. 21

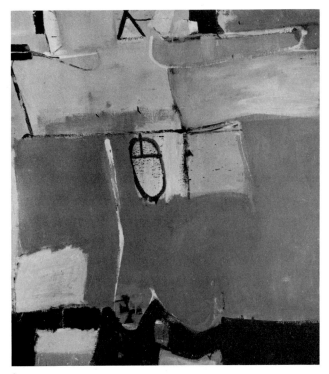

fig. 22

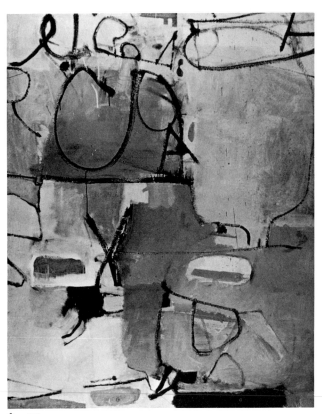

fig. 23

this time, reminiscent of elements in work by Picasso, Miró, Motherwell, and also in Adolph Gottlieb (whose pictographs were known to Diebenkorn). The artist's initials, R.C.D., appear in several paintings now. These and other letters appear in many paintings of the time, sometimes as in *Untitled*, 1951 (fig. 23), comprising a virtual "alphabet soup" and serving to "get the picture on." The lower left area is almost a fusion of two or more miniaturized Rothkos, and indeed, the planar surface may relate to Rothko. Diebenkorn, however, connects the central organizing plan to his persistent memory of the Bayeux Tapestry, in which "the main events are central and in flanking panels above and below there are dead men and devils and coats of arms – therefore, three dialogues paralleling one another, horizontally." When a picture is successful, there exist simultaneously three types of discourse among anatomical, still life, and landscape imagery. The discrete presentations are kept in precarious balance, obliquely relating to each other, with a delicate, restrained sense of presence. For example, there appears in *Albuquerque No. 4* the most basic element of Diebenkorn's vision in these years – the high, hanging pendulous shape in the areas just above the central lavender section, but it is not readily apparent. Contrast this configuration with related ones in *Disintegrating Pig*, 1951 (fig. 24), or *Untitled*, 1951 (fig. 25), a painting that was destroyed by the artist because of its excessive literalness.

Among the ranchyard animals around Diebenkorn's house and studio, pigs especially struck his imagination. Many pictorial elements derive from the physiognomy of this animal, a creature commonly disliked for its greed but fascinating for the artist in its single-mindedness. (Paul Harris remembers seeing fanciful drawings by Diebenkorn of black and white dogs gleefully urinating on pigs.) This relates to the equation in the Albuquerque canvases between the drawn contour of the animal and a map of the U.S. And maps also play an iconographic role, a double one: topographically, they give an impression of ploughed fields viewed from the air, and also cartographically (in somewhat later work), they suggest printed colored maps of America.

Paintings from Albuquerque incorporated direct landscape impressions, along with the bleached cast of things that resulted from dust from the red earth mixing with sand. In *Albuquerque 11*, 1951 (fig. 26), the red shape traversing the canvas derives from a bluff that was prominently visible from the house in New Mexico. Such a configuration remained for years in Diebenkorn's eye and mind; it appears in *Berkeley No. 3* years later, testimony to the exact fusion of things perceived, transformed, made personal – retained permanently.

Perhaps the most radiant of the Albuquerque paintings is *Albuquerque*, 1951 (fig. 27), which was purchased by Mr. and Mrs. Paul Kantor from the artist in New Mexico. (The Kantor's journey from Los Angeles to see the artist in Albuquerque, like that of Mr. and Mrs. Gerald Nordland the same year, was prompted by viewing *Painting No. 3*, 1947 (fig. 28), which Diebenkorn had exhibited in an annual invitational show at the Los Angeles County Museum of Art in 1949.) The white eruption of light at the right evokes some mysterious desert phenomenon. The lightninglike streak here seems related to Indian designs on pottery. This image is a fully-integrated landscape and still life – a table top shape is coincident with aerial landscape space, further matched with the gouge shape at the top, vestigial or abstracted sexual parts; again this structure derives from that of the

Bayeux Tapestry, in which diagonals thrust from above and below.

Albuquerque (The Green Huntsman), 1952 (fig. 29), painted at the end of the Albuquerque period, is one of the most disturbing images Diebenkorn has created. Titled after the novel by Stendhal, the painting, with its apparent exploration of sexual turbulence and its dramatic menacing air, is quite opposite from the logical clarity of the French writer. It is an unsettling picture for many viewers, characteristic perhaps of the connection between abstraction and sexually suggestive elements that often appears in the Albuquerque pictures and less so later on. The acid colors and dark green cast of the canvas seems deliberately unpleasant. The phallic elements intrude upon the sarcophaguslike shrouded reclining figure; at left, a figure in profile seems to appear or disappear while holding the "white head." Such a Rorschachlike reading, generally avoided by trained art observers, seems nevertheless to have been at the heart of many reactions to this singular work over the years.

Diebenkorn had earned his M.F.A. at the University of New Mexico one year after his arrival, at which time he held a one-man exhibition in the University Gallery in 1951 (fig. 30). Although the faculty generally did not know quite what to make of him – one must stress that his pictures were not only abstract, but bewilderingly tough, by any art standards – he was regarded with a bit of awe. His absolute dedication to painting and his characteristic gentleness, thoughtfulness, and far-ranging knowledge of art history served to keep potentially hostile colleagues at bay – at least most of the time. Kenneth Lash recalls however an occasion when Diebenkorn, having been criticized as an abstract painter "who probably couldn't draw, whipped off an extremely polished realistic portrait of a passing Navajo woman almost in a matter of seconds," in fleetingly angry retaliation. Diebenkorn took a creative writing course with Lash, who remembers an original piece on potatoes and who regarded the

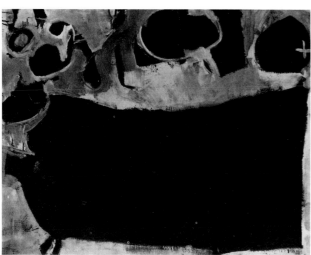

fig. 24

fig. 26

fig.25

fig. 27

18

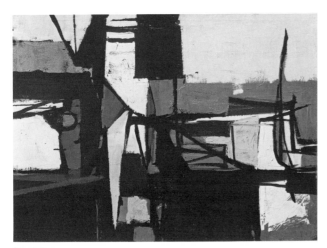

fig. 28

young painter as an excellent writer with an instinct for language.

Diebenkorn was allowed to spend a second year at Albuquerque on the G.I. Bill although clearly there was no proper place for him as a student. The only teaching position he was able to land for the following year was one at the University of Illinois at Urbana for the fall semester 1952.

Before settling at the university the Diebenkorns spent the summer of 1952 in California. At that time Diebenkorn saw the Matisse retrospective in Los Angeles, which was to energize and alter his work. Brilliantly selected by Alfred H. Barr, Jr., the exhibition was organized by The Museum of Modern Art, traveled west and was presented by the Los Angeles Municipal Art Department. It comprised forty-five important paintings and an even greater number of sculptures and works on paper, including many of Matisse's most resounding achievements such as *The Red Studio, Goldfish, Goldfish and Sculpture, Woman on a High Stool, The Piano Lesson, The Moroccans,* and *Tea.*

A painting such as *Urbana No. 4,* 1953 (fig. 31), is openly inspired by Matisse in its high-keyed vibrant coloring, but remains true to Diebenkorn's experience in its action-filled brushwork, organic imagery, and abstract inclination. The impetus of the Matisse show helps to explain why the Urbana paintings are often intensely colored – given Diebenkorn's propensity to absorb the look of the immediate environment into his work. There is no reflection of the brown, flat ambience of the American Midwest in these canvases at all. The artist's wife remembers the rather bleak environment as so depressingly unrelieved that they had barely settled before starting to plan their departure. Perhaps in turning toward the studio as an escape from the unattractiveness of the landscape Diebenkorn invented a range of color values in compensation. The area was "blotted out" of his consciousness; his studio was a dark, blacked-out room on the upper floor of their house. The artist notes however that in the town of Urbana itself there were lush and green landscape elements far more brilliant than had been witnessed at Albuquerque, or possibly even in California.

One of the most haunting Illinois pictures, *Urbana No. 2,* 1953 (fig. 32), has subsequently been called *The Archer.* The image was inspired by a cave painting from Altamira which

Diebenkorn had seen in colored reproduction. This is the only picture I know of for which the artist made preparatory sketches. The painting apparently made quite an impact at Urbana, recalls artist Don Weygandt, who was struck by the "beautiful expansion" of the painting, its "grace and elegance that is so rightly awkward."

After having abolished the color blue from his palette for most of his time at Albuquerque in order to avoid the connotation of representational space, Diebenkorn here uses it in a central way, perhaps to diminish the figurative impression of the hermaphroditic archer. The tensions implied by a crossbow are close to the heart of Diebenkorn's painterly objective. He has spoken of a "kind of tension that would involve a large flex," a sense that "potentially, something was to happen;" he is attracted to something that may "spring, a cocking apparatus, armlike fulcrum mechanisms;" themes of "potency and impotency." Earlier devices continue here: the red centrally spotted smear "nails" the picture space down while simultaneously evoking blood associations and recalling the vivid image in the Bayeux Tapestry that implies Harold is being slain by an arrow shot in his eye.

The Archer seems clearly a studio invention removed almost completely from the outdoor environment. Yet, other paintings, such as the superbly architectonic *Urbana No. 5,* 1953 (fig. 33), now called *Beach Town,* appear as virtual maps of an imagined landscape. Elements in this picture can be traced back several years: the strong diagonal that runs left to center, implying middle to background, derives from Diebenkorn's appreciation of Cézanne's viaduct in the familiar *Mont Sainte-Victoire.* Other sections are prophetic such as the blue and agitated green in the upper left-hand section which anticipate later landscapes. The graceful relatedness of small to large parts, curvilinear rhythms to straight edges, and the masterly interlocking of forms mark a new high point for the artist. In his use of diagonals, first introduced perhaps in a consistent way in this picture, Diebenkorn aims for a more complex and subtle space, allowing a greater sense of atmosphere without fear of losing abstractness.

In saying this may be the first picture to stress diagonal usage, it should be noted that the paintings from Urbana, San Francisco and Albuquerque do not readily lend themselves to chronology. Diebenkorn paints one to four pictures at a time, often with different painterly tasks set for each canvas; but each is realized independently. Only with the Berkeley pictures, starting at the end of 1953, can one attempt to follow an ongoing line of approach with any degree of assurance. At Urbana it is particularly difficult to find a key to his stylistic evolution.

If *Beach Town* is an abstracted aerial landscape, *Urbana,* 1953 (fig. 34), seems to be the next step – a materialized map. One of Diebenkorn's most interestingly conceived paintings, with all brilliantly colored areas lying precisely on the picture plane, there is no atmosphere or perceived space implied here. The deliberate humor of the three-dimensional cup at lower right might signal this as an experimental picture. Diebenkorn here employs neither a triple-banding approach to space, nor a central dividing line; the composition is rather a family of irregularly edged patches.

Some pictures hark back to Albuquerque for their basic color sense and for devices such as letters – "R.C.D." again being frequent – used to develop the surface. Calligraphy is freer, and larger sections work to hold impulsive scribbling in check.

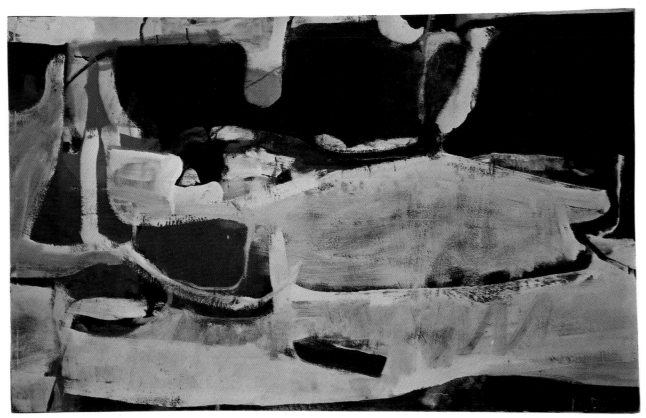

fig. 29

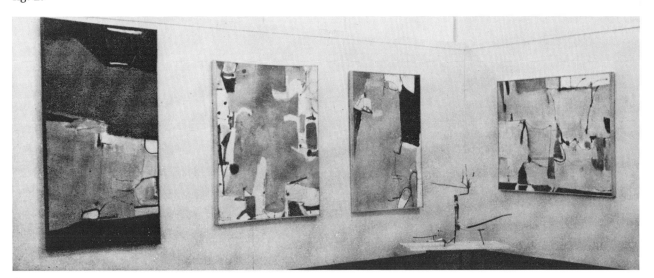

fig. 30

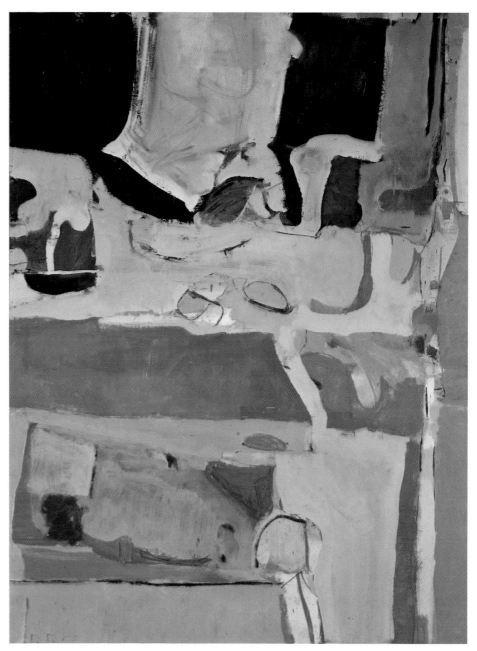

fig. 31

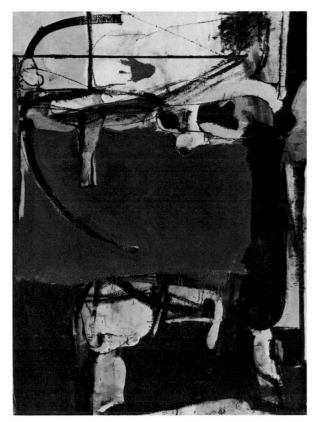

fig. 32

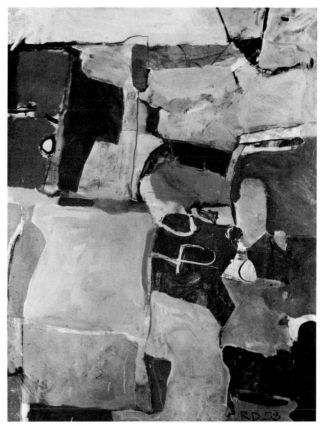

fig. 34

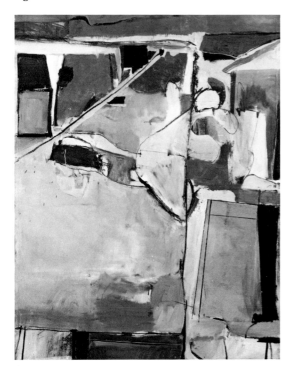

fig. 33

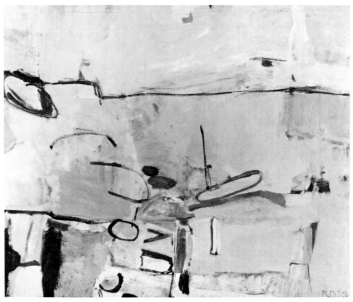

fig. 35

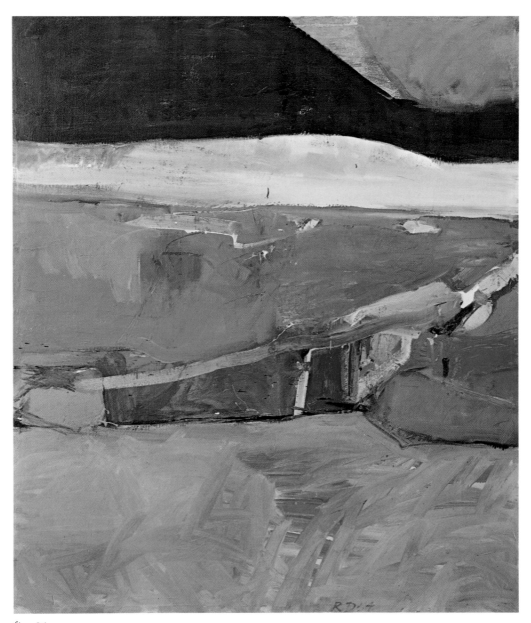

fig. 36

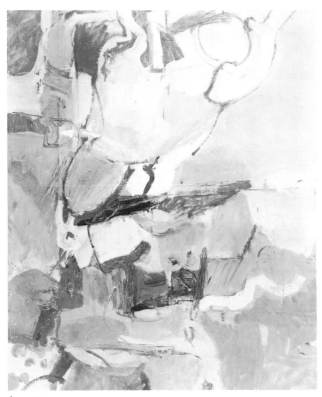

fig. 37

At the end of the Urbana year Diebenkorn decided to move to Manhattan, where he rented a studio on east 12th Street. He became friendly with Franz Kline, who would later urge Poindexter Gallery to take him on, and saw Ray Parker, John Hultberg, and others. Abruptly he announced one afternoon at the end of the summer that they were going home. They left the next morning, driving cross-country. It was the environment in New York that put Diebenkorn off – the humidity, eating in automats; the fact that his car was broken into and art was stolen from it – but most importantly, perhaps, it was the irregular pattern of New York artists that was inconducive to Diebenkorn's disciplined manner.

In the fall of 1953, after setting up a studio in Berkeley, Diebenkorn won a Rosenberg Fellowship, which prompted a new release in his painting energies.

The earlier striving for integration of various formats is now echoed by the desire to integrate drawing and painting in one picture. The canvases of 1953-55 are both drawn and painted, relating to both ends of the New York School polarity, between color field and expressionism, and they assimilate the contrary inclinations of Rothko and de Kooning.

Early Berkeley paintings such as *Berkeley No. 3* (fig. 35) of the fall of 1953 relate to the Albuquerque works in their pink tonality, as well as in more specific ways – for example, the line crossing the canvas laterally at the top derives exactly from the bluff he had painted frequently in New Mexico (see fig. 26). Or in *Berkeley Landscape*, 1954 (fig. 36), there is an obvious tripartite vision, as was common earlier, with a diagonal (perhaps an actual viaduct here) that connects the lower to the upper band. Yet at Albuquerque the paintings had mood; in *Berkeley No. 3*, for all its seeming congruity with the earlier work, there is an aspiration toward the "moodless."

It is difficult to get away from a prevailing set of emotions in a painting, the artist remarked, and "moodlessness has traditionally not been painted," but the attempt is made. The painting is undeniably anti-dramatic, neutral, like the light of a clear noonday scene referred to by Bischoff above. The presentation of emotion remains in the forefront of the artist's concerns, but the desire is to make it come from different sources than even the remotely referential. Contrast between the sense of colors (low keyed and gentle) and lines (impulsive, almost chaotic) is a favorite means of achieving this new emotional expression. Another type of contrast is like an oxymoron (i.e., "hot ice") when passages of an expressionistic vitality lie in fields of serenely radiant pigment. Diebenkorn once remarked: "I would prefer doomsday in the bright sun." Much of the atmosphere of menace and terror conveyed by the darker Urbana paintings is reflected at Berkeley, but sublimated. And thoroughly sublimated, too, are images that trace to views at Albuquerque – Indians preparing jerky, stretched wires with red raw meat hanging to dry slowly in the sunlight. Initials or insignia are similarly apparent at Berkeley, but these are now presented more freely, with Diebenkorn's characteristically agile, looping line. The rhythms, more gestural, flow relaxedly but confidently throughout the canvases. More nuanced shades of color and more varied textures seem to appear effortlessly.

Unusually strong landscape suggestions often dominate now, and this prompted the term "abstract landscape" that was applied to the paintings of Diebenkorn and others in 1954 by *Life* magazine. This epithet was resented then, but now that the argument about abstraction versus figuration is long dead the term seems not irrelevant but descriptive, indicating that Diebenkorn is understood as an artist whose vision is directly tied to the perceived world. In the Berkeley paintings the landscape format overwhelms the earlier fused themes – of landscape with anatomy with still life. The ambiguity of pre-Berkeley pictures is now suffused into the most agitated and spontaneous painting Diebenkorn has ever made. The exhilarated gaiety is held in check by seriousness; the stroking is never excessively exuberant or perfervid, being restrained by strong architectonic structure. Perhaps encouraged or sanctioned in this by de Kooning's example (see *Berkeley No. 16*, 1954 [fig. 37], with its suggestion of female anatomy recalling de Kooning's *Woman* series), Diebenkorn opens up full throttle, as it were, and paints in his own lyrical and expansive way an inspired series of Abstract Expressionist canvases of the first importance.

If the earlier compositional formats had been predominantly triple-banded or horizontally centered, the Berkeley pictures focus on a heightened "situational" characteristic. The cuts which divide areas and allow each to develop its own particular sense are characterized by greatly heightened impulsiveness and improvisation. Such released dynamics, especially when diagonal movements are involved, impel Diebenkorn to "use all wiles to avoid too much recession."

In the Berkeley pictures the effect "is of objects totally clear of a deep space behind them" – indeed the "space" is quite as palpable and felt as the object. As before, there is no focal point in Diebenkorn's canvases after 1949. Sometimes "things tumble through space," as in the confettilike sprinklings in various paintings; this is an interesting evolution from the hanging mass found in earlier work.

The diagonal plays a key role in *Berkeley No. 8* (fig. 38). Diebenkorn recalls his interest at the time in Chaim Soutine's

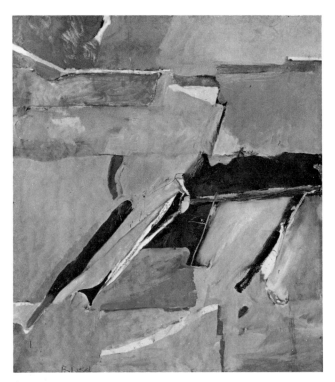

fig. 38

uprooted landscapes, with "their almost totally broken surfaces" oriented around angled thrusts. (Diebenkorn had seen an early Skira publication with Soutine reproductions at this time.) These brilliantly rendered canvases present an interesting tension between the frontality and the inclination of forms which bend upward and backward. One can establish a format for certain images – a field of six-layered areas, say, with a central band fractured and made asymmetrical, but Diebenkorn adroitly manages to avoid formula repetition. Every canvas is unique, singular in color and in resolution of the compositional problems. The overall color of every painting varies, but we are a far distance from the dry arid desert tones of Albuquerque.

Diebenkorn employed "systems" to pack "every hue and every variation into the picture. With six basic hues, and at least one variant for each – that's twelve – plus black and white and grays, I would get the ball rolling. I would ask, how much further can I go, what further break in the color system can I make?" With a "break in the system, paintings remained complete regardless of the turmoil" but one "came as close as possible to where no further expansion can work." "It wasn't fun unless all the colors, all the characters, were present." Such use of bright basic hues constituted "a different way of working" for Diebenkorn at this time; different from using earth colors or experimenting with black and white (this latter usually as a "reaction" away or change of pace from color throughout his career).

I began this article by noting that Diebenkorn's contribution to Abstract Expressionism has been seriously neglected, and that paintings made as early as 1949 and a considerable number in the next few years hold their own with the great achievements of older New York artists. It must also be stressed, however, that while Diebenkorn's early paintings

make claim to historical importance, they are distinctly the product of a younger artist's sensibility. Predominant in these paintings is a sense of distancing, a self-consciousness about the improvisational aspect that anticipates Jasper Johns' work later in the decade almost as much as they relate to the action painting of de Kooning. Agitated scribbles in wet paint lie adjacent to rhythmically flowing curves; sections of the seemingly most exhilarating handling are coolly repeated elsewhere in the canvas. Spontaneous as the painting appears, study shows how intensely it has been analysed, painted, and reworked to the minutest detail. Impulse is a closely watched procedure in Diebenkorn. This element of distancing is accountable to the artist's well-known restraint and modulation as a personality, and to his careful, almost scholarly, study of earlier art and of the many possibilities of modern examples. In this way he remains ultimately true to the experience of his own generation.

Maurice Tuchman
Senior Curator of Modern Art
Los Angeles County Museum of Art

NOTES

1. Everyone I contacted about this period of Richard Diebenkorn's work went out of his way to extend me courtesy and seriously attempted to recall the exact way things were. First, I wish to thank the artist, who unfailingly made our sessions a challenge and a pleasure. His wife Phyllis was a model of thoughtfulness and a mine of information; much of the latter did not find a place in this introductory article, but will be used at a later time. The Diebenkorns' daughter, Gretchen Grant, provided interesting early recollections. Artists Elmer Bischoff, Paul Harris, John Hultberg, Ray Parker, Frank Lobdell, and Don Weygandt were extremely generous with their time, as were Mr. and Mrs. James Byrnes, Walter Hopps, John Humphrey, Paul Kantor, Kenneth Lash, Gerald Nordland, and Mr. and Mrs. Gifford Phillips. At LACMA various forms of assistance were provided by Stephanie Barron, Nancy Grubb, Barbara McQuaide, and Grace Spencer.

2. Douglas MacAgy, quoted in Mary Fuller McChesney, *A Period of Exploration, San Francisco 1945-1950*, The Oakland Museum Art Department, 1973, p. 74.

3. Unless otherwise specified all quotations are from conversations with the artist tape recorded in Los Angeles during the spring of 1976. All other quotations attributed to various individuals were recorded during this period as well.

4. Frederick S. Wight, Richard Diebenkorn, Emerson Woelffer and Lee Mullican in a discussion of the Phillips Collection, *Artforum*, vol. 1, April, 1963, p. 26.

5. *ibid.*

6. *ibid.*

7. Hassel Smith exhibited "beast" paintings at the San Francisco Museum of Art in 1947.

8. Quoted in Wight, *op. cit.*, p. 26.

9. This painting won the Emanuel Walter Purchase Prize at the 67th Annual Exhibition held at the San Francisco Museum of Art.

10. McChesney, *A Period of Exploration*, p. 82.

11. Quoted in Wight, *op. cit.*, p. 26.

The Figurative Works of Richard Diebenkorn

Richard Diebenkorn was in grade school when he first expressed the idea that he wished to become an artist. From the time of his earliest recollections, he had drawn from his imagination as well as from observation. He can remember more than 200 drawings of trains meticulously detailed on the cardboard rectangles around which his father's dress shirts were folded when they came from the laundry. "I looked very carefully at every train I saw, trying to grasp its mass and proportions as well as its wheel systems." The boy's grandmother encouraged him to consider art as a profession. She was an amateur painter and she told him, "It is one of the great professions of life; to be an artist." Later she gave him her kit of oil paints and he painted outside from nature.

In the early 1930s Diebenkorn attended an exhibition of van Gogh when he couldn't have been much more than ten or twelve years of age. Visits to museums were infrequent and this particular experience was highlighted by an earnest docent who was very serious and made a great effort to help the visitors see and understand the work. Diebenkorn recalls many of them laughing at the work and ridiculing it.

In childhood, Diebenkorn had become aware of the illustrated books of Howard Pyle and of N.C. Wyeth with their romantic writings coupled with skillfully and intelligently executed genre illustrations. Pyle and Wyeth paid great attention to the details of dress and to authentic stagings in their illustrations which made their work more convincing than that of lesser illustrators. Later in his school career Diebenkorn became interested in the work of Frederic Remington, for the artist's vigorous paintings more than his sculpture. He also enjoyed – if to a lesser extent – the work of Charles Russell and Will James. Still later the artist's own drawings focused on imaginative depictions of violent adventure stories from the 17th century to the modern. Giving illustrative form to the swashbuckling chronicles of Alexandre Dumas, Rafael Sabbatini and others consumed countless hours. In his high school years Diebenkorn read a series of articles in *Esquire* Magazine by Harry Salpeter which examined the lives and art of such painters as Aaron Bohrod, David Burliuk, Jon Corbino and Abe Rattner and gave him quite a different sense of the ways in which contemporary artists made their careers.

The possibility of Richard's attending Stanford University had been discussed in the Diebenkorn household throughout his childhood. He had become familiar with the university and he looked forward to attending. While Richard's grandmother encouraged him to become an artist, his father was not at all sure that being an artist was a respectable or worthy objective for his son and he hoped that Stanford would provide more appropriate goals such as medicine, law or business. Stanford's lower division general survey courses proved stimulating to the young student. However, Diebenkorn could not resist beginning a few painting courses in his second year. He enrolled in watercolor painting with Daniel Mendelowitz and oil painting with Victor Arnautoff. The art department was not large and it was conducted rather loosely at the time, so Diebenkorn was permitted to leave the studio to work from nature and to submit his work to the instructors at the end of each week for criticism. Arnautoff taught classical fundamentals of form delineation with emphasis on precision, discipline and accurate rendering while Mendelowitz emphasized principles of color and paint handling. Perhaps the art department was a little light on theories of modernism; nonetheless, there was a history survey in

which large reproductions of works by artists such as Edward Hopper were shown. Diebenkorn responded strongly to Hopper's imagery and its American nature, which "fitted in with the writings of Sherwood Anderson, Hemingway and Faulkner whom I had been reading." Perhaps this response to Hopper was his first experience of art in the profound sense in which he would soon see Cézanne, Picasso and Matisse.

One of the earliest surviving works of the artist's formative years is *Palo Alto Circle*, 1943 (fig. 1). It was painted during the artist's last six months at Stanford while he was on contract with the Marine Corps. The image is a frontal view of a hotel building on the circle with railroad tracks, a chain link fence, a passenger platform, and another fence standing between the observer and the hotel. Strong afternoon sun slants across the hotel's second story facade with its curtained and blinded windows and its strong shadow patterns, while "cafe" and "Coca-Cola" signs can be read at the first level. Quite clearly the artist had angled about to obtain this "American" view; the strong Hopperesque light, the frontal imagery, the framing devices of rails in the foreground and the powerful vertical lamp standard along the right margin of the painting. There is a vivid sense of heat, a quality of specific visual experience and considerable precocious compositional skill demonstrated in the canvas.

After his third year at Stanford, the Marine Corps called Diebenkorn to service in the V-12 Officer Training Program and transferred him to the University of California, Berkeley. He was only enrolled at Berkeley for one semester but wearing a uniform for the first time, attending physics classes, and managing to take art courses as well, gave the period a richness of impression which makes it in memory seem much longer. He studied with Erle Loran, Eugene Neuhaus, and Worth Ryder during his stay at Berkeley. "Loran gave me quite a bit. He permitted me to work outside of the studio. After he'd seen my work on one occasion he said to me that he thought I'd like Niles Spencer. I looked him up, and, indeed, I liked his work very much." Art training at Berkeley was more structured and more professionally oriented than it had been at Stanford. During this brief period Diebenkorn first visited the San Francisco Museum of Art where he purchased a number of catalogues that he took with him in the Marines.

Diebenkorn was ordered to South Carolina to Parris Island for Marine boot camp and then to North Carolina for four months prior to Officer Candidate School at Quantico, Virginia. In North Carolina he began to paint again. While at Quantico he made his first visits to The Phillips Collection, Washington, D.C., and saw the Henri Matisse painting, *The Studio, Quai Saint-Michel*, 1916 (fig. 2). It was also at Quantico that the artist made his first abstractions. "It was at about this time, after having visited New York and Philadelphia and having encountered Mondrian and Cézanne and still other Matisse paintings that I concluded that a painting's pictorial structure could be seen apart from its objective stimulus."

Diebenkorn then prepared for duty as a war artist and was transferred to Hawaii on active duty. His first efforts to achieve a new and deeper understanding of Cézanne and his building sequences of planes with the goal of architectural monumentality were made in Hawaii. By that time the experiences of Stanford, the University of California, and the eastern museums could begin to be sorted out and understood. The artist found an excitement in the creative process

and an absorption and intensity of feeling regarding it and its intriguing artifices that was deeply rewarding.

After the years of military service Diebenkorn knew that painting was his vocation. As he felt that vocation could be best followed in a professional art school, rather than by returning to the university, he enrolled at the California School of Fine Arts, San Francisco, in January 1946. It was at the CSFA that he met David Park who became his most influential teacher and friend. Other important new acquaintances included Douglas MacAgy, Director of the School, Clay Spohn, the painter with whom he studied for a time, and John Grillo, a fellow student.

Diebenkorn applied for and received the Albert Bender Grant-in-Aid which gave him the freedom to paint most of the next school year (1946-47) in Woodstock, New York, with visits to New York City. As he began that period on the grant he accepted MacAgy's invitation to join the CSFA faculty for the 1947-48 school year. Upon returning to San Francisco in the late spring of 1947 he learned of the vital new influence of a painting faculty member – Clyfford Still. In June he saw Still's one-man show at the Legion of Honor and he recognized the unusual contribution being made by the elder painter. In the autumn Diebenkorn began his teaching responsibilities with classes in life drawing, drawing and composition, and introduction to painting, part of a remarkable faculty which included Bischoff, Park, Hassel Smith, Clyfford Still, and the newly arrived Edward Corbett. He came to know and admire his colleagues while at the same time, because of his youth, he also became associated with a group of students which included John Hultberg, Walter Kuhlman, Frank Lobdell, and George Stillman, among others.

During the period of his military service, Diebenkorn was growing in his control of the painting medium. The Bender grant gave him the time to consolidate his gains and to become more self-critical of his new found ability to organize, assemble and reassemble his painting ideas. Painting was becoming malleable for him and he could use parts synthetically. Just about the time that he assumed his teaching post, the artist was invited by Germayne MacAgy, Curator of the Palace of the Legion of Honor, to hold a one-man exhibition in that museum. That show was held in 1948, in the same museum in which, as a boy, he had first encountered the painting of van Gogh. He also received the Emanuel Walter Purchase prize in the 67th San Francisco Museum of Art Painting and Sculpture Annual.

In the passing of eight years the young man had moved from student to award-winning professional with an appointment to a faculty and the beginnings of a career. In the next decade he would develop his concept of abstract painting, broaden his exhibition credits, deepen his relationship with David Park, move to Albuquerque to take an M.A. degree, teach a year at the University of Illinois (Champaign-Urbana), return to Berkeley to develop further his emotional abstract painting style, and finally question it and turn to representational painting in the company of his old colleagues, David Park and Elmer Bischoff.

In 1950-51 David Park had suspended his own abstract painting and had begun a series of canvases of genre scenes from Berkeley experience. Park felt an unselfconscious satisfaction in that work, and acceptance of less formal thinking. As a result he painted in a more fully absorbed manner with new enthusiasm. His direct and forceful painting, modeled boldly with a broad brush, painting-out, correcting, delineating a form through emphasis of the negative, had an intel-

lectual vitality and a healthy simplicity about it which exuded freshness. His spontaneous abstract painting skills were not blunted by his figurative work. "David Park was an astute, complex and educated man. He was my teacher at the California School of Fine Arts. He knew music and played Bach as well as jazz at the piano. His friends included a group of intellectuals from the University of California – Roger Sessions, Mark Shorer and Stephen Pepper. He was paternal toward me and more than often he reverted to the role of teacher. He was born in 1911, and there was a consequent difference in our thinking. It was a rewarding relationship. David was committed to extreme painterliness and he related this to quality and to emotion."

Elmer Bischoff had painted in a figurative manner while studying for his M.A. at Berkeley in the 1930s. After a tour in England with the 8th Air Force during the war, he returned to the Bay Area to teach at the California School of Fine Arts, and he worked in abstract painting until 1952. Since leaving the CSFA he has served on the faculty of the University of California, Berkeley, for more than fifteen years. In the early fifties, his work was characterized by a pearly sense of atmospheric space, which gave way later in the decade to new strong color and massings of a spontaneously brushed nature metaphor.

Diebenkorn had returned again to the Bay Area in the early autumn of 1953 and had resumed his friendships with both Park and Bischoff. He was impressed with the development of his friends' work and he introduced both to his Los Angeles art dealer, Paul Kantor, who subsequently held solo exhibitions for each. His own work had taken on a vigorous commitment to experimental use of the medium, to daring and dissonant effects and juxtapositions achieved through forming with color. The Albuquerque and Urbana years had enabled Diebenkorn to develop his fluency and his painting was well defined as he began his Berkeley period. Opportunities to exhibit multiplied including a second one-man show at Paul Kantor Gallery, and an invitation to the "Younger American Painters" exhibition organized by James Johnson Sweeney for the Guggenheim Museum. He received the Abraham Rosenberg Fellowship and was able to continue painting full time without teaching. In 1954 the San Francisco Museum of Art held a one-man show of the new Berkeley paintings which was followed by a solo exhibition at the Allan Frumkin Gallery, Chicago. In 1955 he was invited to show in a three-man exhibition at Oberlin College (Ohio), and to exhibit in the Sao Paulo Bienal.

In the summer of 1955, perhaps twenty months into his emotional Berkeley abstractions, the artist began to question what he was doing. He told Paul Mills, "I came to mistrust my desire to explode the picture. . . . At one time the common device of using the super-emotional to get 'in gear' with a painting used to serve me for access to painting, too, but I mistrust that now."[1] "Something was missing in the process – I sensed an emptiness – as though I were a performer. I felt the need for an art that was more contemplative and possibly even in the nature of problem solving."[2] "It was almost as though I could do too much [in the last of the abstract paintings, around '55] too easily. There was nothing hard to come up against. And suddenly the figure paintings furnished a lot of this."[3] It was in this state of self-questioning, and undoubtedly troubled by the impressive examples of his good friends Park and Bischoff, that Diebenkorn chose to experiment in making a representational painting. He selected a small canvas and began painting "a messy still life,"

the subject of which he recognized among the accumulations in his studio. He was not delighted with the painting but it gave him a satisfaction of release from "performance" and it offered something real to work with and against which to push. When David Park responded affirmatively to the new work Diebenkorn felt some sense of confirmation in his search for a new direction. He devoted himself to a series of representational paintings over the ensuing months, even though his gallery exhibitions continued to be drawn from work in emotional abstraction. He was, of course, uncertain as to how the new work would develop and he knew that it was possible that he could return to the explosive abstract manner. He pushed ahead into the figurative work with an increasing excitement and a new sense of powerful purpose. In the first few years of representational work the artist could not keep up with the flow of his ideas and the suggestion of stimulating possibilities. Abstract expressionist paint and direct handling adapted to figurative imagery gave him a rewarding freshness and stimulation. He worked in continually shifting ways with different themes or aspects of subject painting, gravitating to the "American" themes in his own life. As always, he worked from his own feelings, and he learned to develop, criticize, reassemble and synthesize his visual concepts in the development of a painting. He began his new work in representation with what might be thought of as exercises – painting directly and objectively from still life. The painter took a subject that was simple and complete in itself and one that he felt able to handle without invention or imaginative investment. At a slightly different level he might choose a still life subject with some special appeal – some peculiar "juice," to use his own word – which showed a potentiality for painting. Then, in the process of working, the artist would hope to find the elements which were meaningful to him and give them expression. For the purpose of analysis one may discern three more-or-less separate ambitious and synthetic themes or approaches to subject matter which occupied the artist in the period of his representational researches: The composition involving one or more figures; the interior composition, often with a windowed view of cityscape or landscape; and the landscape or cityscape proper. Such an analysis suggests a programmatic approach which is misleading; nonetheless these distinct approaches do exist and have developed simultaneously, recurring throughout the evolution of the representational work.

Three paintings from still life subjects – *Still Life with Orange Peel*, 1956, *Still Life with Letter*, 1961, and *Poppies*, 1963 – tend to typify the most direct and objective of the artist's approaches to representation. It must be noted that Diebenkorn's still life paintings tend to be seen at an angle to the table plane which is not traditional in western painting. There is no accident in this abrupt angle of vision, which often concentrates on the table to the omission of both foreground and background. One might conjecture a relationship with naive painting from this device but that is not the case. More properly one must relate it to the artist's observation of Persian and Indian miniature paintings, and to his knowledge of Matisse's famous masterpiece of 1911, *The Painter's Family* (fig. 39), which draws upon the Islamic tradition. It is perhaps surprising that this planar tilt has not been more fully discussed in Diebenkorn's work, for the seating of his still life objects in the picture space is made more complicated by the forced angle of the plane.

The seating of the elements in a still life is in truth a mechanical thing and is the result of mastering the art of drawing. In the larger sense of painting, composition, color, line and the proportions of the formal elements are often spoken of as "sitting" rightly or wrongly. The artist has written of that sense of the art of painting, whether representational or abstract, about illusions of space and of flatness and their inevitable tensions: "If it doesn't sit right I'm not really saying it. Getting it to sit right is another thing, – complicated, time consuming, wasteful. It comes around to what is contained in 'sitting right.' This is what the picture is about."[4]

In *Still Life with Orange Peel*, 1956 (fig. 40), we look down upon the tilted table top with its striped throw and the asymmetrically spaced still life items. There is a tactile assertion of paint material overall. We recognize it in the table cloth and its rhythmical stripings, in the orange and the bottle, and in the floor and wall background. This is clearly the expressive, emotional, non-traditional handling of the abstract expressionist period. The tension between spatial illusion and flatness, between painterly gesture and the representation of objects is forcefully made. The artist introduces a note of questioning what is "sitting right" in all of the still life elements which gives the work a compelling sense of immediacy.

Still Life with Letter, 1961 (fig. 41), is less dramatic than the *Orange Peel* painting. It is a seemingly matter-of-fact vision of the studio table with match-striker, opened sketch book and letter, coffee cup and can lid spread out across the blue-gray paint surface. As simple and forthright as these elements seem, they should be looked upon as unconscious expressions of choice, renditions of familiar objects for which the artist feels sentiment. That match-striker has occupied an easily available spot in every studio over the years. The artist's keen observation and effective translation of an ink surface is demonstrated in the cropped sketchbook. The subdued illusionism of the classic roadside-diner coffee cup touches a quality of imagery which is both routinely familiar and satisfyingly universal. "I have found in my still life work that I seem to be able to tell what objects are important to me by what tends to stay in the painting as it develops." That affection and respect for these apparently trivial counters is communicated through the dramatic close-up camera vision of the composition, the subtleties of the blacks and dynamism of the cropping.

A comparable painting of 1963 – *Poppies* (fig. 42) – works changes on the still life convention. The severely centered table tilts at an even more exaggerated angle and the just off-center glass of poppies leans slightly to the right. The gray-blue table cloth appears transparent, permitting a shine-through of parallel stripes which underlines the severe angle of the table plane and questions the "rightness" of the seating of the glass vase. Two wedges of black and white striping can be read at the unbalanced right-hand corners of the table as a corroboration of the transparency that is as much felt as read in the table cover. The floor and backwall merge without horizontal demarcation in a harmonic deep midnight blue with painterly accents. Only an unexplainable ribbon of blue, white and red running from the upper canvas margin to the table top both asserts the background plane and forces it forward with abrupt vigor. The artist's own satisfaction in surprise can be recognized throughout.

fig. 39

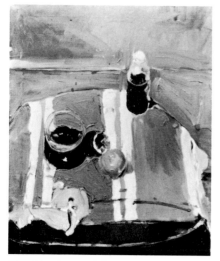

fig. 40

fig. 41

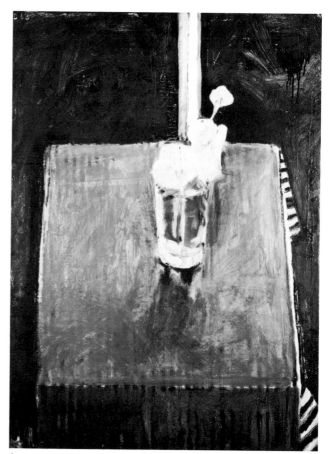

fig. 42

Other still life paintings of the period 1959-61 are of special interest because of symbolic content that is unusual in the artist's work. *Scissors and Lemon*, 1959 (fig. 43), presents the heavily painted green and white striped table cover seen in the *Orange Peel* painting. The cover occupies the upper one-third of the picture space, and the double white stripes serve as emphasis for the placement of the awkwardly halved lemon and its intense cast shadow. The lower half of the painting is dominated by a heavily impastoed pair of scissors widespread upon the dark red wooden table, and menacing the vulnerable fruit. Directional brushstrokes underline the negative spaces around the scissors. The modest scale of the canvas tends to make the vertical flatness of the composition appear unforced.

Three small canvases with still life subjects have been acknowledged by the artist as reflective of symbolic meaning. In *Tomato & Knife*, 1962 (fig. 44), the viewer's eye is close to the tipped table plane and the knife handle extends off the canvas to the lower left, as the point extends almost to the right margin near the upper corner of the table plane. A shadowed white table cloth falls away at the foreground and upper edge of the table and is met with a purple void, so that the white table surface is a brilliantly lighted just off-square staging for the simple objects. The knife blade lies on the textured white surface between the two hemispheres of fruit. The tomato is characteristically colored and suc-

fig. 43

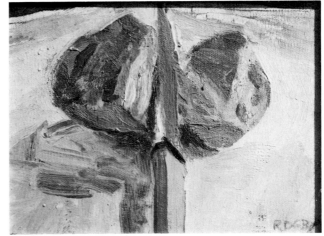

fig. 45

fig. 44

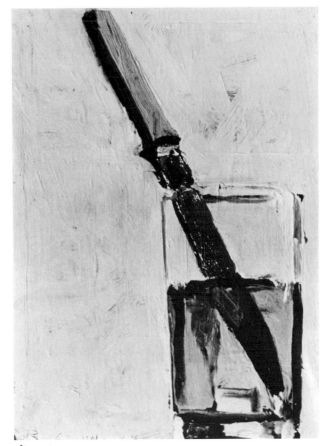

fig. 46

culent with a painterly veracity which verges on *trompe l'oeil*. The phallic, threatening knife, and vulnerable colored flesh carry the device of a Bonnard into the modern context of Freudian document. *Tomato & Knife*, 1963 (fig. 45), a companion painting, recasts the previous subject on the vertical axis of an even smaller canvas, where the knife handle falls outside the lower margin while the blade touches the upper margin, resting upon the severed flesh of the tomato. The painting is an ambiguous image of sexuality and of confessional self-awareness. As the artist has said, "I trust the symbol that is arrived at in the making of the painting. Meaningful symbols aren't invented *as such*, they are made or discovered as symbol later."

Knife in a Glass, 1963 (fig. 46), is the third and last in this brief series. The same ivory-handled knife is propped up in an off-center glass, with the blade partially submerged in a clear liquid, partly distorted by the upper curve of the glass and partly to be seen emerging from the glass. Hilton Kramer has written of the painting:

> The single most impressive painting in the Poindexter exhibition last month was, for me, one of the smallest, the still life called *Knife in a Glass* (1963). Here the advance in realism has thrown the artist back about a hundred years in the history of style: impure Diebenkorn is, in this instance, the purest Manet. Only a painter of the greatest skill and sensitivity could have produced it, yet there is something almost anonymous in its old-fashioned emulation of a received vision and a practiced technique. One hardly knows whether to embrace its audacity – it is certainly a very beautiful painting – or shudder at such naked esthetic atavism. . . .[5]

Compositions involving one or more human figures, whether in an enclosure, on a porch or veranda, or in nature, are the best known and most "typical" of Diebenkorn's work in the representational vein. Many of these images have been reproduced a number of times and they may even occupy a position in the public mind that is more significant than should, on balance, be true. Very often the figure is embedded in the frontal plane, in opposition to the illusion of space suggested by massings of color and a perspective which deny the classical treatment. The artist has said ". . . in a (successful) painting everything is integral – all the parts belong to the whole. If you remove an aspect or element you are removing its wholeness." That is to say that the entire arrangement of the composition is essential – the figure or objects, the negative spaces between elements, the proportions, lines, shadows and colors. Diebenkorn has said, "I'm a little ashamed of them [mistakes] in my pictures, so I obliterate them. You can't see what *I* consider a mistake in my work. . . ." Everything that remains, then, is considered, verified and confirmed by repeated examination and acceptance.

Diebenkorn has seldom painted directly from the figure. He has worked as a rule from drawings made from the figure, moving synthetically to assemble a vision which achieves an integration of figure with environment. Often, as in *Woman in a Window*, 1957 (fig. 47), the subject's face is turned away from the viewer, as she looks out a window toward the sea. The weight of her head, elbow and hand is focused at the corner of the table where the chair arm, table leg and window stretcher coordinate their visual forces. Reverie and geometry are tied together in the evocation of mood. It is clear that the artist works on at least two levels: constructing a picture in which shapes (colors and spaces) form a set of unique relationships, independent of subject matter, while at the same time capturing and preserving the physical and emotional overtones aroused in him by visual experience.

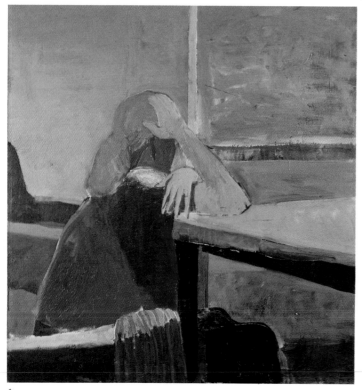

fig. 47

In *Girl on a Terrace*, 1956 (fig. 48), the artist evokes a similar mood, with a standing figure, left arm behind back, hand holding the right forearm, motionlessly studying this landscape. One may ask what emotional meaning this subject with her back turned to the viewer has for the artist. "Maybe the given (subject) person, cup, or landscape is lost before one gets to painting. It isn't as easy as 'painting what you see' with a figure. A figure exerts a continuing and unspecified influence on a painting as the canvas develops. The represented forms are loaded with psychological feeling. It can't ever just be *painting*. That kind of feeling *can* be enriched to the total work, but it can also be continuously troublesome, setting up overtones and talking back (to the painter)."

At another time the artist made the effort to explain the somewhat mysterious dynamics of how a painting is brought to completion, when he made this note: "As a work progresses, its power to elicit and dictate response mounts. There seems to be an optimum moment when this power is at its greatest which just precedes the point where 'elicit' is no longer apt usage. 'Dictates' is the word for this condition and tyranny is the adversary."[6]

In *Coffee*, 1959 (fig. 49), one senses the depiction of a characteristic gesture of a particular subject, as many Diebenkorn paintings would tend to suggest. Since drawings of different models, or imagination, form the initial impetus of his imagery, one may only conclude that the unique sense of subject suggested springs from the artist's own subjective sense of the charm and appropriateness of a figure in the particular balanced and harmonious unity toward which he is working.

Woman on Porch, 1958 (fig. 50), is a prototypical example of Diebenkorn's figure painting. A skirted female figure sits in an arm chair at the lower left, engulfed in sunlight which seems to erase all details of recognition. The intensity of light is emphasized by the yellow-orange-red ground plane and is relieved by the deep blue shadowed parapet which is in turn surmounted by a pale band of blue sky. Even the most casual examination of this work will reveal a sensuous pleasure in the plastic nature of the medium and the balance of the strong color tones which complement and enrich rather than destroy or dilute each other.

Woman with Hat and Gloves, 1963 (fig. 51), is another of those memorable works where the figure dominates the surface plane and the remainder of the picture space falls into shallow staging. Here the figure is one of those self-embracing subjects, like *Girl in Window*, 1957, and *Girl Smoking*, 1963 (fig. 52), which the artist so often employs. The subject is seated on a divan leaning forward with her right leg drawn up under her, and her left leg extended out to lower right. A high-heeled shoe establishes a bright incident at each lower corner of the canvas, while the crossed weight of gloved hands rests on the centered knees and the hatted figure turns to its right, looking out of the picture space. A nude figure, reclining in the upper right corner is ambiguous – a drawing is suggested by the use of grey. In any case, the depiction in the upper right pulls our attention back into the painting and recycles our investigation of the complex structure of the subject image.

In those few works which pose two human figures, we may find the subjects standing or sitting in a room with a steeply tilted floor plane (*Man and Woman in Large Room*, 1957 [fig. 53]), or closely grouped in an indeterminate landscape (*Women Outside*, 1957 [fig. 54]). Perspective is expressed emotionally, abruptly, without the devices of one-point

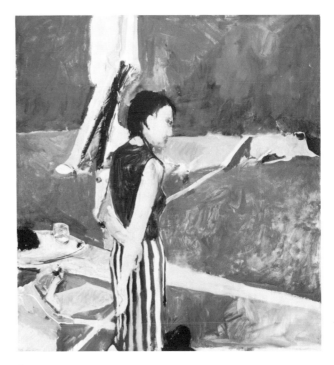

fig. 48

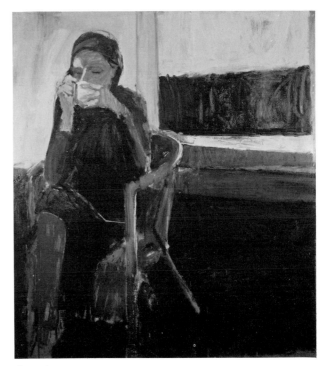

fig. 49

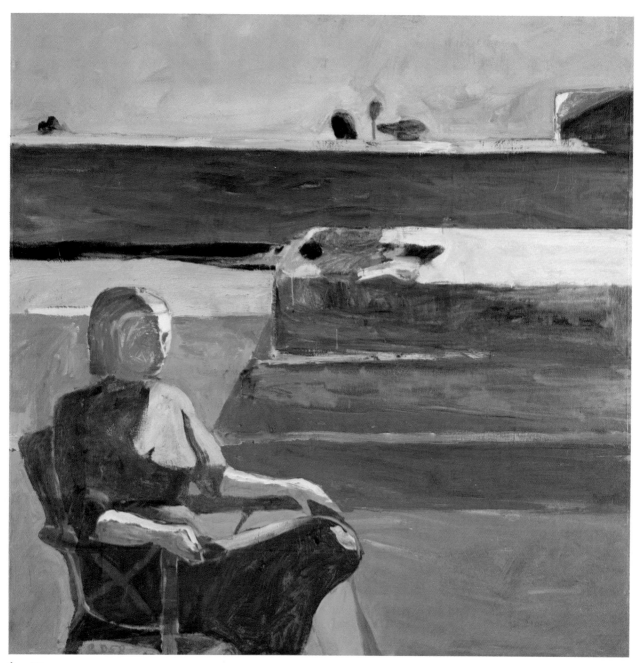

fig. 50

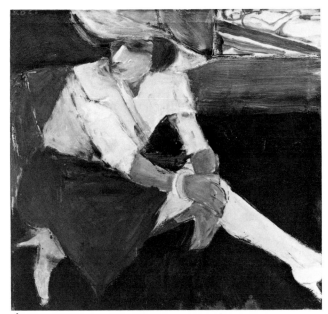

fig. 51

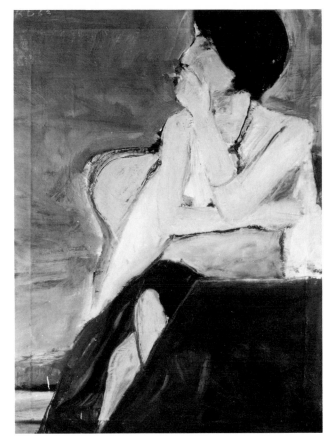

fig. 52

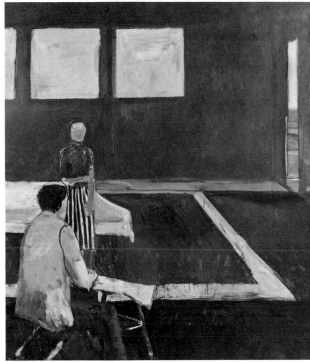

fig. 53

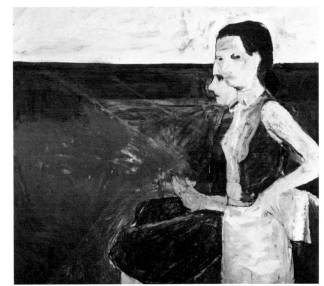

fig. 54

procedures. Contradictions are typically inserted. Space is evoked only to be denied by internal evidence and the energy of the surface plane. The limited space asserts its own tensions with the flatness of the canvas and the matter-of-factness of the paint and its application. Diebenkorn has tended to move toward the reductive, the simplification of form, the structuralizing of elements, the stripping away of inessentials in the modernist tradition. The faces of his subjects tend to be minimized, serving as an impression rather than as a likeness. At the same time psychology is expressed in the wholeness of the work rather than in the singularity of its composite figures. The effort is to express a universal rather than a specific, to avoid particularization, illustration or sentimentality, despite the feelings invoked by the subjects and their continuing power to affect the paintings. There is a monumentality to the figures and an ambiguous uncertainty about their relationship to the environment despite their "locked-in" structural relationship to it – *Woman by a Window*, 1957, *Woman in a Window*, 1957, *Woman with Hat and Gloves*, 1963. In Diebenkorn's representational works one senses that these figures are at rest, in a repose of their own, a part of the environment at which they gaze. They do not belong to that environment and will surely depart from it to appear in another space, against another landscape, averting a frontal gaze, immersed in privacy, reflecting an existential balance. Human interest is not magnified.

During the summer of 1956 Diebenkorn took some time out from painting for about two months to build a studio in

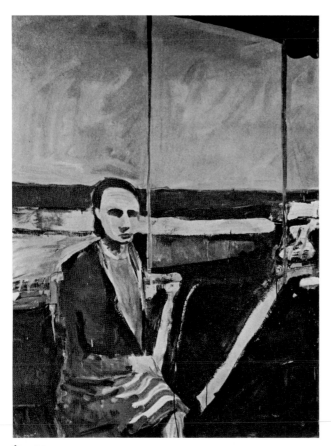

fig. 55

the rear of his property in Berkeley. He had only recently made his change to representational imagery and he wondered whether it was permanent. *Art News* magazine (New York) commissioned Herschel Chipp, Professor of Art History, University of California, Berkeley, to write an article focused on the evolution of a canvas by Diebenkorn. Chipp describes Diebenkorn's work practices, and then records the development of *Woman by the Ocean*, 1956 (fig. 55), in an article published in May 1957. The artist began by sketching a seated male figure. The following day, after intensive study, he repainted the canvas, moving the figure forward and into a standing position, and he developed the background. Still later the painter returned to a simplified, layered and spacious landscape which changed his feeling for the figure and it was repainted as a woman. Finally he was prompted to paint the figure out and replace it on the left side of the canvas, where she was seated. Some structural aspects of the previous state were retained; some of the earliest aspects returned to be included at the last.

At the time the Chipp article was published the trial and error methodology reflected in the artist's efforts seemed to some observers to reflect uncertainty, hesitancy or indecision, rather than the artist's commitment to improvisation and his total conviction that each work must be approached differently, without formula, but with relentless self-demanding willingness to pursue the fresh line at any cost. "I would like the colors, their shapes and positions to be arrived at in response to and dictated by the condition of the total space at the time they are considered," the painter has written in a studio note. Elsewhere he has gone further, saying: "A premeditated scheme or system is out of the question. Search for a mutation in a sequence that is sensible, inevitable, perhaps predictable. One is enough. The mutation too is sensible and inevitable but it is so in violation of the system of forces that called it up."[7]

In *Interior with View of the Ocean*, 1957 (fig. 56), we come to an imaginative masterpiece. Light pours in through great windows in a dark Matissean wall, plays dramatically across the floor, leaps to the table in the foreground and puddles about. The angled window at the upper left provides a classical release through a view of a road rising to a distant horizon and water. The paint application is typically built up of transparent layers of color reflecting its facture and ghosts of early revisions, culminating in a delectable sumptuousness minus any sense of academic *belle peinture*.

Two memorable interiors with landscape views date from the year 1959. The *Interior with Book*, 1959 (fig. 57), is a meticulously constructed painting with a powerful illusion of three-dimensional space in the corner of a windowed porch. An arm chair is set facing inward toward a table where a book, tumbler and a plate hold their respective places and occupy the illusionistic space without need for a human subject. *Horizon – Ocean View*, 1959 (fig. 58), is a companion painting and perhaps even more unusual for its bonding of the three-dimensional illusion to the surface effect and the integration of a two-dimensional structure as relentless as that of Piet Mondrian. The window plane corresponds to the picture surface, with incidents established along every margin and at every corner. The artist has tied the picture plane to deep space through the device of the telephone poles and their looping wires, at the same time that the expressionist handling of the modulated field and the layered effect of land, sea, sky and sunshade remind us of the spontaneous effects of Berkeley period abstractions.

Some collectors and critics were disappointed when Diebenkorn moved away from his Berkeley abstractions to his representational work in 1955-56. They seemed to feel that his change heralded a judgment that the creative possibilities of abstraction had been exhausted. Diebenkorn was not making that statement. He felt that the possibilities for his painting were renewed for him in representation, and he would continue to use the knowledge and insight gained from non-figurative experience in his new work. On the other hand there were other critics and collectors who thirsted for an end to abstract expressionism, and they embraced his new art with superficial understanding and an uncritical acceptance which proved embarrassing to the artist. Along the way the artist found himself bedeviled by personal doubts, troubled by friends and collectors who misunderstood his oftentimes painful trial-and-error search. As before, he wasn't looking for a specific result: he spurned formula. He could turn to abstract painting for a time, find himself unconvinced and return to his subjects. "When I get it all together in a picture and it is alive and successful it would be just as much so in the abstract as in the figurative."

It is almost inconceivable in examining the high achievement of *Interior with a Book, Horizon – Ocean View* and the figure painting *Coffee*, that the artist was undergoing an inner questioning. However, he has said, "Later, it became much harder work. It is always difficult to say what you mean whether in words or in paint. I hope for an element of surprise – a break in the system, or the system I'm using at the time, may do that for me and that will be enough. I am mistrustful of extra-painting allusions and would ordinarily end up painting them out. I suppose that I was worried because I feared that what I was doing had already been done." One may understand that an artist could have qualms of uncertainty when moving against the contemporary "mainstream" as reported in the art press. He might suffer doubts about pursuing what could be mutually conflicting purposes in making "modern paintings" and painting recognizable images, in an era of formalist dogma. Happily, the artist resolved his doubts in new work and two important exhibitions were held in 1960 – at the Palace of the Legion of Honor, San Francisco, and at the Pasadena Art Museum.

The artist continued his explorations in still life, figure, interiors and landscape. *Interior with Flowers No. 10, 1961* (fig. 59), reflects that effort with the viewer looking across a table with a vase of flowers to a bed with a red coverlet and the corner of a black chair. The work is precisely structured in fragment islands of massed color with pictorial incidents reinforcing the visual logic and surprise of the painting. *Interior with View of Buildings,* 1962 (fig. 60), builds upon the familiar interior with window view format. A low wall beneath the view window has a number of canvases leaning against it at lower left and a chair is seen partially at lower right. The corner of a table impinges on foreground space at lower left and a hand-mirror rests flat upon the table surface, reflecting light and sky from outside. Through the window one can discern what appears to be the upper floors of apartment buildings with repeated window openings and the occasional crown of a tree. *Ingleside,* 1963 (fig. 61), is a skillful projection of that residential subdivision in deep space, following a suburban street across three intersections and up a hill, with rows of houses on either side, reflecting strong mid-day light. There are surprising incidents of color and telling touches of impasto white in the buildings which are set off by acres of steel-gray macadam. *Ingleside* is a confident effort of great skill which leads to the *Cityscape* (fig. 62) of the same year. The latter is an aerial perspective of a

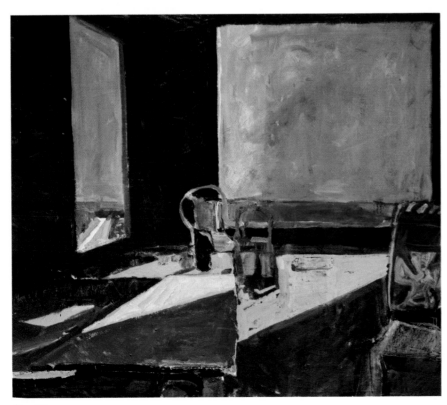

fig. 56

hill street, observed on the left and imaginatively invented on the right by the removal of a line of buildings and the improvisation of a field and a wash. The powerful effect of using the shadows of the massed buildings on the left side of the street to darken the grassy field while throwing alternating triangles of bright yellow-green into sunny relief, is seductive. This painting is related to the *Cityscape I, 1963,* owned by the San Francisco Museum of Modern Art. 1963 was an outstanding year and the artist recalls his M.H. de Young Museum exhibition as a particular satisfaction. It made his strongest figurative statement to date.

Corner of Studio – Sink, 1963 (fig. 63), represents a number of works beginning in the early '60s which utilized a mirror in a corner for telling reflections and surprising effects. In this case the viewer recognizes an industrial sink with double faucet and single spigot assembly. Above the sink may be seen a wooden shelf with a still life of jars and bottles, soaps and cigarette packages. The sobriety of the color scheme of black, brown, dark gray, with pale gray chest and sink, accented with oranges and reds, is reminiscent of Chardin. The canvas has a grand monumentality in keeping with its ambition.

The year 1964 was hectic and unusual and no paintings were signed and dated with that number. Diebenkorn served for a period as artist-in-residence at Stanford and did a great deal of drawing. His father died that year. He was invited to visit the USSR as a guest of the Soviet Artists Congress and with the good offices of the U.S. State Department. He held a retrospective exhibition at the Washington Gallery of Modern Art. He began the series of etchings and drypoints which was eventually published in 1965 by the Crown Point Press, Berkeley.

The impact of the Soviet trip, particularly the remarkable Shchukin Collection of paintings by Henri Matisse in Leningrad and Moscow, had been profound. Only three post-

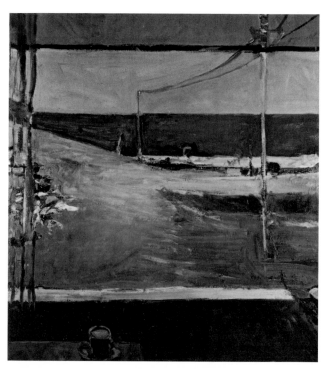

fig. 58

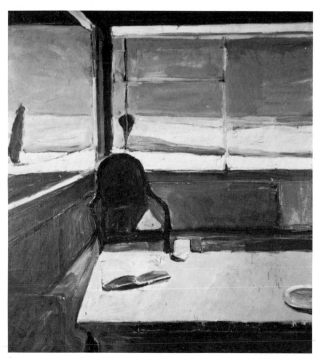

fig. 57

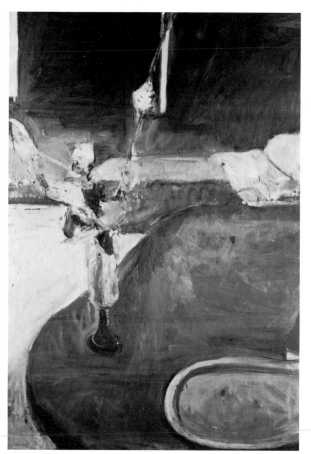

fig. 59

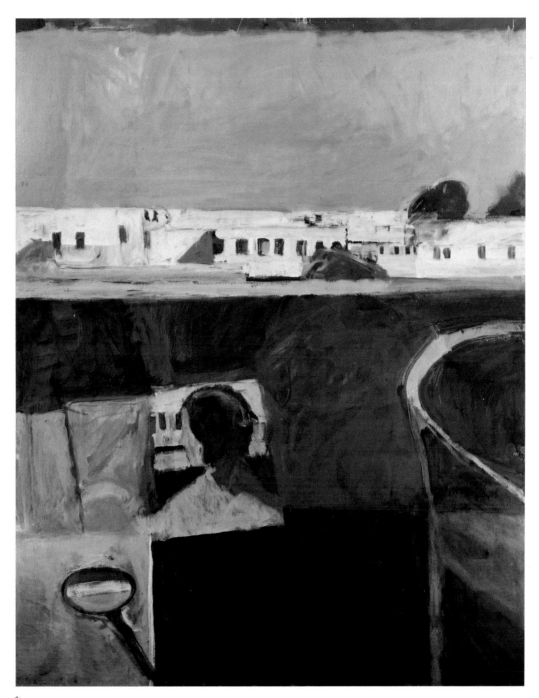

fig. 60

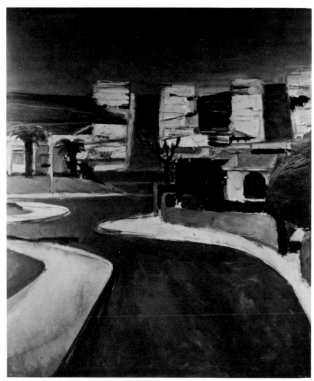

fig. 61

fig. 62

fig. 63

Leningrad representational paintings are included in our selection and two of them reflect the deep impression made by those paintings which were then so little known in the West. *Recollections of a Visit to Leningrad*, 1965 (fig. 64), is divided vertically into two spaces – a room on the left with an elaborate wall covering in a garland pattern with many colored flowers, and a vista through a window in the right wall which runs at right angles to the garland covered rear plane. The active wall covering pattern is made more complex and yet subdued by two panels of shadow which soften its colors and vivacity. These shadowed panels flank the intense light on the central part of the wall in analogy with horizontal elements of sea, sky and sunshade found in earlier works. The view through the window to the right is severely simplified and schematized into trapezoids of green (lawn) and yellow (field), with two bands of blue for water and sky. A patch of dark green at the merging point of grass-green and sea-blue indicates a cluster of trees. It is an astonishing painting and one which is loaded with references to the experience of Henri Matisse's paintings in Leningrad's Hermitage Museum.

At the time of his visit to Leningrad, Diebenkorn saw Matisse's *The Painter's Family*, 1911, with its tilted floor plane, and its proliferation of vying patterns in carpets, couches and pillows, wall coverings, tile mantel designs, game tables and clothing patterns. This and other Russian-owned works were known to the artist from his reading of Alfred Barr's *Matisse – His Art and His Public*[8] and from lesser monographs. He had also seen *Conversation*, 1909 (fig. 65), wherein two figures, the male standing to the left and the female seated to the right, maintain eye contact with Egyptian solemnity in a room of unmodulated deep blue. There is only a window to relieve this amazing saturation of color and it is placed midway between the two figures. Outside, a spring garden in a brilliant green excites an even greater intensity from the surprisingly unrelieved blue of the inner space. Finally, Diebenkorn saw *Harmony in Red*, 1908-9 (fig. 66), which is a depiction of a bourgeois dining room following a meal. A maid bends over the dining table gathering scattered fruits and organizing compotes and half-full decanters of wine. The entire room – dining table cover and surrounding wall space – is painted a single intense violet red over which is imposed an extremely bold traditional French design known as *Toile de Jouy* in which a garland pattern surrounds a basket of flowers. The heavy pattern, carried out in a rhythmic repetition in dark blues on the powerfully concentrated red ground, appears to flatten out the picture space in a most radical fashion. When seen in full scale, with the emphasis gained by the green window vista outlined in orange, its power to move is indescribable.

Diebenkorn returned from Russia and Europe, and resumed painting in his Berkeley studio. The new work inevitably reflected overtones of Matisse and remembrance of the Leningrad masterpieces. *Recollections of a Visit to Leningrad* is an homage to the originality and genius of Matisse as those great works of 1908-9 were transformed in the mind of the American painter. Despite the open reference to the garland pattern from *Toile de Jouy* (it was actually taken specifically from an East Indian batik bedspread often used as a studio prop) and the use of saturated color (after *Harmony in Red* which had once been entirely green and later entirely blue) *Recollections* is vintage Diebenkorn both in color and form, a bona fide masterpiece and an offering of respect in the tradition of European painting.

The *Large Still Life*, 1966 (fig. 67), emerges from the same inspiration as *Recollections*, and yet it is solved in a totally different fashion. In this case Diebenkorn actually started with a tilted table plane juxtaposed to a powerfully decorated rear wall. The table occupied more than half of the canvas – similar to the domination of the interior in the *Recollections* canvas. The *Large Still Life* began as a vertical canvas, slightly taller than wide, but after two separate states in Version I, he repainted the canvas completely as a horizontal. The repeated Indian bedspread pattern from the earlier work is abstracted and simplified on a grayed blue wall, toning down the references to both earlier paintings but acknowledging them. The table plane is an inimitable pink-rose-orange which complements the dusty blue wall panel. An array of papers, books, notes, reading glass, coffee cup and ink bottle are littered across the table in casual disorder. One feels in this painting, as in most of Diebenkorn's ambitious works, that no effort has ever been spared in evolving a solution

fig. 64

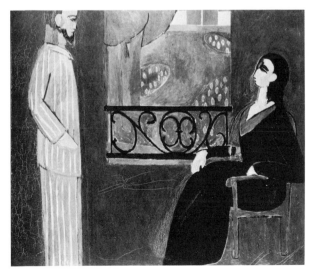

fig. 65

in the most searching and consistent manner. "I can never accomplish what I want, only what I would have wanted had I thought of it beforehand." *Large Still Life*, like many other canvases, was in process for several months. The artist understands the risks associated with building an art with reference to earlier landmarks. He has chosen to acknowledge that he is engaged in a dialogue with the heroic years of the modernist achievement. He is a spontaneous, energetic and emotional painter who is also prone to self-torturing criticism. Hence, paintings are often long in process, subject to countless repaintings and revisions before they meet in his satisfaction with every element, every line and color playing the role he has given it. Nothing accidental or meretricious can survive if the work is to have its harmonious unity.

In October 1966 Diebenkorn moved from Berkeley to assume a professorship in the art department at the Univer-

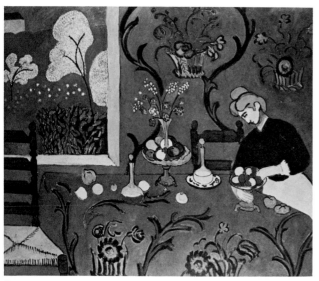

fig. 66

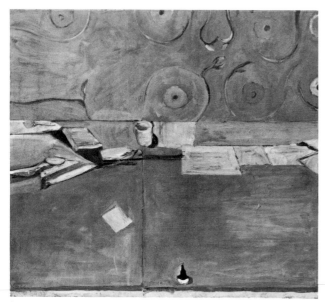

fig. 67

sity of California, Los Angeles. He established a studio in a section of Santa Monica which takes its name from an amusement park called Ocean Park. The painting *Window*, 1967 (fig. 68), is one of the last representational paintings completed prior to the appearance of the new *Ocean Park Series* paintings, which has occupied the artist during the last nine years. The window is located in a room on an upper floor. The viewer looks through the window and an abutting transparent door with a decorative metal bracing to a vista of large buildings. A post or wall element at the right, and a detail at the upper margin of the door establish the limits of the picture space. A folding chair edges its way out of the picture space at lower right. This is another Diebenkorn interior, pre-Leningrad in feeling, with a flat edge-to-edge compositional structure in shallow space within the room and hints of deep space in the vista which are contradicted by a large orange trapezoid (roof or balcony?) outside the window. Diebenkorn has returned to his American vision and to the proven disciplines of the Nelson Gallery and Cincinnati paintings, while making a reference to the wrought iron balconies of the hotels of Nice. *Window* is an austerely simple and grandly composed design, with large open areas of color, a few accents of concentrated visual activity in the chair, the ornamental brace and the arrangement of windows and shadows in the buildings. It is a taut and athletic composition, flat as a drum head but suggestive of spatial illusion. The artist's attitude toward the medium is never more clear – he preserves its character as a liquid transparent, revising freely, painting in corrections, and developing a tough and honest film which satisfies his need for a marriage between illusion and flatness.

Diebenkorn is an artist of keen intelligence and enormous natural gifts which he has subjected to training; learning from his peers and his own seeing, but most importantly from his own unflinching criticism. In the early years of the second war he moved toward abstraction which he confirmed for himself in the San Francisco years and thereafter. At one point of uncertainty, in Berkeley in 1955, he easily could have taken shelter in the success of the abstract expressionist bandwagon and his own considerable achievements parallel with it. He moved, instead, against the current, into representation out of a need to experience the tradition of modern figuration and to explore the permissions and insights of Matisse and Bonnard, the master colorists of the early century. He did so within his own convention of free brushwork and his own growing sense of structure, originality and surprise. As a result he found it possible to grow for a decade in dealing with the ideas and issues of modern painting.

As a traditionalist, Diebenkorn looks closely at the work of his peers and predecessors, examining and learning from them, finding insights and suggestions which can be preserved and utilized. He has found reward in working within the tradition of figurative imagery to evoke feelings complementary to his highly developed sense of abstract structure and his ethic of "forming with color." His compulsion is to make a fresh and significant art on his own terms, regardless of fashion or critical or financial success.

He is truly a student of painting who has carried on a public dialogue with the past and present, sharing his discoveries, enthusiasms and conclusions about the modern masters and the evolution of the medium. His fierce independence has cost him heavily in the destruction of paintings which finally did not meet his exacting requirements. He

takes no pleasure in that critical independence but accepts it as necessary to his expression. He is not falsely modest, but genuinely a seeker after learning in the practice of painting. He has written, "If what a person makes is completely and profoundly right according to his lights then this work contains the whole man. A work which falls short of this content, is only of passing value and lends itself to arbitrariness and fragmentation." Diebenkorn seeks the wholeness and completeness of a unitary visual expression and he cannot be satisfied with partial, fashionable or convenient solutions. "One's sense of rightness involves absolutely the whole person and *hopefully others* in some basic sense." (Author's italics.) Diebenkorn's search is then a public one in which his achievement is exposed to the scrutiny and discussion of those who follow. His dialogue with painting and the nature of the medium, with his peers and predecessors, is set out herein. It is one of the significant achievements in American art in the last twenty-five years. In another twenty-five years, at the turn of the century, we will find that these amazing blendings of intellect and emotion are continuing to show the way for the development of painting.

Gerald Nordland
Director
Frederick S. Wight Art Gallery
University of California
Los Angeles

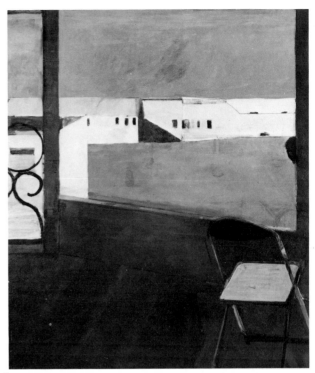

fig. 68

NOTES

1. Paul Mills. *Contemporary Bay Area Figurative Painting*. The Oakland Museum, 1957, p. 12.

2. Unattributed quotes are from interviews with the artist in May and June 1976.

3. Los Angeles County Museum of Art. *New Paintings by Richard Diebenkorn*. Comment and interview by Gail R. Scott. Los Angeles, 1969, p. 6.

4. From miscellaneous studio notes compiled by the artist and made available to the writer.

5. Hilton Kramer. "Pure and Impure Diebenkorn." *Arts*, Vol. 38 (December 1963), pp. 46-53.

6. From miscellaneous studio notes compiled by the artist and made available to the writer.

7. *Ibid.*

8. The Museum of Modern Art, 1951.

9. From miscellaneous studio notes compiled by the artist and made available to the writer.

The Ocean Park Paintings

Richard Diebenkorn's paintings are deeply affected by his immediate environment. "Temperamentally," Diebenkorn once said, "I have always been a landscape painter." It was not surprising that within two years after he took up residency in Los Angeles, initially to teach at the University of California there, Diebenkorn's painting had taken a distinctive and new stylistic turn.

Other places he has lived that contributed certain qualities to his work include New Mexico and the San Francisco region. In the former, a number of dynamically composed abstract expressionist works were painted while Diebenkorn was completing graduate work toward a degree at the University of New Mexico, Albuquerque in 1951 and 1952. Stark, sun-drenched suburban views of the San Francisco Bay Area in which, according to one critic, Diebenkorn "worked with the American townscape as Rodin worked with the human body,"[1] date from 1955 to 1965. This is not to imply the simplistic and misleading formula that the environment shapes the artist and hence, each move in this artist's life automatically caused stylistic change. With accomplishment so personal and essentially autobiographical as Diebenkorn's, the viewer is required to seek indications from the work itself revealing concerns *important to the artist.* Coloration in the early *Albuquerque, Urbana,* and *Berkeley* abstractions was noticeably affected by the terrain, atmosphere and light of those regions. They can be seen without exaggeration to represent abstracted landscapes, much as with de Kooning's work of the mid- and later fifties. The artist's own designation of the works in series after the places they were painted reinforces that these works resulted from sensitivity to and synthesis of observation of the painter's immediate environment.

More recently in Los Angeles, Diebenkorn has created a series of large, reductive, non-objective abstractions combining a new interpretation of structural, formalistic concern with expressionistic and lyrical tendencies continually apparent in his work. The *Ocean Park* paintings, which the artist has worked on steadily since 1967, represent the most significant accomplishments of his career to this point and are among the major contributions of the past decade to contemporary American painting.

These luminous and open works called the *Ocean Park* series by the painter after the section of Santa Monica where his studio is located, are nonetheless carefully controlled by superimposed linear structure, fusing both closed form and spontaneity into what the artist himself described in earlier years as "tension beneath calm."[2] The works are the product of concern continually in evidence in Diebenkorn's work with added attention to surface, chromatic range, spatial definition, luminosity, and resolution of open and closed form.

Non-objectivity, normally of no concern within the context of a leading contemporary American painter's achievement, is conspicuous here by its absence as the paintings follow on the heels of a decade of figurative works by Diebenkorn which are also without parallel in post World War II American painting. Diebenkorn's remarkable career continues to surprise and amaze. Just at a point when his name was frequently invoked in conservative defense of figuration (that is, before the advent of "superrealism" and "photorealism") as proof enough that the best of twentieth century art was not unremittingly committed to an abstraction of non-objectivity, Diebenkorn departed on a bold, new non-objective course leaving such inconstant supporters in the lurch. His ability to resolve his talents during the past three decades in directions at once so diverse and yet related makes him a unique and altogether unparalleled figure in contemporary art.

The first *Ocean Park* paintings were created in 1967 and the painter has continued to work only in this mode. The origins of the *Ocean Park* paintings, like the earlier *Albuquerque* and *Berkeley* works, lie in the vast and open landscape of the American West. In 1970, a few years after moving to Los Angeles, itself carved out of arid land largely dependent on massive water control and irrigation from nearby mountain sources, Diebenkorn was invited by the U.S. Bureau of Water Reclamation to participate in a new program asking artists to photograph areas where systems of irrigation had been created in eastern-central California. While working from the air, he experienced the far reaches of desert land banded by irrigation channels and road networks. Diebenkorn had been recuperating from a back operation in 1968 and was not painting, although he had already reached *Ocean Park No. 12* by the time of the operation. Numerous related drawings ensued, serving as the basis for compositions on a broadened scale. As previously noted, Diebenkorn was long committed to inspiration which observation of landscape, above all, could provide him, and this experience caused him to continue experimental compositions though remaining, at that time, loyal to figuration.

It would be mistaken, however, to regard these flattened, richly worked linear compositions as only personal recapitulation of landscape by the painter, for the experience transcends this. The works incorporate the integrity of a lifetime of observation and analysis, and constitute a remarkable synthesis and new realization of visual cross-reference and influences upon him as diverse as Matisse, Cubism, and the New York School.

Richard Diebenkorn expressed a feeling of new possibilities he could achieve because of his shift again into non-objectivity as "total artistic freedom without any recognizable imagery."[3] For a man who had grown suspicious in earlier

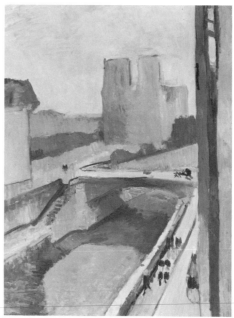

fig. 69

years of his own dependence on "gearing up" emotionally to get into each work, the previous transition in 1955 from abstraction to figuration had provided an immediate means of plunging into form and structure as compositional pre-requisites. In the late sixties, any topical reference is discarded once again with the *Ocean Park* paintings which, instead, result from the artist's full resolution of creative impulses, a blend of spontaneity and painterly qualities with a deepened sense of emerging structure and space. The analogy remains one of natural truths transformed into personal ones.

Diebenkorn's first encounter with Henri Matisse's work came during the Second World War while he was serving in the Marine Corps in Washington. Among the many splendid examples of Matisse's paintings housed in The Phillips Collection, *The Studio, Quai St. Michel,* 1916 (fig. 3), was foremost among his remembrances. For purposes of analysis here, an earlier work by Matisse, *A Glimpse of Notre Dame in the Late Afternoon,* 1902 (fig. 69), will serve to demonstrate. Diebenkorn was also familiar with a later painting dated 1914 of the same subject, now in The Museum of Modern Art, which he saw in a 1964 retrospective exhibition of Matisse at the University of California at Los Angeles. That painting, it should be noted, holds remarkable affinity to Diebenkorn's recent development, especially its abstract structuring and worked surfaces (See page 49, fig. 69a).

Let us analyze momentarily Matisse's achievement in the earlier, less solemn work. Matisse's daringly summarized composition reduces all elements of architecture and landscape to a number of abutting and interlocking color planes. For a viewer of the period, the most unexpected and, undoubtedly, an aggravating element in Matisse's painting, is the disappearance altogether of the elaborate and delicate Gothic tracery which comprises the balanced articulation of the facade of Notre Dame, reduced by the painter to box-like forms of soft grey and lavender tones. In John Russell's words, "Notre Dame melts like an ice cream in paintings made by Matisse from his window on the Quai St. Michel."[4] The resulting simplicity emphasizes and strengthens the geometric delineations of summarized architectural mass while concentrating even more strongly on what the painter uniquely may accomplish. Matisse's brush richly describes the surfaces of architecture, landscape, and space defined in terms of reduced mass with painterly freedom and dexterity, creating a composition which, as with Gaugin and Cézanne, is no longer naturally descriptive in purpose. The surface plane of the work itself becomes emphasized. A distinct homogeneity of surface overtakes the work and a luminous atmosphere glows from within the most solid masses such as the corner portion of the block-like Sûrete Nationale at the left edge of the painting, or the cathedral itself. Curiously, as if to drive the point home, Matisse paints the River Seine as if poured of blue cement and, by doing so, de-emphasizes the facile beauty of reflecting aqueous surfaces so prominent in Impressionism. As did Cezanne, Matisse prefers to emphasize holistic, formal concern. The viewpoint chosen by Matisse appears to cause the viewer to hover a few feet outside his window. This provides him the device to reinforce the edge of the canvas and therefore its planar quality, with three adjoining painted strips representing the edge of the building, the shutter hinged in open position, and the shadow between. This architectural detail is later reduced in the 1914 version to a single black line running the length of the work.

The river provides the dominant diagonal thrust into the center of the painting while the mass of the cathedral, ephemeral though it is, tends to anchor the composition by means of the dominance of its block-like form. Fleeting figures on the sidewalk below and a carriage crossing the Pont St. Michel are reduced by Matisse to mere daubs of paint reminiscent of similar handling in the Parisian boulevard scenes of Claude Monet. The formal development in this early, brilliant work by Matisse is enhanced by sensuous color already Fauve in effect, a quality in his work deeply affecting Diebenkorn as well. Coloration and the geometric, reductive qualities in Matisse's painting are, then, immediately perceptible as influential upon Diebenkorn, although by no means exclusively in the *Ocean Park* paintings. The figurative work consistently shows a calculated, analytical approach to architectural setting not unlike that described in Matisse above. Diebenkorn incorporates similar impersonal and detached placement of humans as well. One writer observes that Diebenkorn's figures are "understood as a vertical coordinate which intersects the horizontal bands of landscape color."[5] What distinguishes the *Ocean Park* paintings as distinct from the figurative work and akin to the early Matisse is evident in his departure from previous handling of tone, luminosity, spatial definition, and surface treatment. Both the Matisse painting and recent Diebenkorn works find their underlying and unifying major characteristics along similar lines, creating an intense and spiritual reality transcending natural cause and effect.

Diebenkorn openly pays homage to early Matisse, especially of the Moroccan period, in two works just preceding the first *Ocean Park* paintings: *Recollections of a Visit to Leningrad,* 1965 (fig. 64), and *Window,* 1967 (fig. 68). Each relies on dividing the field into straight geometric portions determined by the placement of architectural elements and the ensuing play of strong light and shadow across the architecture. Flattened, frontally-oriented composition and human absence mark the works as important transitions to the *Ocean Park* paintings. Moreover, one of them, *Recollections of a Visit to Leningrad,* draws its title, unusual for Diebenkorn, from a direct reference to the artist's trip to Russia in 1964 on the State Department Cultural Exchange Program during which he relates being deeply moved by seeing the Matisse paintings on view in Moscow and Leningrad. Among these, Diebenkorn especially cites the so-called Moroccan triptych, paintings completed by Matisse in Tangier in 1912 and 1913 and bought by Ivan Morosov, the Moscow collector. Though Morosov subsequently hung them as a triptych, this was not exactly Matisse's intent. The hanging, originally one determined by the artist for his Bernheim-Jeune Gallery show in 1913 and continued today in the Pushkin Museum, Moscow, is nonetheless a highly satisfying one. The last of the three works to be completed was *Zorah on the Terrace,* 1913 (fig. 70), which is also the most reductive and abstract, indicating a departure for Matisse into simplified architectonic and flat compositions of subdued hues and increased luminosity compared to the other works completed the previous year. A striking element is the 45° angle of light cutting across the upper left area of the work, bordered across the top by a sky-blue band. Another work of the triptych, *Entrance to the Casbah,* 1912 (fig. 71), with its Moorish archway and brilliant, almost jarring color contrasts could well have served Diebenkorn's memory as an inspiration for *Ocean Park No. 32* (fig. 72). It would be an error, though, to consider any specific work of Matisse's as a direct determination of any in Richard

fig. 70

fig. 71

Diebenkorn's oeuvre. We are instead discussing stylistic and compositional relationships which illuminate traditions and processes of artistic choice and creativity. Classic modern sources underscore the significance of Diebenkorn's achievement in the *Ocean Park* paintings.

No less stimulating for comparative purposes from the same period are *The French Window*, 1914 (fig. 73), and *The Piano Lesson*, 1916. Both are continued explorations of reduced geometric interplay, linear structure and generally subdued coloration. *The French Window*, described by the poet and friend of Matisse, Louis Aragon, in hyperbolic terms as "the most mysterious picture ever painted,"[6] is the closest point Matisse reached toward total abstraction in his early work. Were it not for the title, the viewer could be totally disoriented by the cavernous, black void occupying the central portion of the canvas and, indeed, its subject matter. It is all the more ominous, as Aragon observes, because of the year and summer in which it was painted. *Ocean Park No. 59* (fig. 74), too, is composed of black presences loosely bordered and shows similar weighty choices of green, brown and blue. The upright rectangular format so successfully employed by Matisse in the period 1911-15, it has been noted, is that of the *Ocean Park* paintings as well.

Another instructive analogy to the *Ocean Park* paintings in addition to works by Matisse can be remarked with Piet Mondrian, who was deeply affected by Cubism. The genesis of the neo-plastic work of Mondrian whose early paintings, as with Diebenkorn, yield few hints of their later development, serves as a consummate example in modern art of the logic of abstraction. Twenty years before becoming the single greatest progenitor of the aesthetic movement *De Stijl* (the Style), Mondrian's landscapes explored the Dutch countryside with an increasing tendency to a personal and mystically interpretive vision. His first landscapes resemble those of the so-called Amsterdam School, mild Dutch followers of Impressionism, who were the most appreciated painters in Holland at that time. Mondrian's landscapes, though, became more and more charged with a passion for the abstract, and were increasingly influenced by *art nouveau*. The paintings depicting the windmill at Domburg demonstrate this as do those paintings of the apple tree, subjects yielding the artist multiple, mutating images. Mondrian, it should be emphasized, was continually bringing forth in his early work what he felt to be underlying truths about the universal nature of things and the world he saw. His perception led him to seek and re-interpret structural and formal concerns he found at the root of all creativity. His years in Paris and his experience with Cubism deeply affected his growing tendency to non-objectivity which by 1920 had resulted in his famous grid paintings, a concept eventually labelled "neo-plasticism" which he continued to explore the rest of his life. *Composition London*, 1940-42 (fig. 75), a late work, indicates the equilibrium and harmony of elements evident in the grid paintings. In this case, nonetheless, Mondrian's grid emphasizes the edge of the work at the left and separates the field into four horizontal planes leaving sizeable unbroken fields of white. It is not difficult to imagine Mondrian saying the same thing as did Diebenkorn years later that "a realistic or non-objective approach makes no difference. The result is what counts."[7]

Both painters are sensuous and innovative colorists as well, but here the analogy must end. For Diebenkorn, a systematic, intellectualized and rigid philosophical approach to creativity is as foreign as it was natural to Mondrian. The

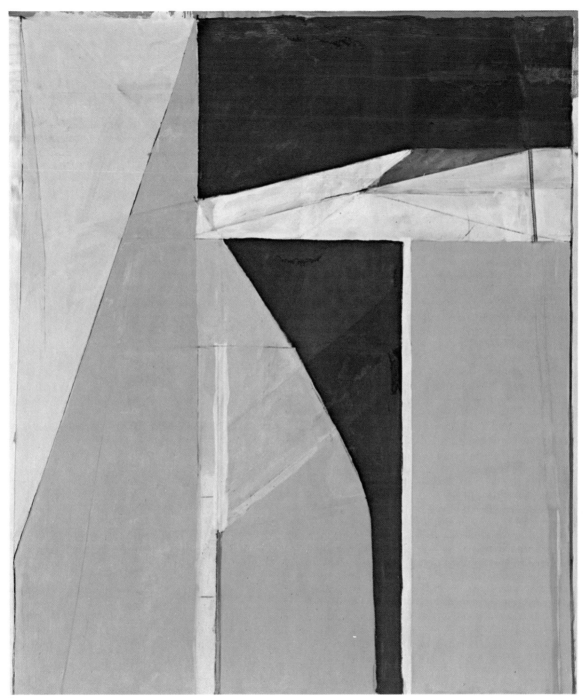

fig. 72

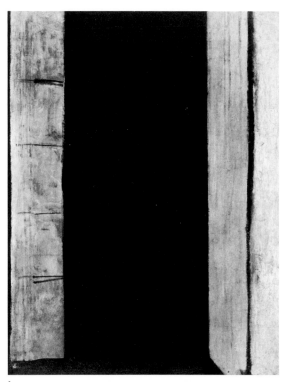

fig. 73

leading creator of *De Stijl*, Mondrian represents the antithesis of approach to formalism – metaphysical as opposed to empirical – from Diebenkorn's and other American artists such as Frank Stella, Ludwig Sander, and Ellsworth Kelly. Modern American abstractionists have generally sought creative impetus *intuitively* rather than by alignment to any dogma, school or system of thought. Certainly characteristic of post-World War II art in America is the image of the independent, lonely and heroic stance taken by an artist as he follows his virtually preordained destiny to the end. This over-dramatized and romanticized notion, fed continuously to the American art public, nonetheless retains some elements of truth. The careers of Pollock and Still need only be mentioned as witness. These artists approach each work as if there were no past traditions to imprison or restrict, a facet of American creativity long ago remarked upon by Gertrude Stein. Conversely, the burden of total freedom is a tremendous one and each work represents an autobiographical chapter in a way not conceived or felt by artists before. This was the atmosphere of the forties, basically existentialist as Harold Rosenberg has noted, which was inherited by Diebenkorn and others of his generation as they set out on their careers. His work retains this unusual awareness, sensitivity and blend of European expressionist and formalist tradition yet preserves the impulses of the unbounded and unfettered creativity of the American abstract expressionist painters.

American painters working before World War II who interested Diebenkorn are not numerous. Hopper remains Diebenkorn's prime early influence but he was also interested in the works of Sheeler, Demuth, Ralston Crawford and Karl Knaths. He has remarked how a colleague mentioned he should look up the work of Niles Spencer years ago. Indeed he did, and liked Spencer's work very much. Although Lionel Feininger's painting was not a special interest, it is instructive nevertheless to note to what extent Feininger's style had become influenced by major contemporary European movements, notably German expressionism and Cubism. In the last decade of his life, his work describes an original approach to landscape painting wherein horizontal lines and formal elements fuse and split into a dynamic, yet delicate linear network reinforced by subtle tonal modulations. The ensuing drama, though less mystically inclined, recalls the work of Turner a century before. Although a direct corollary to the *Ocean Park* paintings does not exist since the differences are still enormous, Feininger's work is a stylistic antecedent to Diebenkorn's recent work in part and like his, is the product of years of refinement and stylistic modification which comes gradually closer toward an intuitively derived abstract geometric field, the point of origin of which remains the natural world.

The *Ocean Park* paintings depend crucially on the artist's ability to create an alliance – strike a balance – between structural concern and tonal, spatial illusion. Space is "negotiated" in John Russell's apt term by definition and re-definition of the relationship of line and tonal field. And yet, unlike the black grid of Mondrian, the colors of Diebenkorn's lines and bars are notably ambiguous as well. The vestiges of figure-ground relationships remain in force though now the emphasis occurs in preserving the integrity of surface while wedding surface notation to spatial illusion within. The colors chosen for the linear elements tend to diminish or strengthen their structural role as Diebenkorn wishes while providing him with an important key with which he integrates pictorial elements with the total formal and spatial unity of the work.

John Elderfield has remarked on the importance of the vertical format of the *Ocean Park* paintings reinforced at the edges by the design thus revealing "the whole spread of the surface."[8] Flatness, not a limiting factor in the most successful paintings of the series, locates the works at a relatively fixed in distance from us. Spatial illusion depends entirely upon Diebenkorn's masterful handling of luminosity emanating from deep within. Just as Matisse had obliterated traditional perspective more than at any other point in his work with the startlingly abstract *The French Window*, Diebenkorn's recent work has by-passed restrictions and limitations inherent to figure-ground relationships in favor of a "cumulative materiality,"[9] by which he contrasts form through varied densities. The experience of facture is purposely and prominently retained in the works which openly present the route taken by the artist whether the method was finally acceptable to him or not. Hence, frequent *pentimenti*, overdrawn and over-painted areas, are left visible across the work and are integrated into the entire experience of its creation eventually reinforcing the linear structure as well. This temporality which points to the time it took to paint the work aligns Diebenkorn with the action-orientated abstract expressionists (e.g. Pollock and deKooning), while the banding, resulting from the linear structure and prevalent luminosity, moves him closer to the static, tonal hierarchies of color field (e.g. Rothko, Newman). A continual dichotomy ensues between the intellect and control on one hand, and spontaneity and invention on the other.

The duration of facture involved, witnessed in the open,

fig. 74

fig. 75

honest character of the works, denies that art is a finished product readied and presented as such to the consuming art world. Just as might be expected, Diebenkorn, pensive and anxious by nature, releases his work from his studio with utmost care and sometimes, it seems, even a bit reluctantly. Sequences of numbers within the *Ocean Park* series disappear, integrated into later works, nascent from the no longer surviving ancestors scraped off or painted over in order to begin afresh. *Trial and error* is the coined term in the English tongue for the process, but a very weak one at that. A preference on the part of the artist to restructure or change tonal impact and alignment of fields can hardly be adequately understood in terms of *error*. Nonetheless, the success of the *Ocean Park* works depends totally on the painter's careful intuitive handling of the self-imposed limitations of his method.

The types of spaces created in these works range alternately from quite constricted to relatively open and unconstrained examples. The final results are of atmosphere and mood. We are witnessing a method of working which tends to defy description as it depends so vitally on the sort of creative and intuitive balancing act which results in just the correct emphasis to all parts of the composition depending on the painter's concern at the moment. The complexities are apparent in work which, although highly structural, yields no secrets of tectonic procedure and although highly coloristic in effect, consist of layer upon layer of diaphanous oil paints which, incidentally, yield Diebenkorn far more resonance and luminosity than any acrylics could. Unlike Cubist works, the *Ocean Park* paintings are not primarily about the formalism which helps create them but are more concerned with a harmony and integration of various elements of surface, space, luminosity and illusion of depth.

Each day when Diebenkorn drives from his home to his studio down the coast, he follows the Pacific Coast Highway in West Los Angeles along the wide stretch of Santa Monica beachfront below the earthen cliffs. The mellow sparkle and soft golden richness of tone bestowed upon this landscape by the California sun are unique. Sam Francis, Diebenkorn's friend and neighbor, describes the effect of light in Los Angeles as "clean and even bright in haze"[10] and he continues to prefer it to all other light he has worked in.

The *Ocean Parks* are a staggering triumph on Diebenkorn's part, summarizing to date a career of concern to turn his experience, sensitivity to observation, and awareness of his immediate environment into a language of non-objective abstraction. The wash quality applied liberally in fields of blues and greens across the surface of many of the works and the wide field of golden color of others contribute to the impression that these paintings are celebrations of the California coast line, ocean and hills virtually at the artist's doorstep.

The banding and marking-off of fields is also generally conceived to emphasize vertical format although no fixed linear system defines or predicts color. The large expanses of the loosely worked green and blue fields in *Ocean Park No. 54, 60* (fig. 76), *64, 66* (fig. 77), and *88*, built up over the luminous foundations of worked, white grounds are unmistakably conceived in the presence of the sea. The artist's new, recently completed studio near the location of the former one is nearer the ocean and from a back, open porch one can catch a glimpse of the languid, calm Pacific, unlike the fierce Atlantic of Winslow Homer. *Ocean Park No. 68* (fig. 78), presents an unusual note in the series because of its horizontality and brilliant emerald tonalities. Diebenkorn has generally avoided the wide format, the expected horizontality of still life and landscape, in favor of the vertical one more receptive of tectonic concern and tighter space. Many early *Ocean Parks* such as *No. 7* (fig. 79), *10* (fig. 80), and *27* refer to the land and earth in hues of amber and golden brown and are distinctly reminiscent of the *Albuquerque* and *Urbana* series' colorations years before. *Ocean Park No. 27*, with its pronounced and solid structure, recalls the urban landscapes of the early sixties while *Ocean Park No. 10*'s juxtaposition of both lively and inanimate greys conjurs up scenes of brilliant sun breaking over the urban industrial zones of Los Angeles.

In reflecting on Diebenkorn's achievements more lucid than ever in the past decade, one easily imagines him the painter-philosopher concerned with penetrating the very structure of natural order as he perceives it with his work much as Thoreau did in his writing a century before; the one describing a deeply personal, even private universal communing through the medium of paints and the other with words.

> We had a remarkable sunset one day last November. I was walking in a meadow, the source of a small brook, when the sun at last, just before setting ... reached a clear stratum in the horizon and the softest brightest sunlight fell on the dry grass and on the stems of the trees in the opposite horizon and on the leaves of the scrub-oaks on the hillside, while our shadows stretched long over the meadow eastward, as if we were the only motes in its beams. It was such a light as we could not have imagined a moment before, and the air also was so warm and serene that nothing was wanting to make a paradise of that meadow. When we reflected that this was not a solitary phenomenon, never to happen again, but that it would happen forever and ever an infinite number of evenings, and cheer and reassure the latest child that walked there, it was more glorious still.[11]

Just like Richard Diebenkorn's *Ocean Parks*.

Robert T. Buck, Jr.
Director
Albright-Knox Art Gallery

(fig. 69a)

NOTES

1. John Russell, *Richard Diebenkorn*, Marlborough Fine Arts, Ltd., London, 1973, p. 7.

2. Paul Mills, *Contemporary Bay Area Figurative Painting*, Oakland Art Museum, 1957, p. 12.

3. Gail Scott, *New Paintings by Richard Diebenkorn*, Los Angeles County Museum of Art, 1969.

4. John Russell, op. cit., p. 6.

5. Jeffrey Hoffeld, *Three Generations of American Painting: Motherwell, Diebenkorn, Edlich*, Gruenebaum Gallery, New York, 1976, p. 25.

6. Louis Aragon, *Je n'ai jamais appris a ecrire on les incipit*, Skira, 1969, quoted in his *Matisse; a novel*, Harcourt Brace Jovanovich, New York, 1972, p. 303.

7. Fogg Art Museum, *Modern Painting, Drawing and Sculpture Collected by Louise and Joseph Pulitzer, Jr.*, Cambridge, 1957, p. 31.

8. John Elderfield, "Diebenkorn at Ocean Park," *Art International* vol. 16, (February 20, 1972), p. 24.

9. Ibid., p. 22.

10. Robert T. Buck, Jr., *Sam Francis*, Albright-Knox Art Gallery, Buffalo, 1972, p. 137.

11. Henry D. Thoreau, *Thoreau on Man and Nature*, Peter Pauper Press, Mount Vernon, 1960.

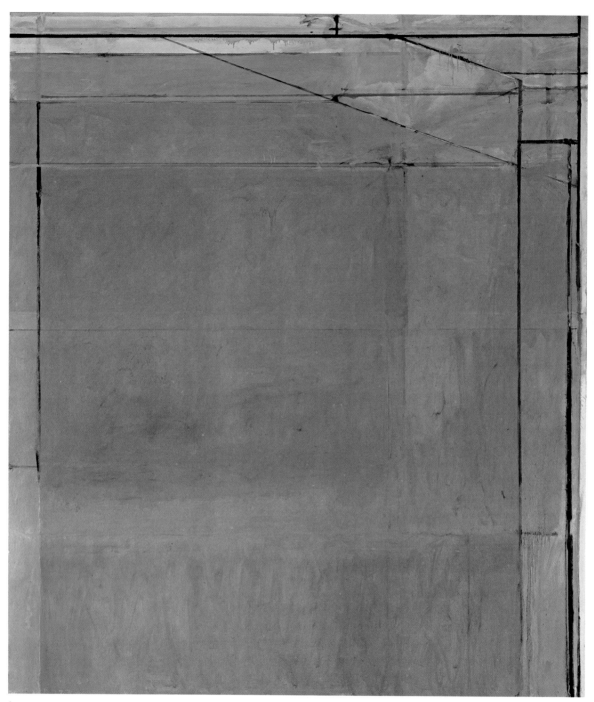

fig. 76

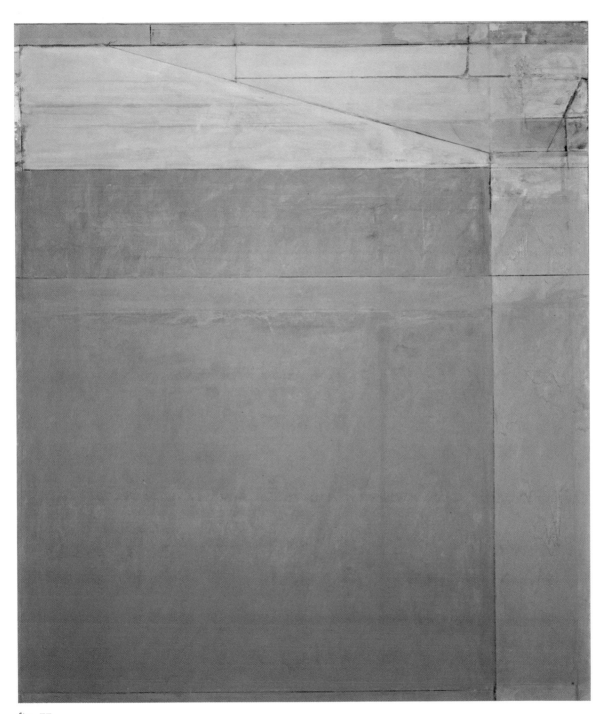

fig. 77

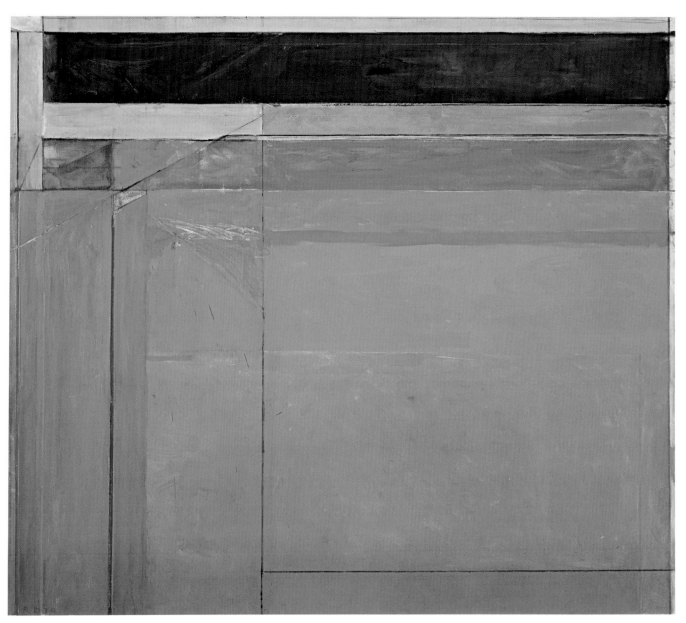

fig. 78

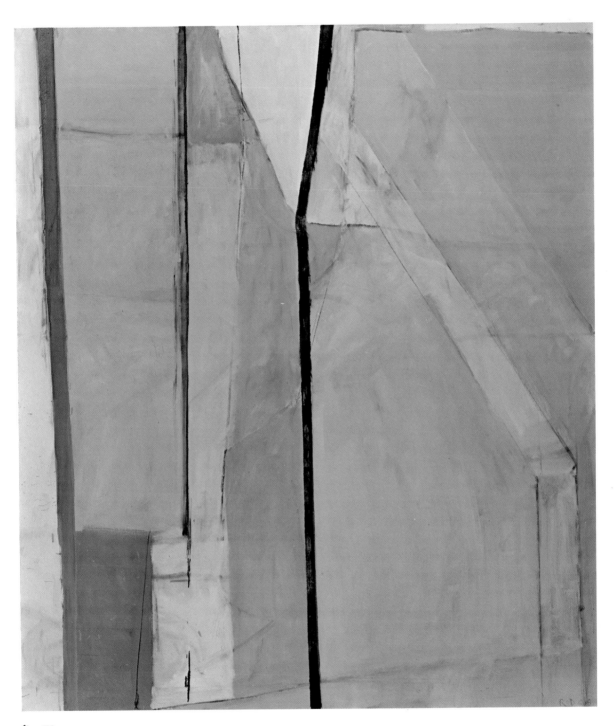

fig. 79

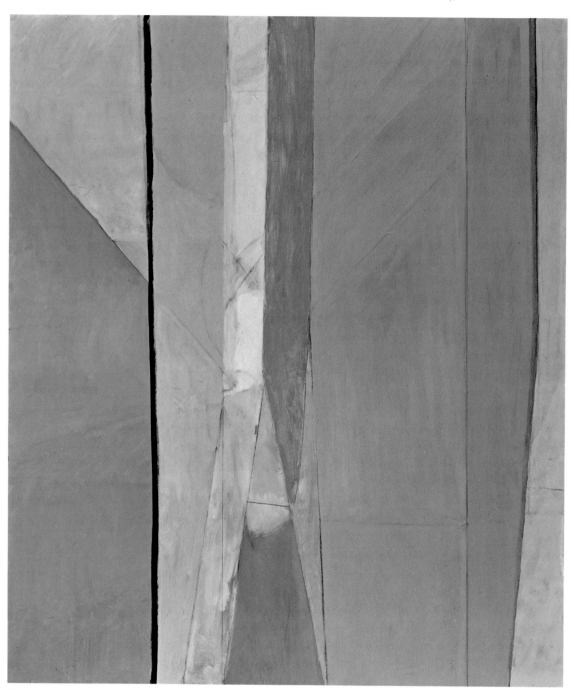

fig. 80

Diebenkorn: Reaction and Response

As I began to formulate a chronology to accompany the Richard Diebenkorn exhibition catalogue I realized how much information one uncovers in the process of organizing an exhibition of this scope. This fact, and the completeness with which Maurice Tuchman and Gerald Nordland have covered the details of Diebenkorn's early life, education and training in their respective essays, made me realize that perhaps another format for presenting the information I had gathered was possible.

This essay has come to be a loosely chronological documentation of Diebenkorn's career. Since in this catalogue we have listed one-artist and group exhibitions, I mean here to allow the reader immediate access to information about the 33-year period between 1943 and 1976 which I hope will illuminate the cultural ambience and critical atmosphere of those years. I have quoted liberally from reviews of and exhibition catalogues for Diebenkorn's numerous shows in order that the reader may, perhaps, better understand the environments in which his work existed at various times and in various places and to answer questions raised by seeing the work brought together (isolated from the work of other artists) for the first time in the new context of a retrospective.

Diebenkorn, who had been making art for several years, finished his undergraduate studies at Stanford University in 1943. After serving in the Marines between 1943 and 1945, which included a semester at the University of California, Berkeley, and during which Diebenkorn continued to study and work on his paintings, he enrolled at the California School of Fine Art in San Francisco. The school was directed by the energetic and innovative Douglas MacAgy. The faculty there included Elmer Bischoff, David Park and Hassel Smith as well as visiting instructors Clyfford Still, Mark Rothko and Ad Reinhardt. Still, who exhibited at the San Francisco Museum of Art in 1943 and at the Palace of the Legion of Honor in 1947, had an immense influence on the area's artists. Rothko came to CSFA in the summer of 1948 "bringing slides of the paintings of Pollock, Robert Motherwell, Adolph Gottlieb, Willem de Kooning and others."[1]

At that time the Bay Area artists knew little about New York painting and even less about European artists. The struggles of painters like de Kooning, Baziotes, Gorky, Hofmann and Pollock with Cubism and the problems of abstraction were largely unknown to them.

Diebenkorn was a student of David Park who was then painting in an abstract style.

San Francisco art was less encumbered than New York art with historic reference – or to put it another way, it had less art-culture to build on. . . . San Francisco artists were less involved in "painting problems." Their work was wilder, less refined, less organized, less intellectual, less concerned with Surrealist metaphor. It was more sensual, more organic, more directed toward nature, which after all was in much closer proximity. More than in New York, painters in San Francisco made landscape abstractions. They were probably willing to take greater chances early on, since there was no art world to worry about. Here too Still served as a model. However, to paint abstractly was really not a matter of choice for young San Francisco artists: it was what everyone was doing. In 1949 the entire San Francisco Annual was totally abstract, which could hardly be said of that year's Whitney Annual.[2]

Diebenkorn's paintings of this time were first exhibited (with the exception of his inclusion in a student/faculty show at the California School of Fine Art in 1946) in a one-artist show at the invitation of curator Jermayne MacAgy,

at the Palace of the Legion of Honor in 1948.

Judged by current standards, the Legion's show was composed of small paintings. The paintings [among them Composition, *1948 and* Untitled No. 22, *1948] had a structural base which rested in cubism and a division of the picture surface which took the form of abstract geometry. Space tended toward flatness but there were passages handled three-dimensionally which created a tension between forward and backward in the picture space. One might say that the first generation of American abstract painters – Dove and O'Keeffe – and a romantic sense of space and color were brought to the artist's impressive debut.[3]*

Hopper and Sheeler and other American painters, like Dove and O'Keeffe, were often mentioned as influences upon Diebenkorn's work. He did know first hand of Matisse, Cézanne, Picasso, Braque and Bonnard from The Phillips Collection in Washington, D.C., where he was stationed during his stay in the Marines.

Diebenkorn had spent part of 1946-47 in Woodstock, New York (on an Albert Bender Grant-in-Aid) where he met Baziotes and Tomlin and others of whose work he would ultimately become actively aware. But, by 1949 his work was firmly linked specifically with that of other Bay Area artists and in general with that of others living and working in California. He exhibited in the San Francisco Painting and Sculpture Annuals, the Lucien Labaudt Gallery (in 1949, a two-artist exhibition with Hassel Smith) and in the Los Angeles County Museum's *California Centennial Exhibition* (his contribution was *Untitled No. 22*, 1948).

Diebenkorn left San Francisco and his teaching to attend the University of New Mexico at Albuquerque in January of 1950. His master's project show in June of 1951 must have been very impressive indeed.

The most important element is the discovered individuality which was suggested in the Palace show of 1948 and had come to fulfillment in 1950-51. . . . There is little of conventional fine handling or seductive surfaces in these works. They have a toughness as of the New Mexico desert. They are "right" but at the same time foreign and obviously subject only to their own rules.[4]

The Los Angeles dealer Paul Kantor came to New Mexico to see the Albuquerque series of which he purchased several. These paintings, later seen in Los Angeles by William Valentiner and James Byrnes from the Los Angeles County Museum, prompted Byrnes to include Diebenkorn in the *Contemporary Painting in the U.S.* exhibition of 1951. That year he received recognition from the east coast, as well. Motherwell included Diebenkorn (with Smith and Corbett) in his book *Modern Artists in America.* New York's Museum of Modern Art curator Dorothy Miller visited his New Mexico studio.[5]

Having received an invitation to teach (drawing to architecture students) at the University of Illinois at Urbana, Diebenkorn left New Mexico in 1952 to spend two semesters in Illinois. While surely feeling somewhat isolated in the three years between 1950 and 1953, Diebenkorn continued to grow as a painter. His first one-artist show at the Paul Kantor Gallery in Los Angeles in 1952 was well received

. . . devoid of seductive qualities, without cues other than what pigment or line imply Diebenkorn requires that the spectator propel himself into his activated surfaces. In No. 3 [1947], atmosphere is segmented by a wiry line that curls in on itself and thrusts across the canvas like a nerve imbedded in muscle tissue. In another oil, titled B, [an Albuquerque painting, now titled The Green Huntsman, *1952] in blacks and whites, Diebenkorn conveys an impressive monumentality, not unlike the grandeur of stark desert mesas on a cold grey morning.[6]*

The summer of 1953 was spent in New York City where Diebenkorn met Franz Kline (who introduced him to the dealer Eleanor Poindexter) and other artists. Diebenkorn remembers already being aware of de Kooning whom he freely acknowledges as an influence on his growing vision. After returning to Berkeley in October, Diebenkorn resumed teaching (this time at the California College of Arts and Crafts) and his close contacts with Bischoff and Park as well as Frank Lobdell. Around 1950-51 Park had begun to work figuratively as Bischoff did in 1952. Diebenkorn was to paint a group of *Berkeley* pictures between 1953 and 1955 after which he, too, began to work including the figure. In 1954, however, he did join his friends in weekly sessions of drawing from the model. Having received a fellowship, Diebenkorn worked steadily in those two years, exhibiting the *Berkeley* paintings at the San Francisco Museum (1954), the Allan Frumkin Gallery in Chicago and one (selected by James Johnson Sweeney) in the Guggenheim's *Younger American Painters*. A second solo show at the Paul Kantor Gallery again received considerable enthusiasm and critical mention.

By this time in New York de Kooning was exhibiting his "Women" paintings and Pollock and Hofmann had had their first one-artist shows in 1943 and 1944 respectively. In curious sequence Diebenkorn's work was first shown in two international exhibitions of 1955 and not until the following year in New York. To the *III Saõ Paulo Bienal* (an exhibition organized by the San Francisco Museum), Diebenkorn sent two *Berkeley* paintings *(No. 24, 1954* and *No. 32, 1955)*. Chosen along with Diebenkorn for this exhibition were Californians Roy de Forrest, Lobdell, Park and David Sacaro. His contribution to *Young Painters* organized by the Congress for Cultural Freedom in Rome was mentioned as "unbeautiful but moving . . . difficult but authentic."[7]

After having been included in a group show in 1955 of Poindexter's gallery artists (Milton Resnick, Leland Bell, Nell Blaine, etc.), Diebenkorn had his first solo exhibition there in 1956. The paintings he exhibited were from the *Berkeley* series (although several months earlier he had begun to experiment with small still life compositions). The first New York showing was well liked.

That same year he was in the opening exhibition of the Ferus Gallery in Los Angeles. The Ferus Gallery was originated by Edward Kienholtz with Irving Blum and Walter Hopps, and was to turn out to be an influential showcase for the best art made in California. The opening show of John Altoon, Billy Al Bengston, Roy de Forrest, Kienholtz, Craig Kauffman, Frank Lobdell, Clyfford Still and Diebenkorn (with *Albuquerque No. 3)* entitled *Objects in the New Landscape Demanding of the Eye*

> was a kind of survey of western abstract expressionism that had been going on, particularly in the San Francisco Bay Area, during the late 40's and early 50's. To emphasize the importance of this movement (and win the attention of potential collectors who had yet to become involved in this new art) Clyfford Still (with an untitled 1948 picture) and Richard Diebenkorn were included as "special guests."[8]

His first figurative canvases appeared publicly later that year in an exhibition at The Oakland Art Museum.

The shift to figuration by several of the San Francisco area artists was greeted with delight by many critics and curators. Many, however, failed to grasp what others thought were the real goals of Diebenkorn as a painter in their haste to claim a new figurative school or movement. Diebenkorn, who up until this time had been content to be called an Ab-

stract Expressionist, when asked about his new work only briefly mentioned the images:

> I came to mistrust my desire to explode the picture and super-charge it in some way. At one time the common device of using the super-emotional to get "in gear" with a painting used to serve me for access to a painting, too, but I mistrust that now. I think what is more important is a feeling of strength in reserve – tension beneath calm. I don't want to be less violent or discordant or less shocking than before, but I think I can make my paintings more powerful this way.[9]

Ellen Johnson, in a thoughtful piece written in 1958, mentioned "Diebenkorn has been welcomed like the Prodigal Son because of his beautiful new figure compositions, he is nevertheless much the same kind of painter he was two years ago. . . . "[10] Comparing *Berkeley No. 42, 1955* and *Woman by a Large Window, 1957,* she concluded the "sensation of being 'in the painting' is transmitted directly to the observer through the size and style of the painting in Diebenkorn's as well as in Pollock's and many other contemporary artists' work."[11] She related Diebenkorn's methods of organizing the picture planes in both of his works to each other, and to the methods of other artists of the time. "It is captivating this way of organizing the picture plane into large, relatively open areas interrupted by a greater concentration of activity, a spilling of shapes and colors asymmetrically placed in one side of the picture. . . ."[12] "In these new figure compositions he has not abjured his earlier abstract style, just as he had not completely turned his back on nature in his abstractions."[13]

Contemporary Bay Area Figurative Painting, organized by curator Paul Mills and circulated by The Oakland Art Museum in 1957-58, presented eight of Diebenkorn's recent paintings, in a survey which included artists like Bischoff, Park, Jim Weeks and Paul Wonner. Mills, in the section of his essay devoted to Diebenkorn, asserted a specific relationship of figure to environment in the paintings – an opinion which is to be disputed by other admirers of the work.[14] He did not, however, name Diebenkorn as the leader of the figurative group. In fact, he pointed out the unevenness of the work in an astute observation of Diebenkorn's working methods.

> An unresolved, paradoxical quality is not infrequent there, in my opinion. I asked him [Diebenkorn] particularly about a large figure painting similar in this aspect to other recent works. It had a kind of deliberate opposition of flat, painterly areas with no specific subject reference and figuratively handled objects existing in a kind of realistic space. . . . Diebenkorn replied this effect was not undeliberate, that he sometimes did use incongruity as a means of keeping paintings unresolved and alive. . . .[15]

Nevertheless, Diebenkorn somehow emerged from this period being referred to as "the reigning chef d'école of Bay Area figurative painting. . . ."[16]

Some writers began to actively disassociate him from this image.

> The place thus accorded Diebenkorn's still-developing oeuvre is more perhaps a cultural than an artistic phenomenon; more, that is, the result of an effort by critics and museums and collectors to resolve the conflicting claims of contemporary styles into a harmonious and political whole than of any very precise insight into particular works of art or commitment to their underlying aesthetic principle. . . . But like all such phenomena, it draws impetus nonetheless from a specific artistic accomplishment.
>
> In the case of Diebenkorn, the scenario of the accomplishment consists of two distinct phases. . . . The first of these was an Abstract Expressionist style that evoked, without explicitly depicting, an imagery drawn from the broad, sunny, open, un-

cluttered landscape of Northern California as it was then – in the later forties and early fifties – being adjusted to pictorial ideas and painterly manners imported from New York. The second phase dates from 1955, when Diebenkorn joined Park and Elmer Bischoff in adopting an explicit representational imagery without modifying his basic manner of painting, which, if no longer abstract in a strict sense, remained Abstract Expressionist in taste, physical deportment and overall aesthetic loyalty. In the pictures of this second phase Diebenkorn was an abstract painter who now painted figures and landscapes.[17]

Herschel B. Chipp published an article, "Diebenkorn Paints a Picture," in *Art News* in 1957. "At the time it was something of an event as a full-scale examination of a west coast artist in a key national art magazine."[18] Chipp explains the presence of Cubist and social realist influences on California painting prior to 1945, the contact with New York painters and Diebenkorn's emergent reputation as an action painter. Tracing the making of *Woman by the Ocean*, 1956, Chipp explains Diebenkorn's manner of working and how he sees it as differing from that of action painting. "While Action Painting partakes of the immediacy of the specific moment of the act and bears the marks of the artist's personal encounter with his materials, the act of painting for Diebenkorn involves mainly a prolonged struggle with the various images that are produced. The appearance of the initial image on his canvas is only the beginning of a lengthy series of appraisals, criticism and modifications."[19]

The Poindexter Gallery exhibition of figurative work and portraits in 1958 generated overwhelming critical response. Diebenkorn was referred to as "one of the best Western painters"[20] with a very individualistic style. He is quoted at length on his new pictures in an *Art in America* article by Dorothy Seckler who notes that other painters of this period seem to be concerned with issues of "surface tension and extreme spontaneity and freedom [which] is in direct conflict with the concentration of emphasis needed by a head or face."[21]

Time magazine reproduced three paintings in color with a general summary of Diebenkorn's career to date. A very brief mention in *Art News* was perhaps the most far-sighted, describing in those paintings the elements which remain there even in today's work – "a feeling of yawning space . . . architectural . . . deceptively colored . . . grittier."[22]

Diebenkorn was honored with an exhibition at the Pasadena Art Museum in 1960. Sixty-six paintings dating from 1952 to 1960 were brought together by director Thomas W. Leavitt. From that show a smaller one of forty-two works traveled to the Palace of the Legion of Honor in the same year. The Pasadena show was received as "a real breath of fresh air" and the figure paintings, of which there were more than sixty in the show were called "a daring blend of compositional freedom and structural integration of weighted form and open space, of sensuous resonance and ideal repose."[23]

Concerning the paintings of this period, James Monte wrote:

Diebenkorn's talent far outstrips all other West Coast Neo-Figurative painters, taken singly or at their collective best. . . . It is well to remember that for the last seven or eight years Diebenkorn has attempted nothing less than the consummate marriage of verifiable subject matter, tightly locked in Renaissance space, with the spontaneity and freedom of gesture learned from the abstract expressionist tradition. To accomplish this aim without impinging and finally decimating either the subject depicted or the wonderfully fluid sense of abstract space Diebenkorn has, is a major accomplish-

ment. . . . Diebenkorn has approached the problem of depicting an area of the urban environment – the planned single-dwelling subdivision – usually rejected as worthless subject matter by other artists. In this case, Diebenkorn approached an area notorious for its 1930's stucco banality. The transformation – one could almost say metamorphosis – is astonishing. Looking at the picture entitled Ingleside, *the district so aptly named is certainly there, while the changes lie somehow elsewhere, a kind of modulation close to, in quality, if not in execution, what happens to a sleazy hotel room depicted by Edward Hopper.*[24]

In 1961, The Phillips Collection in Washington, D.C., presented a survey of eighteen of Diebenkorn's works from 1958, 1959 and 1960. Gifford Phillips wrote the introduction to the illustrated catalogue in which he points out that Diebenkorn "has developed a concern with *composition*, whereas most painters today are principally concerned with *space*."[25]

The occasion of Diebenkorn's one-artist show of figurative works at Poindexter that year prompted Sidney Tillim to mention him in the monthly review section of *Arts Magazine*. He attempted to explain Diebenkorn's works in the context of new realism (discussing *Girl in a Room*, *Bath* and *Girl in a Striped Chair*) and found the work lacking by those standards.

The New Realism pivots on the crucial admission that an object is only as credible as the artist's commitment to the object. In this respect Diebenkorn's new paintings reveal all the uncertainty that he has been able to submerge in design since he turned from Abstract Expressionism, officially, about four years ago. . . . [In Two Nudes*] a figure has never been so present in Diebenkorn's painting before, dominating the space, forcing her action against the picture's action. It is Diebenkorn's most successful attempt to shatter life-throttling design, but the factors working at cross purposes in the management of painting-as-painting form a primer on the problems facing an artist coping with the New Realism.*[26]

The Tillim article and Clement Greenberg's "After Abstract Expressionism" in the October, 1962 *Art International*, are only two which use arguments about Diebenkorn's work to substantiate major critical claims about certain styles. In "After Abstract Expressionism" Greenberg traces the European influences – specifically abstract and Cubist elements – on New York's Abstract Expressionists. He claims a breakthrough was prompted by the artist's dissatisfaction not with figuration, but with illusion.

As the 1950's wore on, a good deal in Abstract Expressionist painting began fairly to cry out for a more coherent illusion of three-dimensional space, and to the extent that it did this cried out for representation, since such coherence can be created only through the tangible representation of three-dimensional objects. It was most logical therefore that when painterly abstraction in New York finally crystallized into a set manner, it did so in a series of outspokenly representational works, namely de Kooning's "Women" pictures of 1952-55. [Diebenkorn's] development so far is what one might say the development of Abstract Expressionism as a whole should have been. Earlier on he was the only abstract painter, as far as I know, to do something substantially independent with de Kooning's touch (and it makes no difference that he did it with the help of Rothko's design). More recently, he has let the logic of that touch carry him back (with Matisse's help) to representational art, and one might say that his consistency of logic is partly responsible for his becoming at least as good a representational as he was an abstract painter.[27]

Between 1960 and 1965 when New York was bursting with Jasper Johns, Robert Rauschenberg and younger art-

ists like Kenneth Noland and Frank Stella, the tone for talking about paintings began to change. It became mostly like that used in Greenberg's article. There is a great deal of discussion about real and pictorial space.

The following was typical of its application to Diebenkorn's work:

[Ingleside No. 2] is one of Diebenkorn's most successful attempts at designing in deep, illusionistic space. The pictorial reconstitution of the scene on the flat surface of the canvas is given priority over the painterly inflection of the surface itself.[28]

Diebenkorn continued to exhibit regularly (Poindexter, 1961 and 1963; Corcoran Gallery of Art, 1962; M.H. de Young Museum, 1963) – mostly figures and landscapes or still lifes. He was quietly noticed. The current fashionable discussions of "form and content" were rarely heard in relation to his work.

There are no pictures dated 1964, but in that year he had two important shows – one of drawings at Stanford University in California, and the other a retrospective at the Washington Gallery of Modern Art. Of the Stanford show, Philip Leider wrote:

It is not Diebenkorn's way to transform his own relationship to his subject matter. Instead of the flat, dull confrontation of stranger with stranger, he will seize upon a relationship between her arm and the wall behind, extend its characteristics to that between her blouse and the table, and find, in the patterns and complexities which his eye articulates a vitality sadly lacking in the real situation. He uses Abstract Expressionist knowledge "not" to reinforce his representational work, nor does he try to reconcile the two. He grows towards the purposeful employment of subject matter towards ends expressive of completely different concerns.[29]

Gerald Nordland wrote on the Washington survey:

In the past five years the artist has become increasingly independent of the self-discoveries of Abstract Expressionism. He finds less need to dramatize his paintings or their subjects. He is more profoundly concerned with the evocation of feelings through an unobtrusive composition, a sometimes obvious subject matter and a growing capacity to invest visual experience with meaning. While the habits of years are not easily lost, there is less of Abstract Expressionist paint handling and more apparent concern for the necessities of the subject than before. As a result, Diebenkorn has transcended the various influences which to some extent survived in the early work and has created a new art which has grown entirely out of his own life experience. The synthesis of his Abstract Expressionist concept of the artist, his interest in a fresh figuration, and his responsiveness to the tradition received from Bonnard and Matisse provide his new foundation.[30]

The catalogues and reviews of these exhibitions in the sixties make it clear the critics and public realize Diebenkorn was his own man. He was often referred to as an independent who retains his own style of individuality. As he obviously did not fit into current schools – color field, hard edge, etc. – and was also somewhat unpredictable (in that there was no way to determine what his subsequent imagery would be) he was treated with respectful reviews which mostly traced the history of his past work and accomplishments.

Diebenkorn has never sought to be a controversial figure, or to argue for any one point of view in his paintings, and the last thing that he wants is to be used as a test-case in someone else's dialectic. But it did come about that he switched from abstract to figurative painting, and then back again, in ways and at times which provoked people to argue this way and that. He could so manifestly do anything he liked, as a figurative painter, that the fact of his not doing "anything" as a figurative painter, after 1966, was bound to be

remarked upon. Remembering the straightforward Impressionist subject matter in the still lives of 1963, and the occasional complete surprise (like the speaking likeness of Bertolt Brecht which is dated 1956), it was difficult for the champions of figuration not to see him as a defector; and difficult, likewise, for the champions of formalism not to see him as someone whose former allegiances had yet to be proved to be extinct.[31]

In 1966 Diebenkorn moved his home and studio to Santa Monica in Southern California. That year he began teaching at U.C.L.A. where the unsurpassed Matisse retrospective exhibition was held earlier in the same year.

By 1967, he was making the series of Ocean Park paintings which he continues today. They are abstract paintings (in the sense that Mondrian's first non-landscape paintings were abstract). The reviews of his first exhibition of the Ocean Parks (at Poindexter in 1968), indicate he is no longer to be thought of as a good West Coast painter, but as one of the finest American artists.

He is noticeably independent of current vogues but at the same time he has never tried to attract attention by rejecting them in a spectacular fashion. Because he has never entered the race, it has often been difficult to tell whether he is a little ahead of the New York scene or hasn't caught up with it. His answer would probably be that he doesn't think of himself in relation to it.[32]

The Ocean Park paintings were exhibited regularly between 1969 and 1976 and were applauded as original and convincing.

Deriving from an investigation of Matisse's pre-World War I paintings, the canvases suggest, as John Canaday has pointed out, a possible path Matisse himself might have followed had he gone abstract then; yet their style and mood are decidedly Diebenkorn's own.[33]

The 1970s have steadily become a period of diversification; a period of wider exposure and acceptance of various kinds of art. Diebenkorn is no longer such an anomaly as perhaps he seemed in the second half of the 1960s when critics searched to find aspects of the work they could discuss in terms of "post-painterly abstraction" and the like. Most settled for ignoring the figures and concentrating on the planar geometry of the backgrounds. Or, on the other hand, they were prompted by some of Diebenkorn's own remarks on his method, such as "All my paintings start out of a mood, out of a relationship with things or people, out of a complete visual impression."[34] They probed what they thought was his need to comment on man and his environment and used phrases such as "the hermetic emptiness of the spaces" and "the lonely isolation of the figures."

Since it is no longer necessary to bring such topics to art writing most of the Ocean Park paintings are now discussed in terms of their structure, color, drawing, and the surface:

. . . with the colors mutually sensitized by contact, his underpainting becomes capable of broadcast effects and encourages a subtle intelligence of its operations.[35]

. . . a most subtle pictorial dialectic between form and color. The structural syntax of his composition, the poetry of his inspiration, serve as checks to each other, not of contradiction, but of mutual enhancement of the rational and irrational.[36]

Colors in the paintings are soft and rich. The under layers burn through, giving a luminous quality to the surfaces. . . . [They] are at once vital and peaceful.[37]

. . . sketching directly on the surface, correcting, refining, scraping

*out, painting again . . . the surface becomes rich with its own record
. . . a delectable, precious and refined skin. . . .*[38]

As he continues to be included in exhibitions in America with work from all periods, the *Ocean Park* exhibitions are greeted with almost unanimous praise. Writing and thinking about Diebenkorn's shows includes comments about his contribution to modern painting.

Diebenkorn has long been recognized as a highly gifted painter. Now he surely must be acknowledged as a major one.[39]

The reasons given are many – his treatment of light and space are most often mentioned. His extension of some of the possibilities offered by Cubism, representation and abstraction, Mondrian, Matisse, Cézanne and de Kooning cannot be doubted. Another acknowledgment often given to Diebenkorn is his ability to work in a personal and private manner *and to remain free* in order to produce these wonderful paintings.

These are compound worlds that Richard Diebenkorn sets before us. . . . They are the record, full and true of one man's negotiations with painting.[40]

Linda L. Cathcart
Assistant Curator
Albright-Knox Art Gallery

NOTES

1. Peter Plagens. *Sunshine Muse.* (New York: Prager, 1974), p. 36.

2. Peter Selz. "Between Friends: Still and the Bay Area." *Art in America* vol. 63 (November-December 1975), p. 72.

3. Gerald Nordland. *Richard Diebenkorn.* Washington Gallery of Modern Art, 1964, p. 8.

4. *Ibid.,* p. 10.

5. *Ibid.,* p. 12.

6. (J)ules (L)angsner. "Art news from: Los Angeles." *Art News* vol. 51 (November 1952), p. 47.

7. Dore Ashton. "Young Painters in Rome." *Arts Digest* vol. 29 (June 1955), p. 6.

8. Betty Turnbull. *The Last Time I Saw Ferus.* Newport Harbor Art Museum, 1976.

9. Paul Mills. *Contemporary Bay Area Figurative Painters.* The Oakland Art Museum, 1957, p. 12.

10. Ellen Johnson. "Diebenkorn's *Woman by a Window.*" *Allen Memorial Art Museum Bulletin* vol. 16 (Fall 1958), p. 19.

11. *Ibid.,* p. 21.

12. *Ibid.,* p. 21.

13. *Ibid.,* p. 23.

14. Paul Mills. *op. cit.,* p. 11.

15. *Ibid.*

16. Hilton Kramer. "Pure and Impure Diebenkorn." *Arts Magazine* vol. 38 (December 1963), p. 47.

17. *Ibid.,* pp. 47-48.

18. Gerald Nordland. *op. cit.,* p. 15.

19. Herschel B. Chipp. "Diebenkorn Paints a Picture." *Art News* vol. 32 (May 1957), p. 45.

20. (A)nita (V)entura. "In the Galleries." *Arts Magazine* vol. 32 (March 1958), p.56.

21. Dorothy Gees Seckler. "Painting." *Art in America* vol 46 (Winter 1958-59), p. 34.

22. (L)awrence (C)ampbell. "Reviews and Previews." *Art News* vol. 57 (March 1958), p. 13.

23. Charles S. Kessler. "Los Angeles: The Seasonal Tide." *Arts Magazine* vol. 35 (November 1960), p. 19.

24. (J)ames (M)onte. "Reviews." *Artforum* vol. 2 (November 1963), p. 4.

25. Gifford Phillips. *Richard Diebenkorn.* The Phillips Collection, 1961.

26. Sidney Tillim. "Month in Review." *Arts Magazine* vol. 35 (April 1961), p. 48.

27. Clement Greenberg. "After Abstract Impressionism." *Arts International* vol. 6 (October 1962), p. 25.

28. Hilton Kramer. *op. cit.,* p. 51.

29. Philip Leider. "Diebenkorn Drawings at Stanford." *Artforum* vol. 2 (May 1964), p. 42.

30. Gerald Nordland. "Richard Diebenkorn: a fifteen year retrospective is organized by the Washington Gallery of Modern Art." *Artforum* vol. 3 (January 1965), p. 25.

31. John Russell. *Richard Diebenkorn, The Ocean Park Series: Recent Work.* Marlborough Fine Art, Ltd., London, 1973, p. 6.

32. John Canaday. "Richard Diebenkorn: Still Out of Step." *The New York Times,* May 26, 1968, p. 37.

33. Grace Glueck. "Open Season: New York Gallery Notes." *Art in America* vol. 57 (September-October 1969), p. 118.

34. Gail R. Scott. *New Paintings of Richard Diebenkorn.* Los Angeles County Museum of Art, 1969.

35. (H)arris (R)osenstein. "Reviews and Previews." *Art News* vol. 46 (December 1971 – January 1972), p. 14.

36. David L. Shirley. "From Diebenkorn, Exhilarating Show." *The New York Times,* December 4, 1971.

37. Cecile N. Cann. "The Ocean Park Series." *Artweek,* October 21, 1972, p. 7.

38. Gerald Nordland. *Richard Diebenkorn, The Ocean Park Series: Recent Work.* Marlborough Gallery, New York, 1971, p. 11.

39. John Elderfield. "Diebenkorn at Ocean Park." *Art International* vol. 16 (February 1972), p. 24.

40. John Russell. *op. cit.,* p. 8.

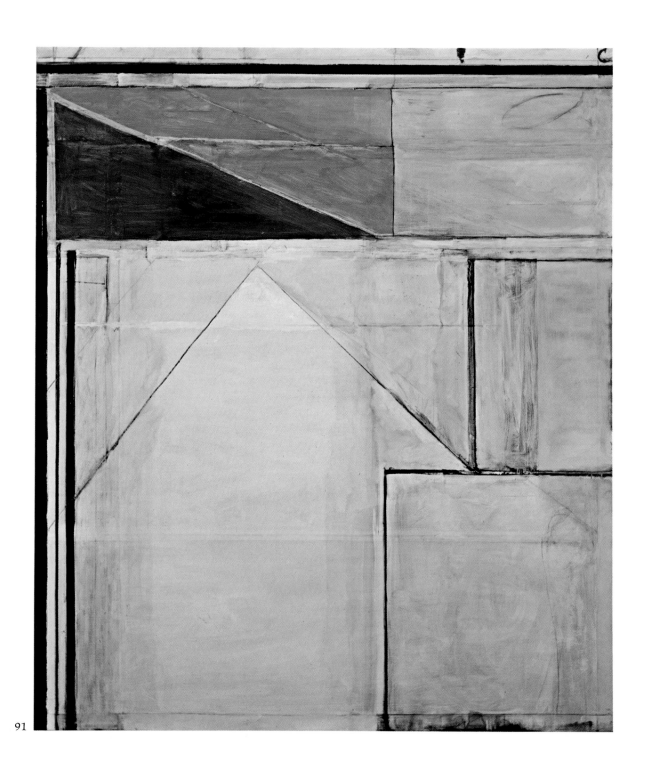

91

91. *Ocean Park No. 94, 1976*
oil on canvas, 93″ x 81″

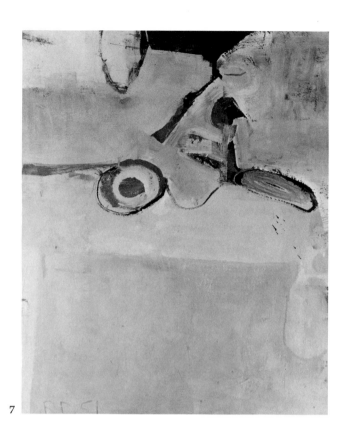

7

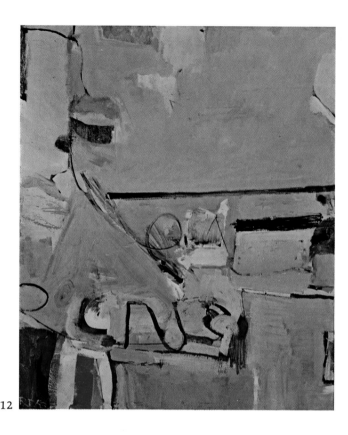

12

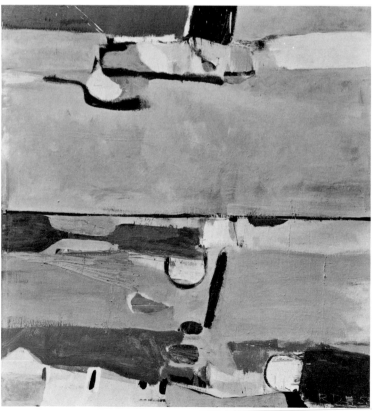

11

7. *Albuquerque*, 1951
 oil on canvas, 48⅛" x 40"

11. *A Day at the Race*, 1953
 oil on canvas, 56" x 52¾"

12. *Berkeley No. 2*, 1953
 oil on canvas, 57½" x 48⅞"

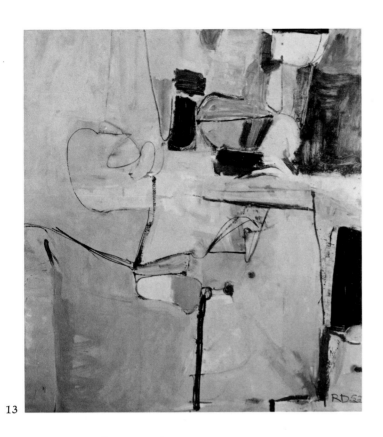

13

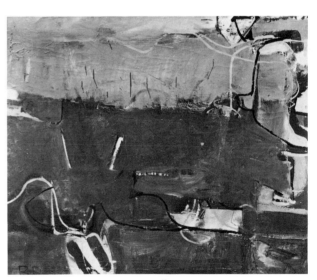

15

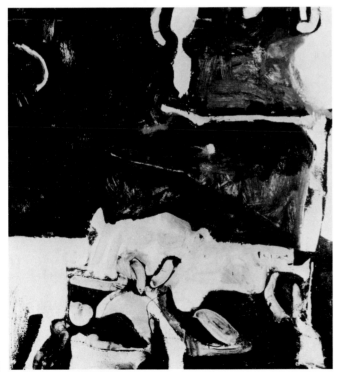

14

13. *Berkeley No. 6*, 1953
 oil on canvas, 54¼″ x 48″

14. *Berkeley No. 7*, 1953
 oil on canvas, 47¾″ x 43″

15. *Urbana No. 3*, 1953
 oil on canvas, 33¼″ x 39″

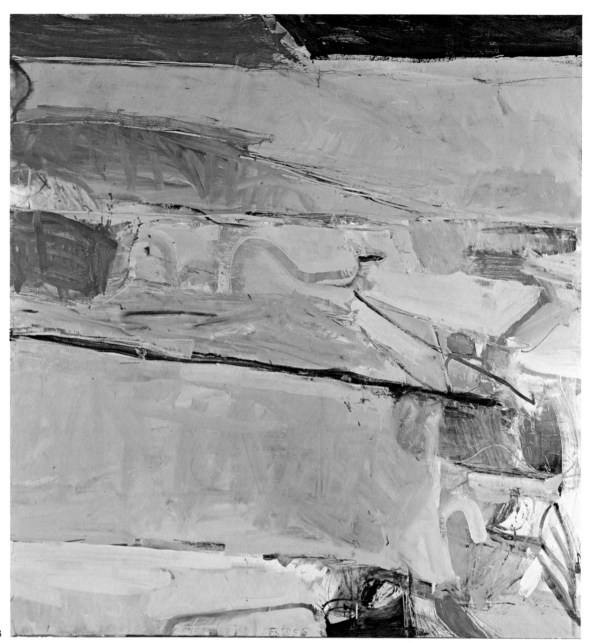

18

18. *Berkeley No. 54*, 1955
 oil on canvas, 61" x 58"

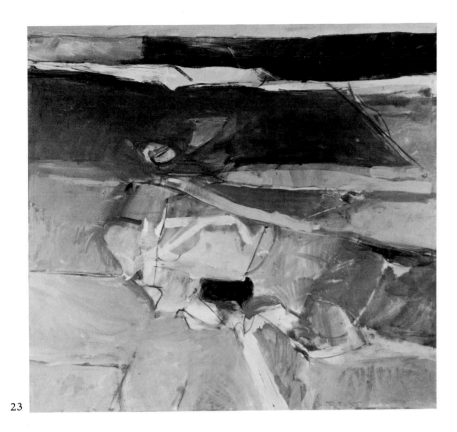

23

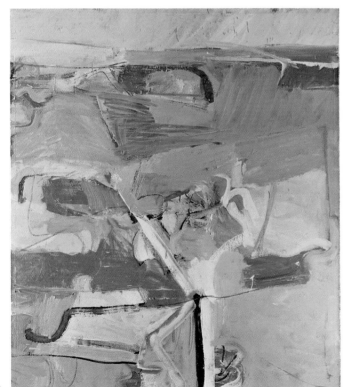

24

23. *Berkeley,* 1955
 oil on canvas, 59¼" x 64¼"

24. *Berkeley No. 23,* 1955
 oil on canvas, 61¾" x 54¾"

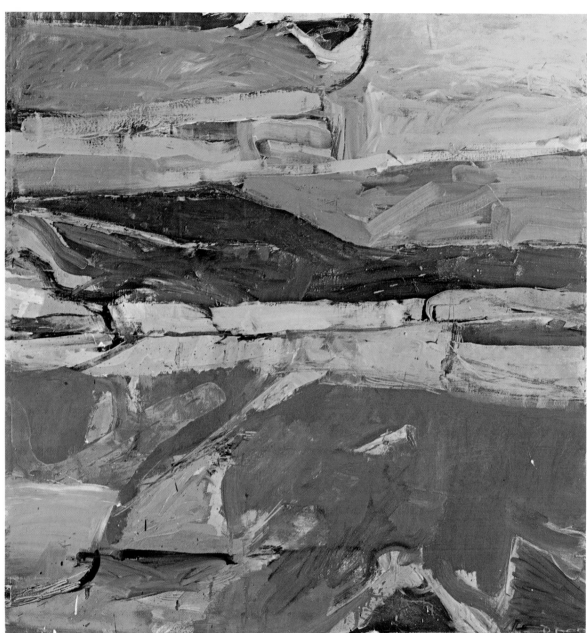

25

25. *Berkeley No. 32,* 1955
 oil on canvas, 59" x 57"

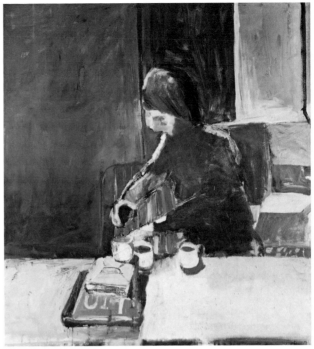

27

28

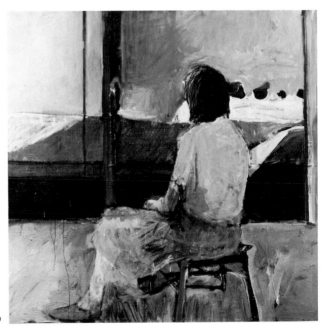

29

27. *Seawall*, 1957
 oil on canvas, 20" x 25½"

28. *Girl and Three Coffee Cups*, 1957
 oil on canvas, 59" x 54"

29. *Girl Looking at Landscape*, 1957
 oil on canvas, 59" x 60⅜"

32. *Woman by a Window*, 1957
 oil on canvas, 64" x 59"
35. *Still Life with Book*, 1958
 oil on canvas, 17" x 19"
37. *Woman Wearing a Flower*, 1958
 oil on canvas, 26" x 22"

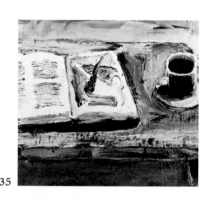

35

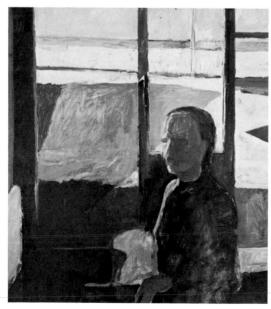

32

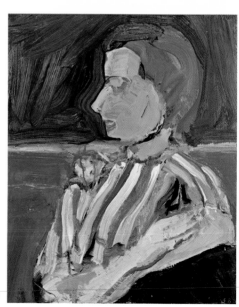

37

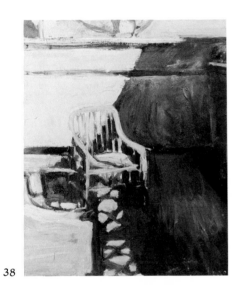

38

38. *Cane Chair Outside,* 1959
 oil on canvas, 32" x 27"

40. *Figure on Porch,* 1959
 oil on canvas, 57" x 62"

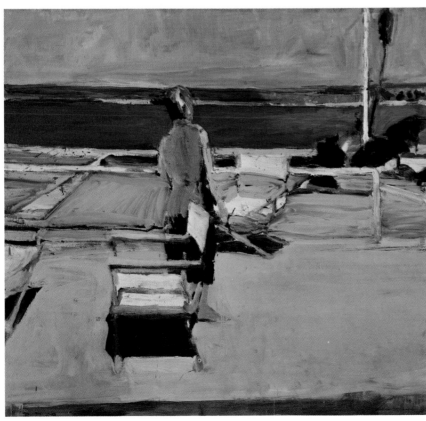

40

42. *Scissors*, 1959
 oil on canvas, 10¾″ x 13″
44. *View from the Porch*, 1959
 oil on canvas, 70″ x 66″
45. *Black Table*, 1960
 oil on canvas, 55½″ x 47″
48. *Girl with Flowered Background*, 1962
 oil on canvas, 40″ x 34″

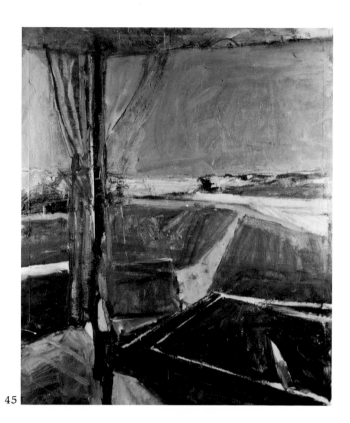

45

42

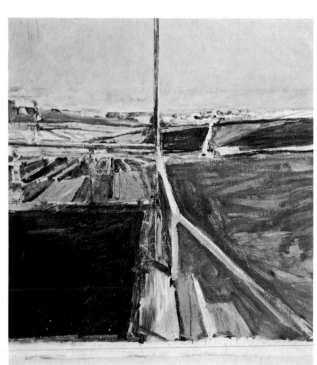

44

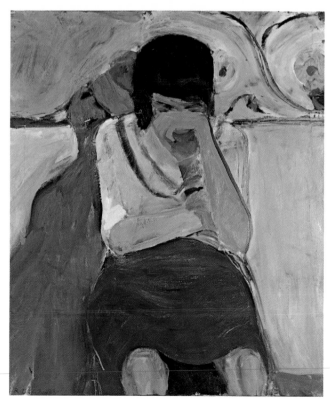

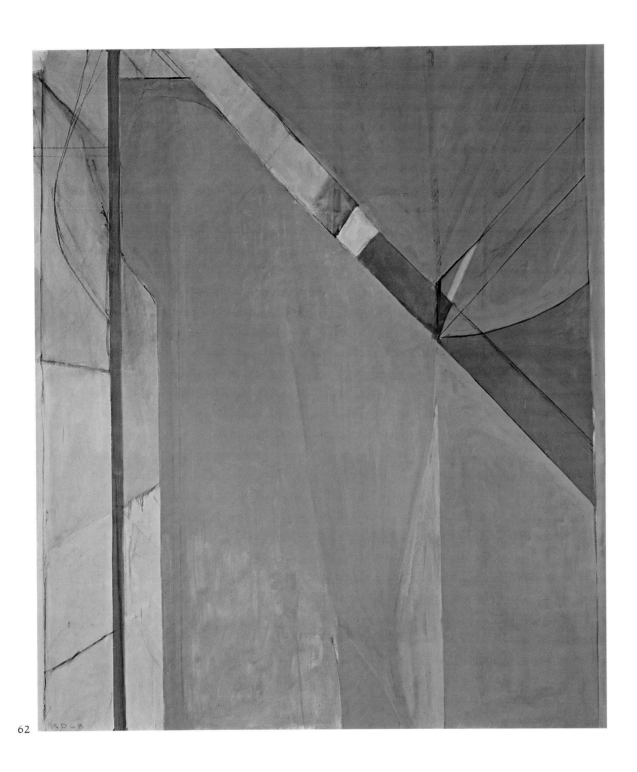

62. *Ocean Park No. 14*, 1968
 oil on canvas, 93″ x 80″

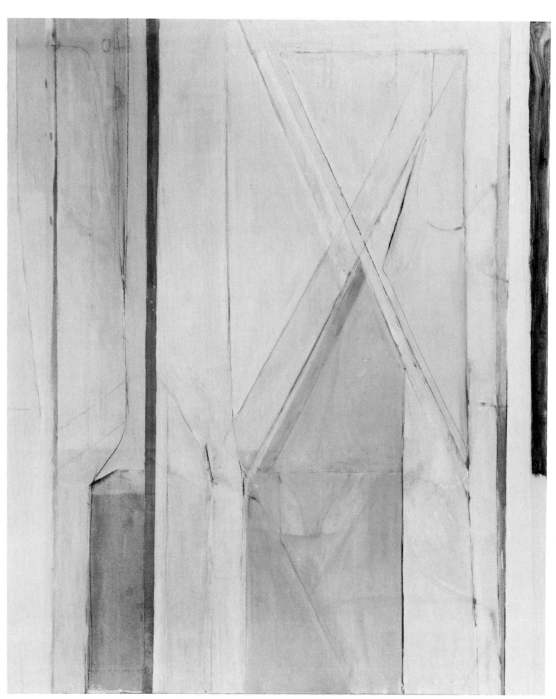

63

63. *Ocean Park No. 16*, 1968
oil on canvas, 92½" x 75⅜"

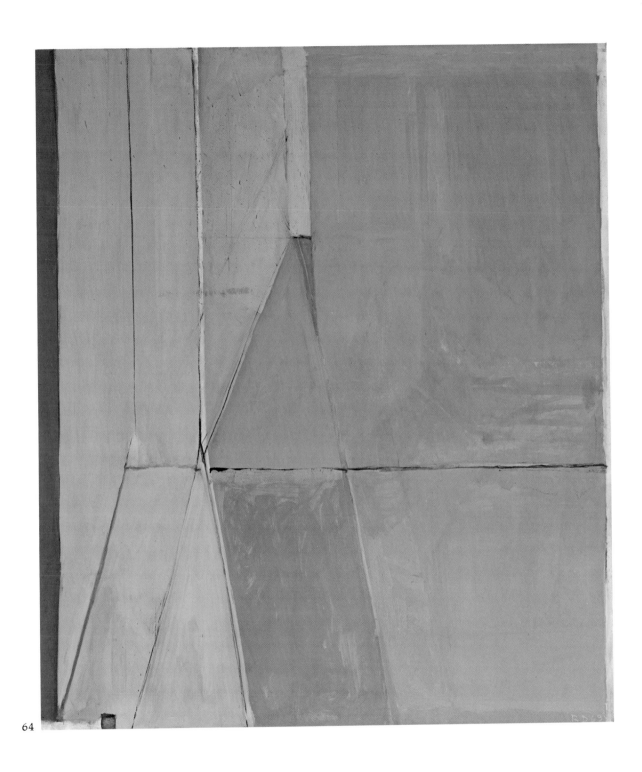

64

64. *Ocean Park No. 21*, 1969
oil on canvas, 93″ x 81″

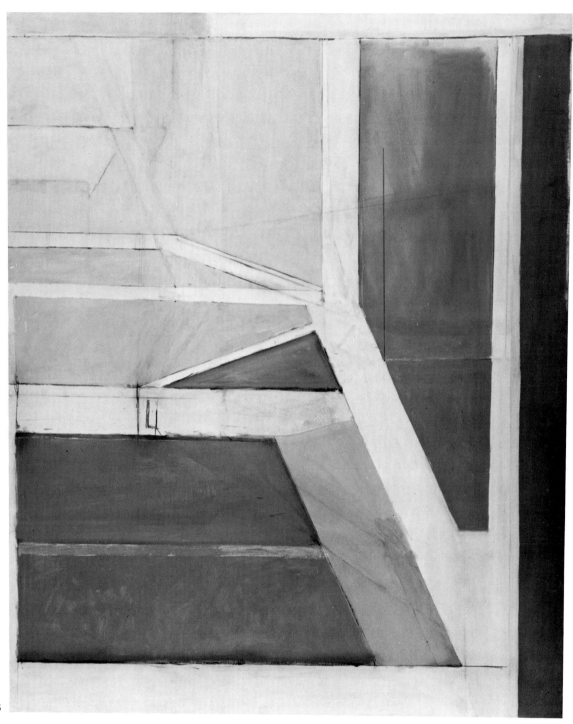

65

65. *Ocean Park No. 27,* 1970
 oil on canvas, 100″ x 81″

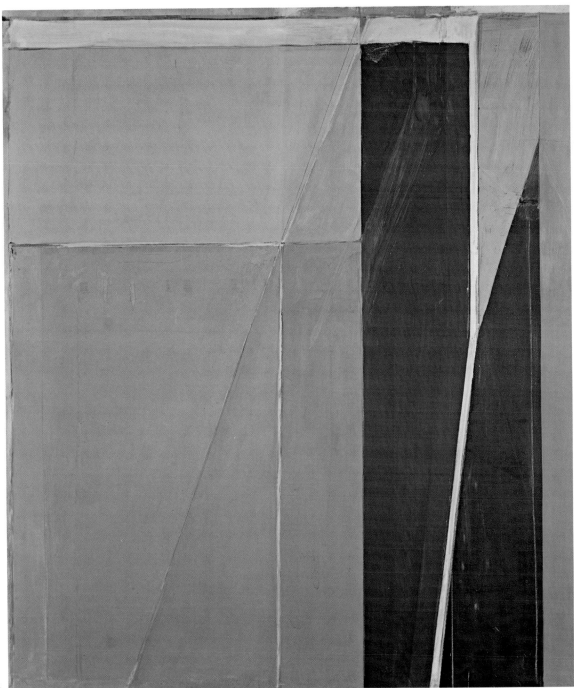

66

66. *Ocean Park No. 28*, 1970
 oil on canvas, 93" x 81"

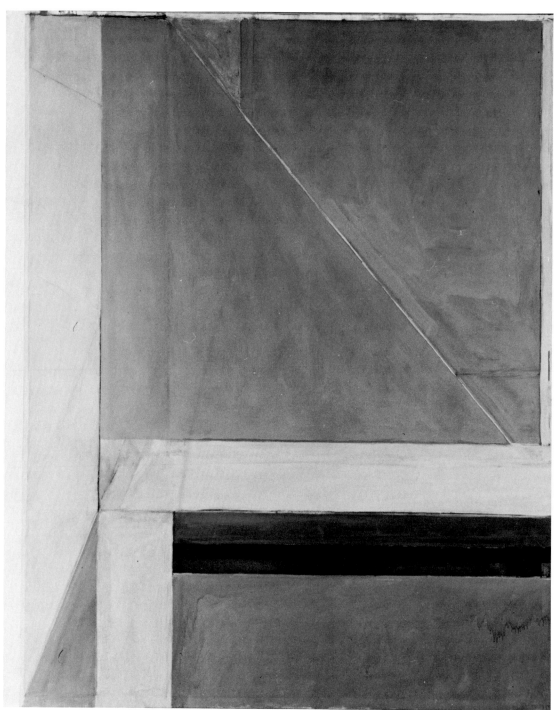

67

67. *Ocean Park No. 29,* 1970
 oil on canvas, 100" x 81"

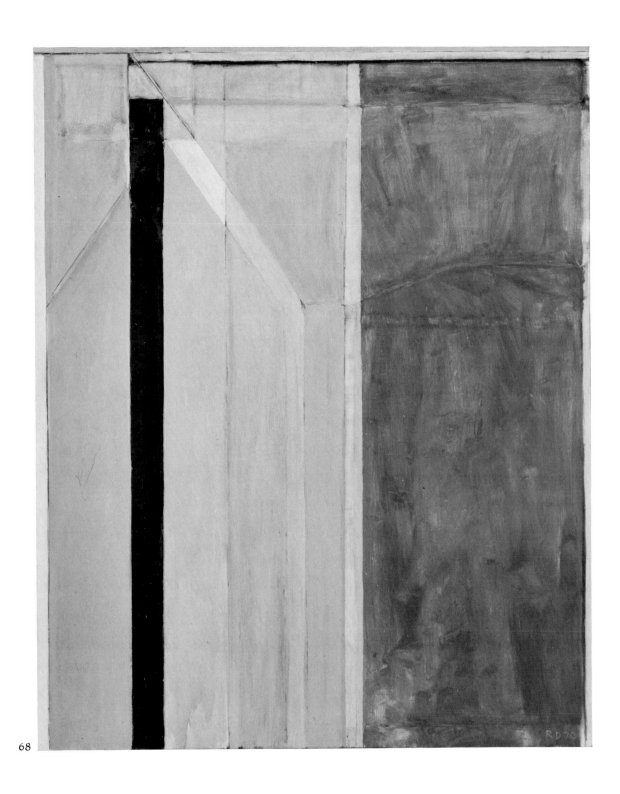

68

68. *Ocean Park No. 30*, 1970
oil on canvas, 100″ x 82″

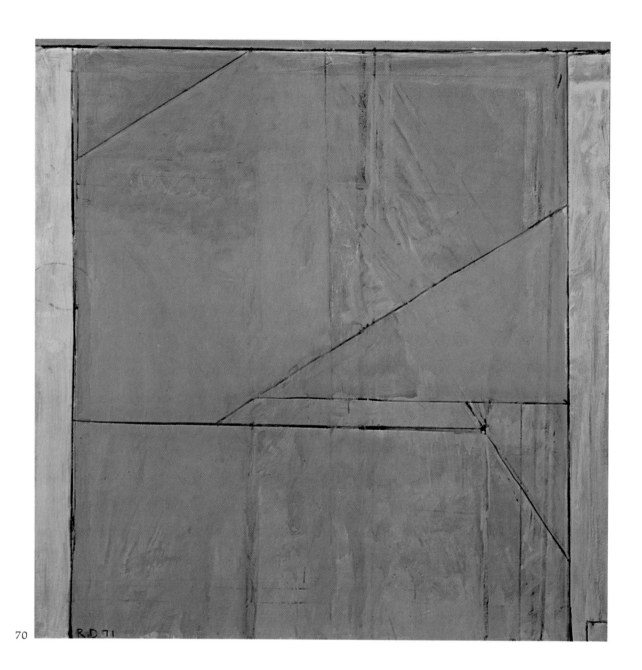

70

70. *Ocean Park No. 37*, 1971
oil on canvas, 50″ x 50″

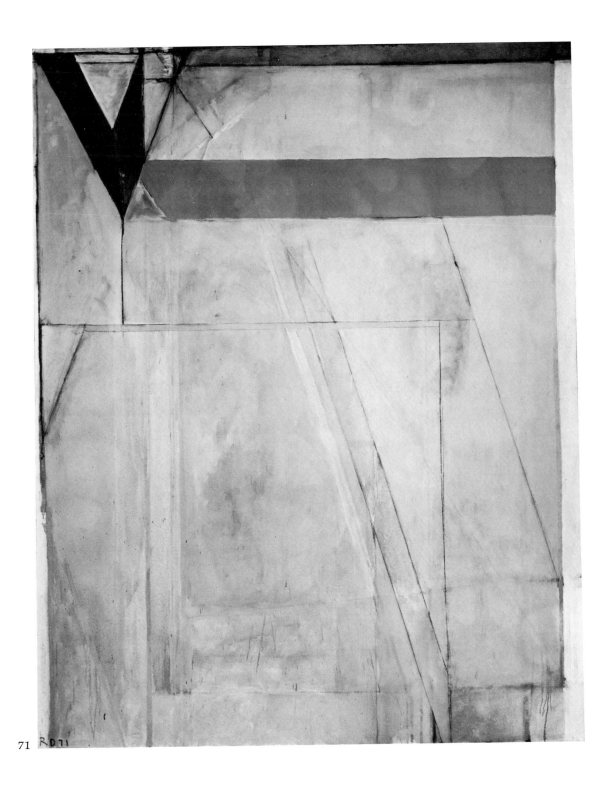

71. *Ocean Park No. 38*, 1971
 oil on canvas, 100″ x 81″

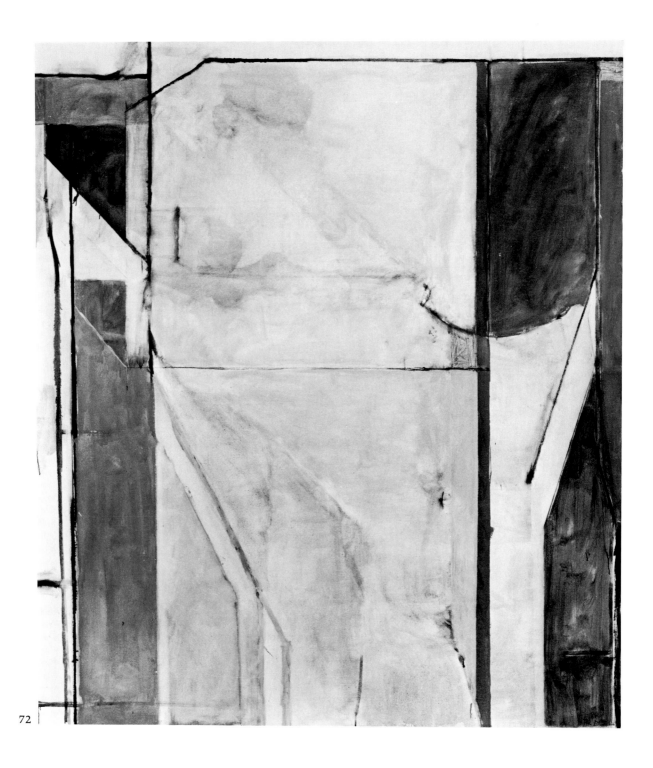

72

72. *Ocean Park No. 43*, 1971
oil on canvas, 93" x 81"

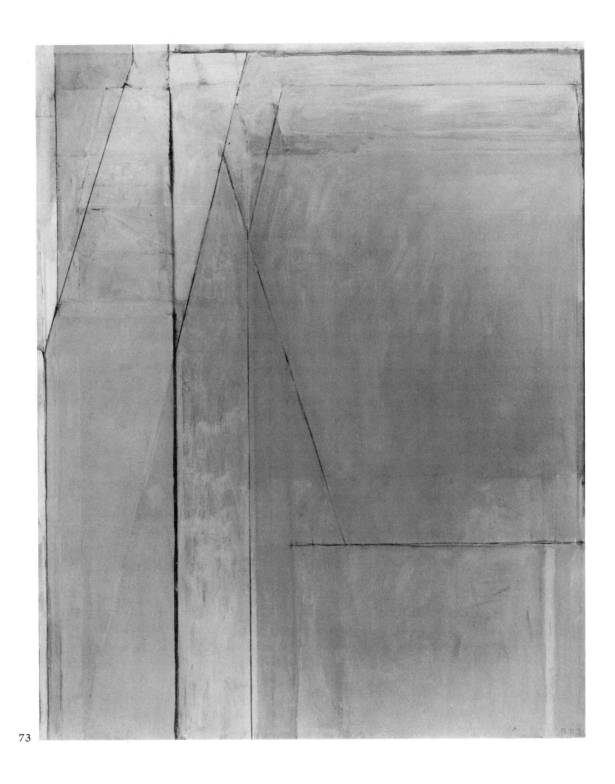

73

73. *Ocean Park No. 44*, 1971
oil on canvas, 100" x 81"

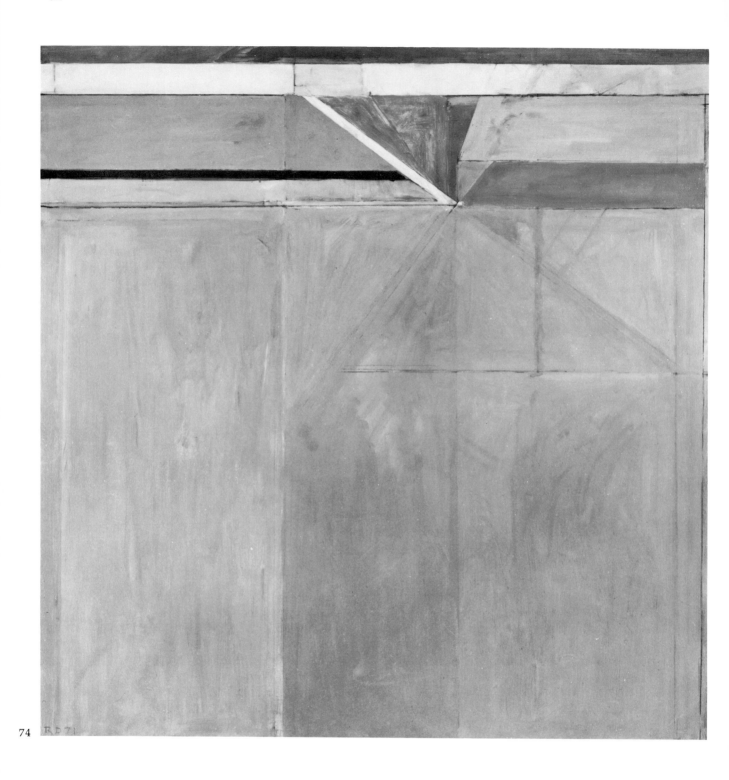

74

74. *Ocean Park No. 46*, 1971
 oil on cotton duck, 81" x 81"

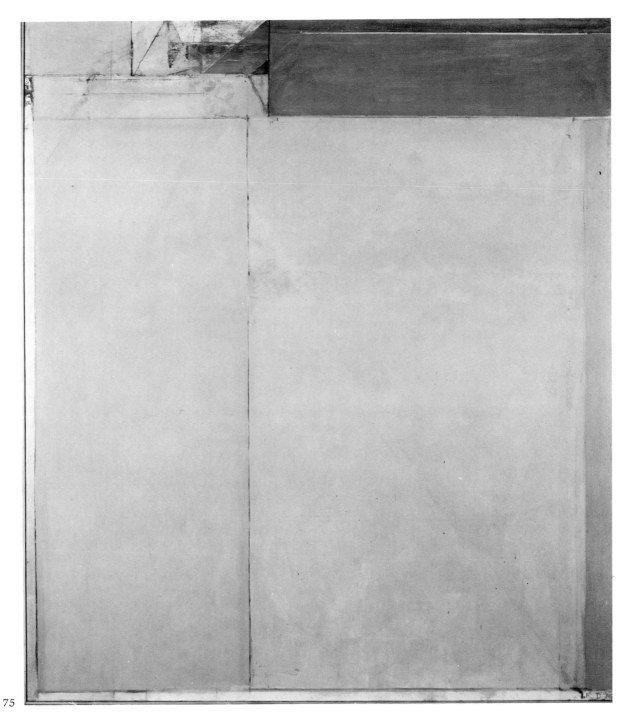

75

75. *Ocean Park No. 49*, 1972
 oil on canvas, 93" x 81"

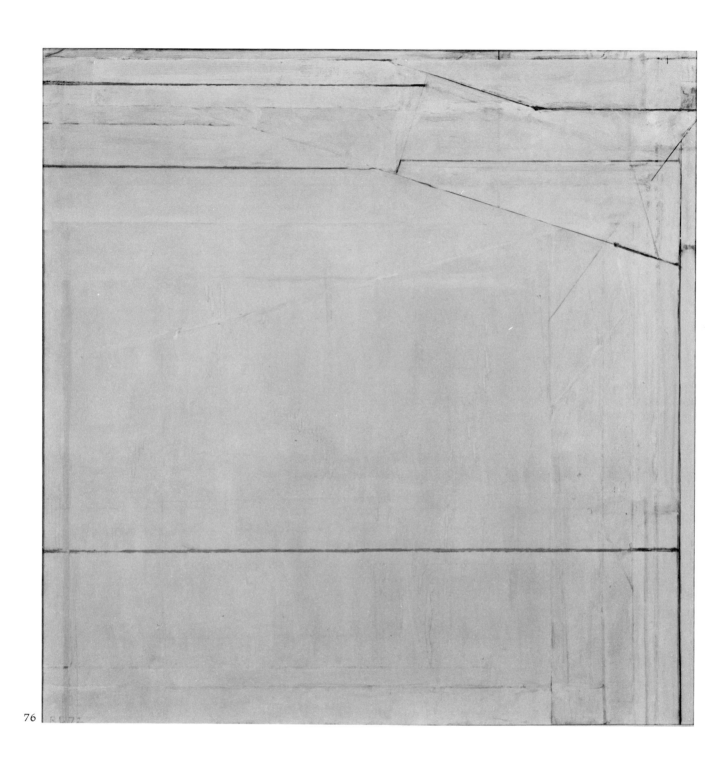

76. *Ocean Park No. 52*, 1972
oil on canvas, 81″ x 81″

77

77. *Ocean Park No. 54, 1972*
 oil on cotton duck, 100″ x 81″

80

80. *Ocean Park No. 61*, 1973
oil on canvas, 93″ x 81″

81. *Ocean Park No. 64*, 1973
oil on canvas, 100" x 81"

84. *Ocean Park No. 83*, 1975
oil on canvas, 100″ x 81″

85. *Ocean Park No. 85*, 1975
oil on canvas, 93" x 81"

86

86. *Ocean Park No. 86*, 1975
oil on canvas, 93″ x81″

87

87. *Ocean Park No. 87*, 1975
oil on canvas, 100″ x 81″

88

88. *Ocean Park No. 88*, 1975
 oil on canvas, 100" x 81"

89

89. *Ocean Park No. 91*, 1976
oil on canvas, 88" x 81"

90

90. *Ocean Park No. 92, 1976*
oil on canvas, 81″ x 81″

1

4

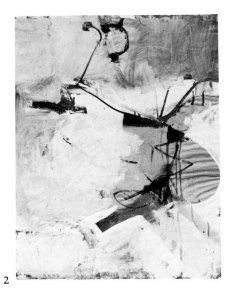

2

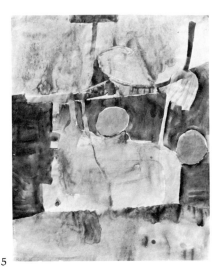

5

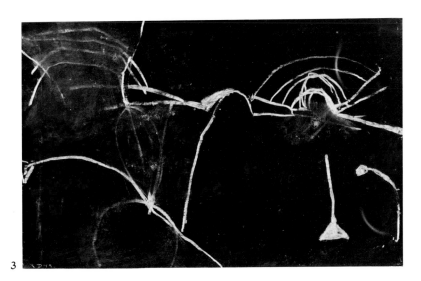

3

1. *Untitled*, 1948
 watercolor, ink & gouache, 9¼" x 10"

2. *Untitled*, 1949
 gouache, 22" x 18"

3. *Untitled*, 1949
 chalk & gouache, 18" x 28"

4. *Untitled*, 1949
 charcoal, 18" x 24"

5. *Untitled*, 1951
 watercolor, 17" x 14"

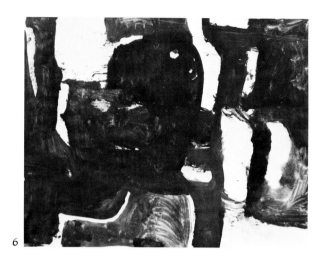

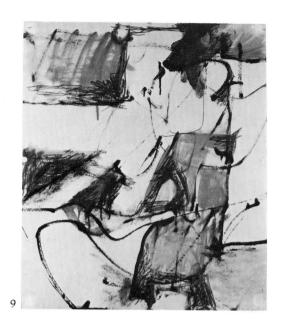

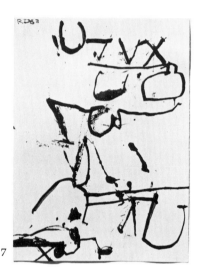

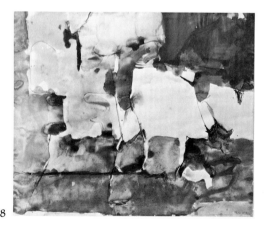

6. *Untitled,* 1951
 watercolor & gouache, 11" x 14"

7. *Untitled,* 1953
 ink, 12" x 9"

8. *Untitled,* 1953
 watercolor & pencil, 16" x 19"

9. *Untitled,* 1953
 ink, watercolor & pencil, 20¼" x 18"

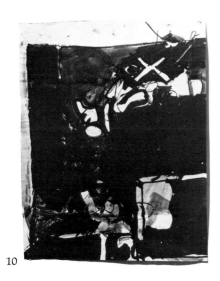

10

11

12

13

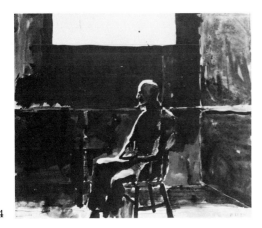

14

10. *Untitled*, 1954
 ink & crayon, 14" x 11¼"

11. *Untitled*, 1954
 India ink, 12" x 9"

12. *Untitled*, 1955
 crayon & gouache, 18¾" x 19"

13. *Untitled*, 1955
 ink, 15" x 12"

14. *Man and Window*, 1956
 gouache, 14" x 17"

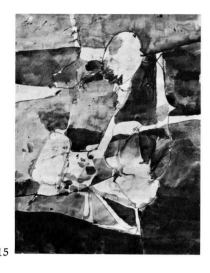

15

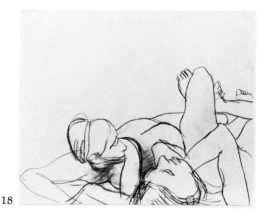

18

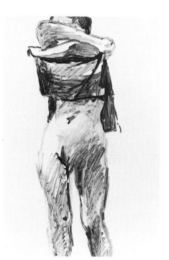

16

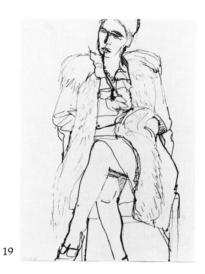

19

17

15. *Untitled*, 1957
 charcoal, ink & wash, 17" x 14"

16. *Untitled*, 1959
 ink wash, 16" x 11"

17. *Pliers & Match*, 1961
 oil on paper, 8½" x 11"

18. *Two Nudes*, 1963
 conté crayon, 14" x 17"

19. *Seated Woman, Fur Coat*, 1963
 ink, 17" x 13"

20

23

21

24

22

20. *Cup & Knife,* 1964
conté crayon, ink & gouache, 11″ x 11″

21. *Ranunculas & Cane Chair,* 1964
conté crayon & ink, 12″ x 18″

22. *Still Life with Hand Mirror,* 1964
conté crayon, ink & wash, 12″ x 18″

23. *Table Top, Cane Chair,* 1964
pencil, ink, wash, 17″ x 12½″

24. *Untitled,* 1964
wash, 9½″ x 12″

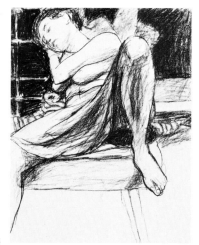

25

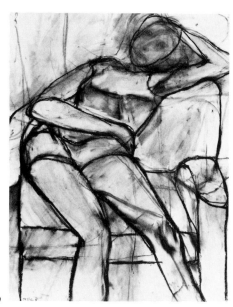

28

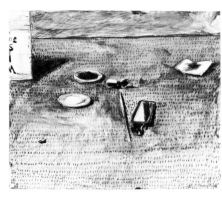

26

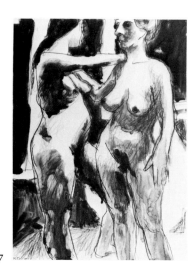

27

29

25. *Seated Nude, One Leg Up*, 1965
 charcoal, 17" x 14"

26. *Still Life with Textured Cloth*, 1965
 conté crayon & gouache, 14" x 16"

27. *Two Nudes Standing*, 1965
 pencil & black wash, 17" x 12⅞"

28. *Untitled*, 1965
 charcoal, 23¾" x 19"

29. *Untitled*, 1965
 charcoal, 23½" x 19"

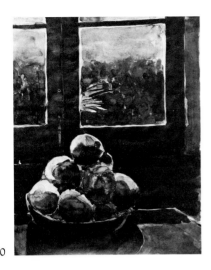

30

32

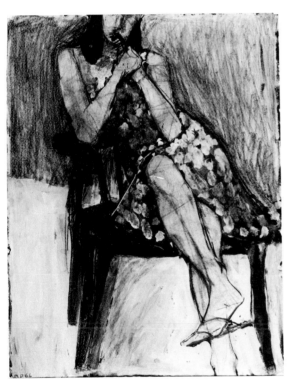

31

30. *Fruit & Windows,* 1966
 ballpoint & inks, 17″ x 14″

31. *Seated Woman No. 44,* 1966
 watercolor, gouache, crayon, 30¼″ x 23½″

32. *Shoes,* 1966
 conte crayon & ballpoint, 14″ x 17″

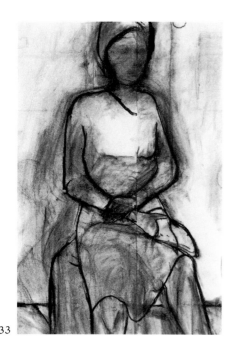

33

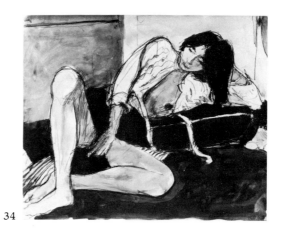

34

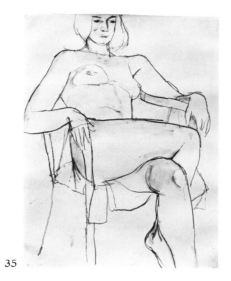

35

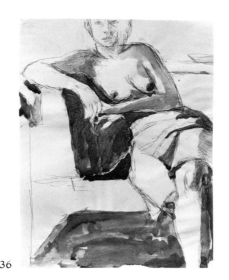

36

33. *Untitled*, 1966
 charcoal, 25″ x 17″

34. *Reclining Woman*, 1967
 conté crayon & ink, 14″ x 17″

35. *Seated Nude*, 1967
 conté crayon, 17″ x 14″

36. *Seated Nude*, 1967
 ballpoint & ink wash, 17″ x 14″

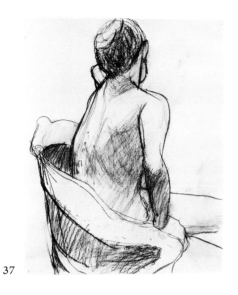

37

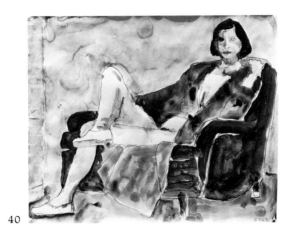

40

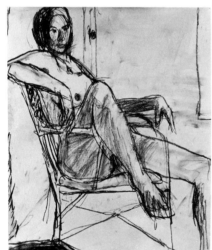

38

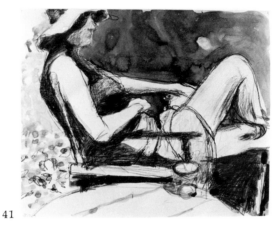

41

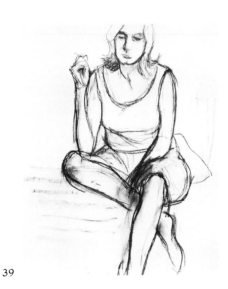

39

37. *Seated Nude, Back Turned*, 1967
 conté crayon, 17" x 14"

38. *Seated Nude, Knee Up*, 1967
 conté crayon, 17" x 14"

39. *Seated Woman*, 1967
 conté crayon & ballpoint pen, 17" x 14"

40. *Seated Woman*, 1967
 watercolor & pencil, 14" x 17"

41. *Seated Woman with Hat*, 1967
 pencil & ink wash, 14" x 17"

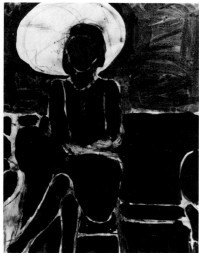

42

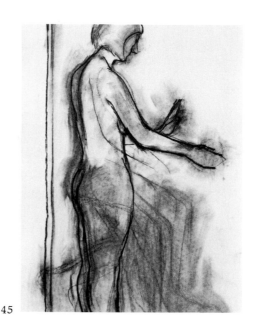

45

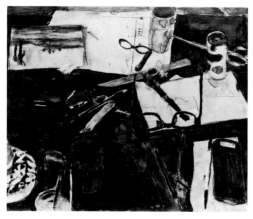

43

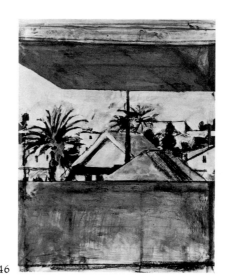

46

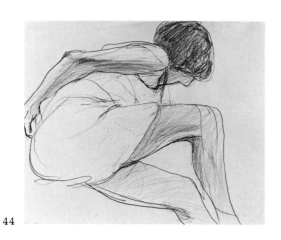

44

42. *Seated Woman/Umbrella*, 1967
conté crayon & ink, 17″ x 14″

43. *Still Life/Cigarette Butts*, 1967
pencil & ink, 14″ x 17″

44. *Untitled*, 1967
pencil, 14″ x 17″

45. *Untitled*, 1967
charcoal, 23¾″ x 18⅞″

46. *View from Studio, Ocean Park*, 1969
ink & gouache, 17″ x 14″

47

48

49

47. *Untitled*, 1971
 acrylic, 23½″ x 17¾″

48. *Untitled*, 1972
 acrylic & pencil, 25″ x 18″

49. *Untitled*, 1972
 acrylic & charcoal, 25″ x 18″

50

51

50. *Untitled*, 1972
 watercolor & crayon, 27" x 19"

51. *Untitled*, 1972
 ink & pasted paper, 25" x 18"

53

54

55

53. *Untitled*, 1973
ink & gouache, 24″ x 19″

54. *Untitled*, 1973
ink, 25″ x 18″

55. *Untitled*, 1973
gouache, 24″ x 19″

56

57

58

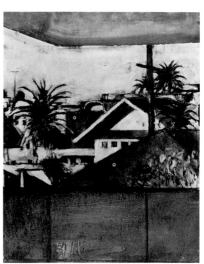

59

56. *Untitled*, 1973
 watercolor & gouache, 24" x 18"

57. *Untitled*, 1974
 acrylic, 23¾" x 15⅛"

58. *Untitled*, 1974
 acrylic, 18¾" x 29⅝"

59. *View from Studio, Ocean Park*, 1974
 ink & gouache, 17" x 14"

60

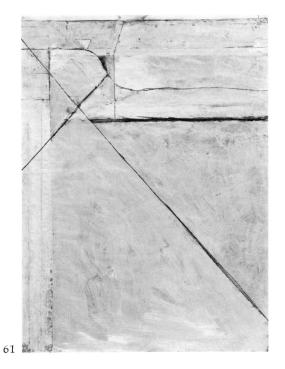

61

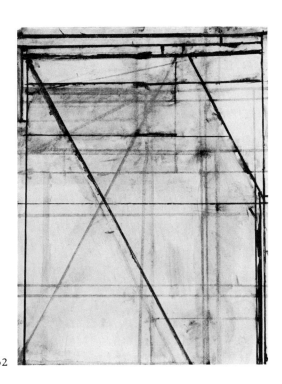

62

60. *Untitled*, 1975
 acrylic, 12″ x 9″

61. *Untitled*, 1975
 acrylic, 23½″ x 17¾″

62. *Untitled*, 1975
 acrylic, 25¼″ x 19″

Catalogue of the Exhibition
Paintings

1. *Palo Alto Circle,* 1943 (fig. 1)
 oil on canvas, 19¾" x 16"
 Private Collection

2. *No. 3,* 1947
 oil on canvas, 27" x 38"
 San Francisco Museum of Modern Art, San Francisco,
 California
 Gift of Charles Ross

3. *Painting II,* 1949 (fig. 15)
 oil on canvas, 46" x 36"
 Howard E. Johnson, Los Angeles, California

4. *Untitled,* 1949
 oil on canvas, 45" x 36"
 The Oakland Museum, Oakland, California
 Gift of the Women's Board of The Oakland Museum
 Association

5. *Untitled,* 1949 (fig. 17)
 oil on canvas, 54" x 31½"
 Mr. & Mrs. Gifford Phillips, Santa Monica, California

6. *Woman in Profile,* 1950 *(Not Illus.)*
 oil on canvas, 68" x 59"
 Howard E. Johnson, Los Angeles, California

7. *Albuquerque,* 1951
 oil on canvas, 48⅛" x 40"
 University Art Museum, University of New Mexico,
 Albuquerque

8. *Albuquerque No. 4,* 1951 (fig. 22)
 oil on canvas, 50¼" x 45¼"
 The St. Louis Art Museum, St. Louis, Missouri
 Gift of Joseph Pulitzer, Jr.

9. *Albuquerque (The Green Huntsman),* 1952 (fig. 29)
 oil on canvas, 42½" x 69¼"
 Mr. & Mrs. Richard Diebenkorn, Santa Monica, California

10. *Urbana No. 2 (The Archer),* 1952-53 (fig. 32)
 oil on canvas, 64½" x 47½"
 Mrs. Richard Diebenkorn, Santa Monica, California

11. *A Day at the Race,* 1953
 oil on canvas, 56" x 52¾"
 Museum of Art, Carnegie Institute, Pittsburgh,
 Pennsylvania

12. *Berkeley No. 2,* 1953
 oil on canvas, 57½" x 48⅞"
 Robert A. Rowan, Los Angeles, California

13. *Berkeley No. 6,* 1953
 oil on canvas, 54¼" x 48"
 Mrs. Gwendolyn Warner, Los Angeles, California

14. *Berkeley No. 7,* 1953
 oil on canvas, 47¾" x 43"
 Washington University Gallery of Art, St. Louis, Missouri

15. *Urbana No. 3,* 1953
 oil on canvas, 33¼" x 39"
 Mr. & Mrs. Max Zurier, Beverly Hills, California

16. *Urbana No. 4,* 1953 (fig. 31)
 oil on canvas, 66" x 49"
 Julianne Kemper, Santa Monica, California

17. *Urbana No. 5 (Beach Town),* 1953 (fig. 33)
 oil on canvas, 33¼" x 39"
 Mr. & Mrs. Gifford Phillips, Santa Monica, California

18. *Berkeley No. 54,* 1955
 oil on canvas, 61" x 58"
 Albright-Knox Art Gallery, Buffalo, New York
 Gift of Mr. & Mrs. David K. Anderson, New York

19. *Berkeley Landscape,* 1954 (fig. 36)
 oil on canvas, 50" x 48"
 Mr. & Mrs. Harry W. Anderson, Atherton, California

20. *Berkeley No. 8,* 1954 (fig. 38)
 oil on canvas, 69" x 59"
 North Carolina Museum of Art, Raleigh
 Gift of W.R. Valentiner

21. *Berkeley No. 16,* 1954 (fig. 37)
 oil on canvas, 56" x 46"
 Mr. & Mrs. Max Zurier, Beverley Hills, California

22. *Berkeley No. 20,* 1954
 oil on canvas, 70" x 61"
 Howard E. Johnson, Los Angeles, California

23. *Berkeley,* 1955
 oil on canvas, 59¼" x 64¼"
 Private Collection

24. *Berkeley No. 23,* 1955
 oil on canvas, 61¾" x 54¾"
 San Francisco Museum of Modern Art, San Francisco,
 California
 Gift of the Women's Board

25. *Berkeley No. 32,* 1955
 oil on canvas, 59" x 57"
 Dorothy & Richard Sherwood, Los Angeles, California

26. *Girl on a Terrace,* 1956 (fig. 48)
 oil on canvas, 71" x 66"
 Neuberger Museum, State University of New York
 College at Purchase
 Gift of Roy R. Neuberger

27. *Seawall,* 1957
 oil on canvas, 20" x 25½"
 Mr. & Mrs. Richard Diebenkorn, Santa Monica, California

28. *Girl and Three Coffee Cups,* 1957
 oil on canvas, 59" x 54"
 Yale University Art Gallery, New Haven, Connecticut
 Gift of Richard Brown Baker

29. *Girl Looking at Landscape,* 1957
 oil on canvas, 59" x 60⅜"
 Whitney Museum of American Art, New York
 Gift of Mr. & Mrs. Alan H. Temple

*30. *Interior with View of the Ocean,* 1957 (fig. 56)
 oil on canvas, 49⅝" x 57¾"
 The Phillips Collection, Washington, D.C.

*31. *Man and Woman in Large Room,* 1957 (fig. 53)
 oil on canvas, 71⅛" x 62½"
 Hirshhorn Museum and Sculpture Garden, Smithsonian
 Institution, Washington, D.C.

32. *Woman by a Window,* 1957
 oil on canvas, 64" x 59"
 Phoenix Art Museum, Phoenix, Arizona
 Gift of Mr. & Mrs. Henry Luce

33. *Woman in a Window,* 1957 (fig. 47)
 oil on canvas, 59" x 56"
 Albright-Knox Art Gallery, Buffalo, New York
 Gift of Seymour H. Knox, 1958

34. *Women Outside ,* 1957 (fig. 54)
 oil on canvas, 54¼" x 58¾"
 Art Gallery of Ontario, Toronto, Canada
 Gift of J.S. McLean, American Fund, 1960

35. *Still Life with Book,* 1958
 oil on canvas, 17" x 19"
 Harold M. Fondren, New York

36. *Woman on Porch,* 1958 (fig. 50)
 oil on canvas, 72" x 72"
 Mr. & Mrs. David Lloyd Kreeger, Washington, D.C.

37. *Woman Wearing a Flower,* 1958
 oil on canvas, 26" x 22"
 Contemporary Collection of The Cleveland Museum of
 Art, Cleveland, Ohio

38. *Cane Chair Outside,* 1959
 oil on canvas, 32" x 27"
 Morgan Flagg Family, Monterey, California

39. *Coffee,* 1959
 oil on canvas, 57" x 52½"
 Private Collection, Los Angeles, California

40. *Figure on Porch,* 1959
 oil on canvas, 57" x 62"
 The Oakland Museum, Oakland, California

41. *Interior with Book,* 1959 (fig. 57)
 oil on canvas, 70"x 64"
 Nelson Gallery – Atkins Museum, Kansas City, Missouri
 Friends of Art Collection

42. *Scissors,* 1959
 oil on canvas, 10¾" x 13"
 Mr. & Mrs. Richard Diebenkorn, Santa Monica, California

43. *Scissors and Lemon,* 1959 (fig. 43)
 oil on masonite, 13" x 10"
 Private Collection

44. *View from the Porch,* 1959
 oil on canvas, 70" x 66"
 Mr. & Mrs. Harry W. Anderson, Atherton, California

45. *Black Table,* 1960
 oil on canvas, 55½" x 47"
 Museum of Art, Carnegie Institute, Pittsburgh,
 Pennsylvania

46. *Interior with Flowers No. 10,* 1961 (fig. 59)
 oil on canvas, 57" x 39"
 Private Collection, San Francisco, California

47. *Still Life with Letter,* 1961 (fig. 41)
 oil on canvas, 20⅝" x 25⅝"
 San Francisco Art Commission, San Francisco, California

48. *Girl with Flowered Background,* 1962
 oil on canvas, 40" x 34"
 Mr. & Mrs. Frederick Rudolph, Williamstown,
 Massachusetts

49. *Interior with View of Buildings,* 1962 (fig. 60)
 oil on canvas, 84" x 67"
 Cincinnati Art Museum, Cincinnati, Ohio
 The Edwin and Virginia Irwin Memorial Fund

50. *Tomato & Knife,* 1962 (fig. 44)
 oil on canvas, 13¾" x 10¼"
 Mr. & Mrs. Jack Falvey, San Francisco, California

51. *Cityscape,* 1963 (fig. 62)
 oil on canvas, 47" x 50½"
 Mr. & Mrs. Richard B. McDonough, Berkeley, California

52. *Corner of Studio – Sink,* 1963 (fig. 63)
 oil on canvas, 77" x 70"
 Private Collection, Washington, D.C.

53. *Ingleside,* 1963 (fig. 61)
 oil on canvas, 81¾" x 69½"
 Grand Rapids Art Museum, Grand Rapids, Michigan

54. *Poppies,* 1963 (fig. 42)
 oil on canvas, 40" x 30"
 Mr. & Mrs. Ray Stark, Burbank, California

55. *Tomato & Knife,* 1963 (fig. 45)
 oil on canvas, 5⅝" x 7⅞"
 Private Collection

56. *Woman with Hat and Gloves,* 1963 (fig. 51)
 oil on canvas, 34" x 36"
 Mr. & Mrs. Francis V. Keesling, Jr., San Francisco,
 California

57. *Recollections of a Visit to Leningrad,* 1965 (fig. 64)
 oil on canvas, 71½" x 83"
 Private Collection, San Francisco, California

58. *Large Still Life,* 1966 (fig. 67)
 oil on canvas, 65" x 70½"
 Mr. & Mrs. Richard Diebenkorn, Santa Monica, California

59. *Window,* 1967 (fig. 68)
 oil on canvas, 92" x 80"
 Stanford University Museum of Art, Stanford, California
 Gift of Mr. & Mrs. Richard Diebenkorn and anonymous
 donors

60. *Ocean Park No. 7,* 1968 (fig. 79)
 oil on canvas, 93" x 80"
 Mr. & Mrs. Gilbert H. Kinney, Washington, D.C.

61. *Ocean Park No. 10,* 1968 (fig. 80)
 oil on canvas, 84" x 72"
 Dr. & Mrs. Ralph G. Greenlee, Jr., Dallas, Texas

62. *Ocean Park No. 14,* 1968
 oil on canvas, 93" x 80"
 Mr. & Mrs. Philip Gersh, Beverley Hills, California

63. *Ocean Park No. 16,* 1968
 oil on canvas, 92½" x 75⅜"
 Milwaukee Art Center Collection, Milwaukee, Wisconsin
 Gift of Mrs. Harry Lynde Bradley, 1974

64. *Ocean Park No. 21*, 1969
 oil on canvas, 93" x 81"
 Dr. & Mrs. Herbert Schorr, New York

65. *Ocean Park No. 27*, 1970
 oil on canvas, 100" x 81"
 The Brooklyn Museum, Brooklyn, New York
 Gift of The Roebling Society and Mr. and Mrs. Charles
 H. Blatt and Mr. and Mrs. William K. Jacobs, Jr.
 through The Roebling Society

66. *Ocean Park No. 28*, 1970
 oil on canvas, 93" x 81"
 Alfred M. Esberg, Pasadena, California

67. *Ocean Park No. 29*, 1970
 oil on canvas, 100" x 81"
 Mr. & Mrs. Algur H. Meadows, Dallas, Texas through
 Dallas Museum of Fine Arts

68. *Ocean Park No. 30*, 1970
 oil on canvas, 100" x 82"
 The Metropolitan Museum of Art, New York
 Bequest of Adelaide Milton de Groot (1876-1967), by
 exchange, 1972

69. *Ocean Park No. 32*, 1970 (fig. 72)
 oil on canvas, 93" x 81"
 Private Collection, San Francisco, California

70. *Ocean Park No. 37*, 1971
 oil on canvas, 50" x 50"
 Robert A. Rowan, Los Angeles, California

71. *Ocean Park No. 38*, 1971
 oil on canvas, 100" x 81"
 Mr. & Mrs. Gifford Phillips, Santa Monica, California

72. *Ocean Park No. 43*, 1971
 oil on canvas, 93" x 81"
 Whitney Museum of American Art, New York
 Anonymous gift

73. *Ocean Park No. 44*, 1971
 oil on canvas, 100" x 81"
 Private Collection, San Francisco, California

74. *Ocean Park No. 46*, 1971
 oil on cotton duck, 81" x 81"
 Private Collection, Fort Worth, Texas

75. *Ocean Park No. 49*, 1972
 oil on canvas, 93" x 81"
 Los Angeles County Museum of Art, Los Angeles,
 California
 Museum Purchase

76. *Ocean Park No. 52*, 1972
 oil on canvas, 81" x 81"
 The University of Michigan Museum of Art, Ann Arbor
 Museum Purchase assisted by The Friends of the
 Museum of Art and the National Endowment
 for the Arts

77. *Ocean Park No. 54*, 1972
 oil on cotton duck, 100" x 81"
 San Francisco Museum of Modern Art, San Francisco,
 California
 Gift of the Friends of Gerald Nordland

78. *Ocean Park No. 59*, 1973 (fig. 74)
 oil on canvas, 93" x 81"
 Marlborough Gallery, New York

79. *Ocean Park No. 60*, 1973 (fig. 76)
 oil on canvas, 93" x 81"
 Mr. & Mrs. Harry W. Anderson, Atherton, California

80. *Ocean Park No. 61*, 1973
 oil on canvas, 93" x 81"
 Private Collection, Washington, D.C.

81. *Ocean Park No. 64*, 1973
 oil on canvas, 100" x 81"
 Museum of Art, Carnegie Institute, Pittsburgh,
 Pennsylvania

82. *Ocean Park No. 66*, 1973 (fig. 77)
 oil on canvas, 93" x 81"
 Albright-Knox Art Gallery, Buffalo, New York
 Gift of Seymour H. Knox, 1974

83. *Ocean Park No. 68*, 1974 (fig. 78)
 oil on canvas, 81" x 93"
 Mrs. Harry Lynde Bradley, Milwaukee, Wisconsin

84. *Ocean Park No. 83*, 1975
 oil on canvas, 100" x 81"
 Corcoran Gallery of Art, Washington, D.C.
 Purchased with the aid of funds from
 the National Endowment for the Arts, The Wm. A.
 Clark Fund and Margaret M. Hitchcock

85. *Ocean Park No. 85*, 1975
 oil on canvas, 93" x 81"
 Private Collection, Topeka, Kansas

**86. *Ocean Park No. 86*, 1975
 oil on canvas, 93" x81"
 The St. Louis Art Museum, St. Louis, Missouri
 Funds given by the Shoenberg Foundation, Inc.

87. *Ocean Park No. 87*, 1975
 oil on canvas, 100" x 81"
 Private Collection, Washington, D.C.

88. *Ocean Park No. 88*, 1975
 oil on canvas, 100" x 81"
 Mr. & Mrs. William C. Janss, Sun Valley, Idaho

89. *Ocean Park No. 91*, 1976
 oil on canvas, 88" x 81"
 Mr. & Mrs. Richard Diebenkorn, Santa Monica, California

90. *Ocean Park No. 92*, 1976
 oil on canvas, 81" x 81"
 Mr. & Mrs. Richard Diebenkorn, Santa Monica, California

91. *Ocean Park No. 94*, 1976
 oil on canvas, 93" x 81"
 Mr. & Mrs. Richard Diebenkorn, Santa Monica, California

*Shown only in Buffalo, Cincinnati and Washington.

**Shown only in Buffalo, Cincinnati, Washington and New York.

Works on Paper

1. *Untitled*, 1948
 watercolor, ink & gouache, 9¼″ x 10″
 Mr. & Mrs. Richard Diebenkorn, Santa Monica, California

2. *Untitled*, 1949
 gouache, 22″ x 18″
 Mr. & Mrs. Richard Diebenkorn, Santa Monica, California

3. *Untitled*, 1949
 chalk & gouache, 18″ x 28″
 Mr. & Mrs. Richard Diebdnkorn, Santa Monica, California

4. *Untitled*, 1949
 charcoal, 18″ x 24″
 Mr. & Mrs. Richard Diebenkorn, Santa Monica, California

5. *Untitled*, 1951
 watercolor, 17″ x 14″
 Mr. & Mrs. Richard Diebenkorn, Santa Monica, California

6. *Untitled*, 1951
 watercolor & gouache, 11″ x 14″
 Dr. & Mrs. Leopold S. Tuchman, Beverley Hills, California

7. *Untitled*, 1953
 ink, 12″ x9″
 Mr. & Mrs. Richard Diebenkorn, Santa Monica, California

8. *Untitled*, 1953
 watercolor & pencil, 16″ x 19″
 Mr. & Mrs. Herbert Rushing, Manhattan Beach, California

9. *Untitled*, 1953
 ink, watercolor & pencil, 20¼″ x 18″
 Gerald Nordland, Los Angeles, California

10. *Untitled*, 1954
 ink & crayon, 14″ x 11¼″
 Mr. & Mrs. Richard Diebenkorn, Santa Monica, California

11. *Untitled*, 1954
 India ink, 12″ x 9″
 Marlborough Gallery, New York

12. *Untitled*, 1955
 crayon & gouache, 18¾″ x 19″
 Mr. & Mrs. Richard Diebenkorn, Santa Monica, California

13. *Untitled*, 1955
 ink, 15″ x 12″
 Mr. & Mrs. Richard Diebenkorn, Santa Monica, California

14. *Man and Window*, 1956
 gouache, 14″ x 17″
 Mr. & Mrs. Michael Blankfort, Los Angeles, California

15. *Untitled*, 1957
 charcoal, ink & wash, 17″ x 14″
 Mr. & Mrs. Richard Diebenkorn, Santa Monica, California

16. *Untitled*, 1959
 ink wash, 16″ x 11″
 Marlborough Gallery, New York

17. *Pliers & Match*, 1961
 oil on paper, 8½″ x 11″
 Mr. & Mrs. Richard Diebenkorn, Santa Monica, California

18. *Two Nudes*, 1963
 conté crayon, 14″ x 17″
 Mr. & Mrs. Richard Diebenkorn, Santa Monica, California

19. *Seated Woman, Fur Coat*, 1963
 ink, 17″ x 13″
 Mr. & Mrs. Richard Diebenkorn, Santa Monica, California

20. *Cup & Knife*, 1964
 conté crayon, ink & gouache, 11″ x 11″
 Mr. & Mrs. Richard Diebenkorn, Santa Monica, California

21. *Ranunculas & Cane Chair*, 1964
 conté crayon & ink, 12″ x 18″
 Mr. & Mrs. Richard Diebenkorn, Santa Monica, California

22. *Still Life with Hand Mirror*, 1964
 conté crayon, ink & wash, 12″ x 18″
 Mr. & Mrs. Richard Diebenkorn, Santa Monica, California

23. *Table Top, Cane Chair*, 1964
 pencil, ink, wash, 17″ x 12½″
 Christopher Diebenkorn, Santa Monica, California

24. *Untitled*, 1964
 wash, 9½″ x 12″
 William Theophilus Brown, San Francisco, California

25. *Seated Nude, One Leg Up*, 1965
 charcoal, 17″ x 14″
 Marlborough Gallery, New York

26. *Still Life with Textured Cloth*, 1965
 conté crayon & gouache, 14″ x 16″
 Marlborough Gallery, New York

27. *Two Nudes Standing*, 1965
 pencil & black wash, 17″ x 12⅞″
 Marlborough Gallery, New York

28. *Untitled*, 1965
 charcoal, 23¾″ x 19″
 Marlborough Gallery, New York

29. *Untitled*, 1965
 charcoal, 23½″ x 19″
 Marlborough Gallery, New York

30. *Fruit & Windows*, 1966
 ballpoint & inks, 17″ x 14″
 Mr. & Mrs. Richard Diebenkorn, Santa Monica, California

31. *Seated Woman No. 44*, 1966
 watercolor, gouache, crayon, 30¼″ x 23½″
 Student Association, State University of New York at
 Albany

32. *Shoes*, 1966
 conté crayon & ballpoint, 14″ x 17″
 Mr. & Mrs. Richard Diebenkorn, Santa Monica, California

33. *Untitled*, 1966
 charcoal, 25″ x 17″
 Marlborough Gallery, New York

34. *Reclining Woman*, 1967
 conté crayon & ink, 14″ x 17″
 Mr. & Mrs. Richard Diebenkorn, Santa Monica, California

35. *Seated Nude*, 1967
 conté crayon, 17″ x 14″
 Mr. & Mrs. Richard Diebenkorn, Santa Monica, California

36. *Seated Nude*, 1967
 ballpoint & ink wash, 17″ x 14″
 Mr. & Mrs. Richard Diebenkorn, Santa Monica, California

37. *Seated Nude, Back Turned*, 1967
 conté crayon, 17" x 14"
 Mr. & Mrs. Richard Diebenkorn, Santa Monica, California

38. *Seated Nude, Knee Up*, 1967
 conte crayon, 17" x 14"
 Mr. & Mrs. Richard Diebenkorn, Santa Monica, California

39. *Seated Woman*, 1967
 conte crayon & ballpoint pen, 17" x 14"
 Mr. & Mrs. Richard Diebenkorn, Santa Monica, California

40. *Seated Woman*, 1967
 watercolor & pencil, 14" x 17"
 Mr. & Mrs. Richard Diebenkorn, Santa Monica, California

41. *Seated Woman with Hat*, 1967
 pencil & ink wash, 14" x 17"
 Mr. & Mrs. Richard Diebenkorn, Santa Monica, California

42. *Seated Woman/Umbrella*, 1967
 conte crayon & ink, 17" x 14"
 Mr. & Mrs. Richard Diebenkorn, Santa Monica, California

43. *Still Life/Cigarette Butts*, 1967
 pencil & ink, 14" x 17"
 Mr. & Mrs. Richard Diebenkorn, Santa Monica, California

44. *Untitled*, 1967
 pencil, 14" x 17"
 Mr. & Mrs. Richard Diebenkorn, Santa Monica, California

45. *Untitled*, 1967
 charcoal, 23¾" x 18⅞"
 Marlborough Gallery, New York

46. *View from Studio, Ocean Park*, 1969
 ink & gouache, 17" x 14"
 Mr. & Mrs. Richard Diebenkorn, Santa Monica, California

47. *Untitled*, 1971
 acrylic, 23½" x 17¾"
 Mr. & Mrs. Richard Grant, Berkeley, California

48. *Untitled*, 1972
 acrylic & pencil, 25" x 18"
 Mr. & Mrs. Richard Diebenkorn, Santa Monica, California

49. *Untitled*, 1972
 acrylic & charcoal, 25" x 18"
 Mr. & Mrs. Richard Diebenkorn, Santa Monica, California

50. *Untitled*, 1972
 watercolor & crayon, 27" x 19"
 Mr. & Mrs. Richard Diebenkorn, Santa Monica, California

51. *Untitled*, 1972
 ink & pasted paper, 25" x 18"
 Mr. & Mrs. Richard Diebenkorn, Santa Monica, California

52. *Untitled*, 1972 *(Not Illus.)*
 acrylic, 18" x 25"
 Mr. & Mrs. Richard Diebenkorn, Santa Monica, California

53. *Untitled*, 1973
 ink & gouache, 24" x 19"
 Mr. & Mrs. Richard Diebenkorn, Santa Monica, California

54. *Untitled*, 1973
 ink, 25" x 18"
 Mr. & Mrs. Richard Diebenkorn, Santa Monica, California

55. *Untitled*, 1973
 gouache, 24" x 19"
 Mr. & Mrs. Richard Diebenkorn, Santa Monica, California

56. *Untitled*, 1973
 watercolor & gouache, 24" x 18"
 Mr. & Mrs. Richard Diebenkorn, Santa Monica, California

57. *Untitled*, 1974
 acrylic, 23¾" x 15⅛"
 Robert Natkin and Judith Dolnick, West Redding,
 Connecticut

58. *Untitled*, 1974
 acrylic, 18¾" x 29⅝"
 John Berggruen Gallery, San Francisco, California

59. *View from Studio, Ocean Park*, 1974
 ink & gouache, 17" x 14"
 Private Collection

60. *Untitled*, 1975
 acrylic, 12" x 9"
 Mr. & Mrs. Richard Diebenkorn, Santa Monica, California

61. *Untitled*, 1975
 acrylic, 23½" x 17¾"
 Mr. & Mrs. Richard Grant, Berkeley, California

62. *Untitled*, 1975
 acrylic, 25¼" x 19"
 Jacques Leviant, New York

Lenders To The Exhibition

Mr. and Mrs. Harry W. Anderson, Atherton, California
Mr. and Mrs. Michael Blankfort, Los Angeles, California
Mrs. Harry Lynde Bradley, Milwaukee, Wisconsin
William Theophilus Brown, San Francisco, California
Christopher Diebenkorn, Santa Monica, California
Mr. and Mrs. Richard Diebenkorn, Santa Monica, California
Alfred M. Esberg, Pasadena, California
Mr. and Mrs. Jack Falvey, San Francisco, California
Morgan Flagg family, Monterey, California
Harold M. Fondren, New York
Mr. and Mrs. Philip Gersh, Beverly Hills, California
Mr. and Mrs. Richard Grant, Berkeley, California
Dr. and Mrs. Ralph G. Greenlee, Jr., Dallas, Texas
Mr. and Mrs. William C. Janss, Sun Valley, Idaho
Howard E. Johnson, Los Angeles, California
Mr. and Mrs. Francis V. Keesling, Jr., San Francisco, California
Julianne Kemper, Santa Monica, California
Mr. and Mrs. Gilbert H. Kinney, Washington, D.C.
Mr. and Mrs. David Lloyd Kreeger, Washington, D.C.
Jacques Leviant, New York
Mr. and Mrs. Richard B. McDonough, Berkeley, California
Mr. and Mrs. Algur H. Meadows, Dallas, Texas, through
 the Dallas Museum of Fine Arts
Robert Natkin and Judith Dolnick, West Redding, Connecticut
Gerald Nordland, Los Angeles, California
Mr. and Mrs. Gifford Phillips, Santa Monica, California
Robert A. Rowan, Los Angeles, California
Mr. and Mrs. Frederick Rudolph, Williamstown, Massachusetts
Mr. and Mrs. Herbert Rushing, Manhattan Beach, California
Dr. and Mrs. Herbert Schorr, New York
Dorothy and Richard Sherwood, Los Angeles, California
Mr. and Mrs. Ray Stark, Burbank, California
Dr. and Mrs. Leopold S. Tuchman, Beverly Hills, California
Mrs. Gwendolyn Warner, Los Angeles, California
Mr. and Mrs. Max Zurier, Beverly Hills, California
Private Collections

Albright-Knox Art Gallery, Buffalo, New York
The Brooklyn Museum, Brooklyn, New York
Museum of Art, Carnegie Institute, Pittsburgh,
 Pennsylvania
Cincinnati Art Museum, Cincinnati, Ohio
The Cleveland Museum of Art, Cleveland, Ohio
The Corcoran Gallery of Art, Washington, D.C.
Grand Rapids Art Museum, Grand Rapids, Michigan
Hirschhorn Museum and Sculpture Garden, Smithsonian
 Institution, Washington, D.C.
Los Angeles County Museum of Art, Los Angeles,
 California

The Metropolitan Museum of Art, New York
The University of Michigan, Museum of Art, Ann Arbor
Milwaukee Art Center Collection, Milwaukee, Wisconsin
Nelson Gallery – Atkins Museum, Kansas City, Missouri
Neuberger Museum, State University of New York College
 at Purchase
University Art Museum, University of New Mexico,
 Albuquerque
North Carolina Museum of Art, Raleigh
The Oakland Museum, Oakland, California
Art Gallery of Ontario, Toronto, Canada
The Phillips Collection, Washington, D.C.
Phoenix Art Museum, Phoenix, Arizona
The St. Louis Art Museum, St. Louis, Missouri
Art Commission, City and County of San Francisco,
 California
San Francisco Museum of Modern Art, San Francisco,
 California
Stanford University Museum of Art, Stanford, California
Student Association, State University of New York
 at Albany
Washington University Gallery of Art, St. Louis, Missouri
Whitney Museum of American Art, New York
Yale University Art Gallery, New Haven, Connecticut

John Berggruen Gallery, San Francisco, California
Marlborough Gallery, New York

Selected Exhibitions

One-Artist

1948 California Palace of the Legion of Honor, San Francisco, California

1951 The Art Gallery, The University of New Mexico, Albuquerque

1952 Paul Kantor Gallery, Los Angeles, California

1954 Paul Kantor Gallery, Los Angeles, California
San Francisco Museum of Art, San Francisco, California
Allan Frumkin Gallery, Chicago, Illinois

1956 Poindexter Gallery, New York
Oakland Art Museum, Oakland, California

1957 Swetzoff Gallery, Boston, Massachusetts

1958 Poindexter Gallery, New York

1960 California Palace of the Legion of Honor, San Francisco, California
Pasadena Art Museum, Pasadena, California

1961 The Phillips Collection, Washington, D.C.
Poindexter Gallery, New York

1962 National Institute of Arts and Letters, New York

1963 M.H. de Young Memorial Museum, San Francisco, California
Poindexter Gallery, New York

1964 Stanford University Art Gallery, Stanford, California
Waddington Galleries, London, England
Washington Gallery of Modern Art, Washington, D.C. (travelled to The Jewish Museum, New York, and Pavilion Gallery, Newport Beach, California, in 1965)

1965 Paul Kantor Gallery, Los Angeles, California
Poindexter Gallery, New York

1966 Poindexter Gallery, New York

1967 National Institute of Arts and Letters, New York
Stanford University, Stanford, California
Waddington Galleries, London, England

1968 Nelson Gallery-Atkins Museum, Kansas City, Missouri
Peale House, Pennsylvania Academy of Fine Arts, Philadelphia
Poindexter Gallery, New York
Richmond Art Center, Richmond, California

1969 Los Angeles County Museum of Art, Los Angeles, California
Poindexter Gallery, New York

1971 Irving Blum Gallery, Los Angeles, California
Marlborough Gallery, New York
Poindexter Gallery, New York
Galerie Smith-Andersen, Palo Alto, California

1972 Gerard John Hayes Gallery, Los Angeles, California
San Francisco Museum of Art, San Francisco, California

1973 Robert Mondavi Gallery, Oakville, California
Marlborough Fine Art, Ltd., London, England
Marlborough Galerie, A.G., Zurich, Switzerland

1974 Mary Porter Sesnon Gallery, University of California, Santa Cruz

1975 John Berggruen Gallery, San Francisco, California
James Corcoran Gallery, Los Angeles, California
Marlborough Gallery, New York

1976 Frederick S. Wight Art Gallery, University of California, Los Angeles

Group Exhibitions

1949 Lucien Labaudt Gallery, San Francisco, California.

1951 Grand Rapids Art Museum, Grand Rapids, Michigan, *20th Century American Painting;* Los Angeles County Museum of Art, Los Angeles, California, *Contemporary Painting in the U.S.*

1954 Colorado Springs Fine Arts Center, Colorado Springs, *New Accessions USA;* The Solomon R. Guggenheim Museum, New York, *Younger American Painters;* Los Angeles County Museum of Art, Los Angeles, California.

1955 Allen Memorial Art Museum, Oberlin College, Oberlin, Ohio, *Three Young Americans: Glasco, McCullough, Diebenkorn;* Corcoran Gallery of Art, Washington, D.C.,*24th Biennial;* Musée National d'Art Moderne, Paris, France, *Jeunes Peintres;* Museum of Art, Carnegie Institute, Pittsburgh, Pennsylvania, Pittsburgh International; Poindexter Gallery, New York; *III Bienal di São Paulo,* Brazil; University of Illinois, Urbana, Illinois, *Contemporary American Painting and Sculpture;* Whitney Museum of American Art, New York,*1955 Annual Exhibition, Contemporary American Painting.*

1956 San Francisco Museum of Art, San Francisco, California, *2nd Pacific Coast Biennial.*

1957 The Art Institute of Chicago, Chicago, Illinois, *LXII American Exhibition of Painting and Sculpture;* Ferus Gallery, Los Angeles, California, *Objects in the New Landscape Demanding of the Eye;* Fogg Art Museum, Cambridge, Massachusetts, Modern Painting, *Drawing and Sculpture Collected by Louise and Joseph Pulitzer;* Los Angeles County Museum of Art, Los Angeles, California; The Oakland Art Museum, Oakland, California; Swetzoff Gallery, Boston, Massachusetts.

1958 Brussels Universal and International Exhibition (World's Fair), Brussels, Belgium, *Seventeen Contemporary American Artists;* Museum of Art, Carnegie Institute, Pittsburgh, Pennsylvania, *Pittsburgh International;* The Virginia Museum of Fine Arts, Richmond, Virginia, *American Painting 1958;* Whitney Museum of American Art, New York, *Annual Exhibition.*

1959 Albright-Knox Art Gallery, Buffalo, New York, *Contemporary Art – Acquisitions 1957-58;* Corcoran Gallery of Art, Washington, D.C., *26th Annual;* James Corcoran Gallery, Los Angeles, California; Florida State University, Tallahassee, *New Directions*

in Painting; Indiana University Art Museum, Bloomington, *New Imagery in American Painting;* The Museum of Modern Art, New York, *New Images of Man;* Nelson Gallery – Atkins Museum, Kansas City, Missouri, *Aspects of Representation in Contemporary Art.*

1960 Art Institute of Chicago, Illinois; Italy, *25 Anni di Pittura Americana 1933-1958;* Göteborgo Kunstmuseum, Göteborg, Sweden, *Modernt Amerikanst Maleri: 1932-1958;* Hessisches Landesmuseum, Darmstadt, Germany, *Moderne Amerikanische Malerei: 1930-1958;* Knoedler & Co., New York, *American Art, 1910-1960, Selections from the Collection of Mr. and Mrs. Roy R. Neuberger;* Munson-Williams-Proctor Institute, Utica, New York, *Art Across America;* Poindexter Gallery, New York; Staempfli Gallery, New York, *Elmer Bischoff, Richard Diebenkorn, David Park.*

1961 American Federation of Arts, New York, *The Figure in Contemporary American Painting;* Museum of Art, Carnegie Institute, Pittsburgh, Pennsylvania, *Pittsburgh International;* Corcoran Gallery of Art, Washington, D.C., *27th Annual;* Santa Barbara Museum of Art, Santa Barbara, California, *Two Hundred Years of American Painting 1755-1960; VI Bienal de São Paulo,* Brazil; University of Illinois, Urbana, Illinois, *Contemporary American Painting and Sculpture.*

1962 Amon Carter Museum of Western Art, Fort Worth, Texas, *The Artist's Environment: West Coast;* Martha Jackson Galleries, New York, *Selections 1934-1961. American Artists from the Collection of Martha Jackson;* Poses Institute of Fine Arts, Brandeis University, Institute of Contemporary Art, Boston, Massachusetts, *American Art Since 1950;* San Francisco Museum of Art, San Francisco, California, *Fifty California Artists;* University of California at Los Angeles Art Galleries, *Lithographs from the Tamarind Workshop;* University of California at Los Angeles Art Galleries, *The Gifford and Joann Phillips Collection.*

1963 Corcoran Gallery of Art, Washington, D.C., *28th Biennial;* Whitney Museum of American Art, New York, *Annual Exhibition 1963, Contemporary American Art.*

1964 Arkansas Arts Center, Little Rock, *Six Americans;* The Art Gallery, University of New Mexico, Albuquerque, *Seventy-fifth Anniversary Alumni Exhibition;* Fine Arts Gallery, Indiana University, Bloomington, Indiana, *American Painting 1910-1960: A Special Exhibition Celebrating the 50th Anniversary of the Association of College Unions;* Fisher and Quinn Galleries, University of Southern California, University Park, California, *New Dimensions in Lithography;* The Solomon R. Guggenheim Museum, New York, *American Drawings;* Museum of Art, Carnegie Institute, Pittsburgh, Pennsylvania, *Pittsburgh International;* Staempfli Gallery, New York, *Seven California Painters;* Tate Gallery, London, England, *Painting and Sculpture of a Decade.*

1965 M.H. de Young Memorial Museum, San Francisco, California, *The San Francisco Collector;* Scottish National Gallery of Modern Art, Edinburgh, Scotland, *Two American Painters, Abstract and Figurative: Sam Francis, Richard Diebenkorn;* The White House Festival of the Arts, Washington, D.C.; Witte Memorial Museum, San Antonio, Texas, *Selection from the Work of California Artists;* Whitney Museum of American Art, New York, *1965 Annual Exhibition of Contemporary American Painting.*

1966 Austin Art Museum, Austin, Texas, *Drawings;* Whitney Museum of American Art, New York, *Art of the United States 1670-1960.*

1967 Henry Art Gallery, University of Washington, Seattle, *Drawings by Americans;* Lytton Center of the Visual Arts, Los Angeles, California, *California Art Festival;* Museum of Art, Raleigh, North Carolina, *American Painting Since 1900 from the Permanent Collection;* The University Art Gallery, Oakland University, Rochester, Michigan, *A Point of View: Selected Paintings and Drawings from the Richard Brown Baker Collection;* Whitney Museum of American Art, New York, *1967 Annual Exhibition of Contemporary American Painting.*

1968 The Art Museum, University of Texas, Austin, *Painting as Painting;* Finch College Museum of Art, New York, *Documentation – Sculpture, Paintings, Drawings;* Los Angeles County Museum of Art, Los Angeles, California, *Late Fifties at the Ferus;* Museum of Art, University of Oklahoma, Norman, *East Coast-West Coast Paintings;* Pennsylvania Academy of the Arts, Philadelphia, *163rd Annual;* San Francisco Museum of Art, San Francisco, California, *"Untitled," 1968;* University of Kansas Museum of Art, Lawrence, *Modern Art from Midwestern Collections; XXXIV Venice Biennale,* Venice, Italy, *The Figurative Tradition in Recent American Art.*

1969 Pasadena Art Museum, Pasadena, California, *West Coast 1945-1969;* Stedeljik van Abbemuseum, Eindhoven, The Netherlands, *Kompas VI-West Coast USA;* Whitney Museum of American Art, New York, *1969 Annual Exhibition, Painting.*

1970 Crocker-Citizens National Bank, Los Angeles, California, *A Century of California Painting 1870-1970;* Fondation Maeght, St. Paul de Vence, France, *L'Art Vivant aux Etats-Unis;* Joslyn Art Museum, Joslyn, Nebraska, *Looking West;* Museum of Art, Carnegie Institute, Pittsburgh, Pennsylvania, *Pittsburgh International;* Geneva, Belgrade, Milan and other cities, *The New Vein: The Human Figure 1967-1968;* University of California Art Gallery, Berkeley, *Excellence;* University of California, Santa Barbara, *Trends in Twentieth Century Art, A Loan Exhibition from the San Francisco Museum of Art.*

1971 Gruenwald Graphic Art Foundation Print Gallery, Dickson Art Center, University of California, Los Angeles, *Made in California;* Hayward Gallery, London, England, *11 Los Angeles Artists;* Purdue University, Lafayette, Indiana, *Two Directions in American Painting;* Stanford University Museum of

Art, Stanford, California, *Stanford Collects;* Stanford University Museum of Art, Stanford, California, *A Decade in the West;* University of Iowa Museum, Iowa City, *Accessions 1970-71.*

1972 Art Institute of Chicago, Chicago, Illinois, *Seventieth American Exhibition;* Museum of Fine Arts, Boston, Massachusetts, *Abstract Painting in the '70's: A Selection;* Whitney Museum of American Art, New York, *1972 Annual Exhibition, Contemporary American Painting.*

1973 Corcoran Gallery of Art, Washington, D.C., *33rd Biennial of Contemporary American Painting;* Des Moines Art Center, Des Moines, Iowa, *Twenty-five Years of American Painting;* Charles McNider Museum, Mason City, Iowa, *American Artists: An Invitational;* University of Maryland Art Gallery, College Park, *Mixed Bag;* University of Maryland Art Gallery, College Park, *The Private Collection of Martha Jackson;* Yale University Art Gallery, New Haven, Connecticut, *American Drawing 1970-73;* The Joslyn Art Museum, Omaha, Nebraska, Sheldon Memorial Art Gallery, University of Nebraska, Lincoln, *A Sense of Place.*

1974 Colorado Springs Fine Arts Center, Colorado Springs, *New Accessions USA;* Fort Worth Art Museum, Fort Worth, Texas, *Twentieth Century Art from Fort Worth Dallas Collections;* Santa Barbara Museum of Art, Santa Barbara, California, *Fifteen Abstract Artists;* University of Illinois at Urbana-Champaigne, *Contemporary American Painting and Sculpture 1974;* Virginia Museum, Richmond, *Twelve American Painters.*

1975 Albright-Knox Art Gallery, Buffalo, New York, *The Martha Jackson Collection at the Albright-Knox Art Gallery;* Brooks Memorial Art Gallery, Memphis, Tennessee, *An Evolution of American Works;* Corcoran Gallery of Art, Washington, D.C., *34th Biennial of Contemporary American Painting;* The Oakland Museum, Oakland, California, *California Landscape, a Metaview;* Pennsylvania Academy of Fine Arts, Philadelphia, *Young America;* University of Texas at Arlington, *Figure and Field in America;* Yale University Art Gallery, New Haven, Connecticut, *Richard Brown Baker Collects.*

1976 John Berggruen Gallery, Los Angeles, California; Gruenebaum Gallery, Ltd., New York, *Three Generations of American Painting: Motherwell, Diebenkorn, Edlich;* Newport Harbor Art Museum, Newport Harbor, California, *The Last Time I Saw Ferus;* Poindexter Gallery, New York; La Jolla Museum of Contemporary Art, La Jolla, California, *Paintings from the Collection of Mr. and Mrs. Max Zurier.*

Public Collections

Albright-Knox Art Gallery, Buffalo, New York

Allen Memorial Art Gallery, Oberlin College, Oberlin, Ohio

Arkansas Art Center, Little Rock

Art Gallery of Ontario, Toronto, Canada

The Art Institute of Chicago, Chicago, Illinois

The Baltimore Museum of Art, Baltimore, Maryland

The Brooklyn Museum, Brooklyn, New York

California Palace of the Legion of Honor, San Francisco

University Art Museum, University of California, Berkeley

Museum of Art, Carnegie Institute, Pittsburgh, Pennsylvania

Chrysler Museum at Norfolk, Norfolk, Virginia

Cincinnati Art Museum, Cincinnati, Ohio

The Cleveland Museum of Art, Cleveland, Ohio

Corcoran Gallery of Art, Washington, D.C.

Des Moines Art Center, Des Moines, Iowa

Grand Rapids Art Museum, Grand Rapids, Michigan

The Solomon R. Guggenheim Museum, New York

Hirshhorn Museum and Sculpture Garden, Smithsonian Institution, Washington, D.C.

University of Iowa Museum of Art, Iowa City

Los Angeles County Museum of Art, Los Angeles, California

The Metropolitan Museum of Art, New York

The University of Michigan Museum of Art, Ann Arbor

The Museum of Modern Art, New York

University of Nebraska Art Galleries, Lincoln

University Art Museum, The University of New Mexico, Albuquerque

Nelson Gallery – Atkins Museum, Kansas City, Missouri

University Art Gallery, State University of New York at Albany

Neuberger Museum, State University of New York College at Purchase

North Carolina Museum of Art, Raleigh

Norton Simon Museum of Art at Pasadena, Pasadena, California

The Oakland Museum, Oakland, California

The Phillips Collection, Washington, D.C.

Phoenix Art Museum, Phoenix, Arizona

Royal Ontario Museum, Toronto, Canada

San Francisco Museum of Modern Art, San Francisco, California

The Santa Barbara Museum of Art, Santa Barbara, California

Stanford University Museum and Art Gallery, Stanford, California

Washington Gallery of Modern Art Collection, Oklahoma Art Center, Oklahoma City

Washington University Gallery of Art, St. Louis, Missouri

Whitney Museum of American Art, New York

Witte Memorial Museum, San Antonio, Texas

Selected Bibliography

Monographs and One-Artist Exhibition Catalogues

1960 California Palace of the Legion of Honor, San Francisco, California. *Recent Paintings by Richard Diebenkorn.* Introduction by Howard Ross Smith.
Pasadena Art Museum, Pasadena, California. *Richard Diebenkorn.* Introduction by Thomas W. Leavitt.

1961 The Phillips Collection, Washington, D.C. *Richard Diebenkorn.* Essay by Gifford Phillips.

1964 Washington Gallery of Modern Art, Washington, D.C. *Richard Diebenkorn.* Essay by Gerald Nordland.

1965 The Waddington Galleries, London, England. *Richard Diebenkorn.*

1968 Richmond Art Center, Richmond, California. *Richard Diebenkorn.*

1969 Los Angeles County Museum of Art, Los Angeles, California. *New Paintings of Richard Diebenkorn.* Essay by Gail Scott.
Poindexter Gallery, New York. *Richard Diebenkorn: "The Ocean Park" Series.*

1971 Marlborough Gallery, New York. *Richard Diebenkorn, The Ocean Park Series: Recent Work.* Essay by Gerald Nordland.

1972 Gerard John Hayes Gallery, Los Angeles, California. *Richard Diebenkorn Lithographs.*
San Francisco Museum of Art, San Francisco, California. *Richard Diebenkorn Paintings from The Ocean Park Series.* Essay by Gerald Nordland.

1973 Marlborough Fine Art, Ltd., London, England. *Richard Diebenkorn, The Ocean Park Series: Recent Work.* Essay by John Russell.

1974 Mary Porter Sesnon Gallery, University of California, Santa Cruz. *Richard Diebenkorn: Drawings, 1944-1973.* Essay by Philip Brookman and Walker Melion.

1975 James Corcoran Gallery, Los Angeles, and John Berggruen Gallery, San Francisco, California. *Early Abstract Works 1948-1955.*
Marlborough Gallery, New York. *Richard Diebenkorn. The Ocean Park Series: Recent Work.*

1976 Frederick S. Wight Art Gallery, University of California, Los Angeles. *Richard Diebenkorn: Monotypes.* Essay by Gerald Nordland.

Group Exhibition Catalogues

1951 Grand Rapids Art Museum, Grand Rapids, Michigan. *20th Century American Painting.*

1955 *III Bienal di Sao Paulo,* Brazil.
Musee National d'Art Moderne, Paris, France. *Jeunes Peintres.*
Walker Art Center, Minneapolis, Minnesota. *Vanguard 1955.* Introduction by Kyle Morris.
The Art Institute of Chicago, Chicago, Illinois. *LXII American Exhibition.*

1957 Fogg Art Museum, Cambridge, Massachusetts. *Modern Painting, Drawing and Sculpture Collected by Louise and Joseph Pulitzer.* Text by Charles Scott Chetham.
The Oakland Art Museum, Oakland, California. *Contemporary Bay Area Figurative Painting.* Essay by Paul Mills.

1958 The Virginia Museum of Fine Arts, Richmond. *American Painting 1958.* Directed by Grace L. McCann Morley.
Brussels Universal & International Exhibition, Brussels, Belgium. *Seventeen Contemporary American Artists.*

1959 Florida State University, Tallahassee. *New Directions in Painting.*
Indiana University Art Museum, Bloomington. *New Imagery in American Painting.*
The Museum of Modern Art, New York. *New Images of Man.* Text by Peter Selz.

1960 City Art Museum of St. Louis, Missouri and United States Information Agency. *25 Years of American Painting: 1933-1958.*
M. Knoedler & Co., New York. *American Art, 1910-1960, Selections from the Collection of Mr. and Mrs. Roy R. Neuberger.*

1961 State University of Iowa. *Main Currents of Contemporary American Painting.*
American Federation of Arts, New York, *The Figure in Contemporary American Painting.*
VI Bienal di Sao Paulo, Brazil.
University of Illinois, Urbana. *Contemporary American Painting and Sculpture.*
Santa Barbara Museum of Art, Santa Barbara, California. *Two Hundred Years of American Painting 1755-1960.*

1962 Amon Carter Museum of Art, Fort Worth, Texas. *The Artist's Environment: West Coast.* Text by Frederick S. Wight.
Martha Jackson Galleries, New York. *Selections 1934-1961. American Artists from the Collection of Martha Jackson.*
San Francisco Museum of Art, San Francisco, California. *Fifty California Artists.* Essays by Lloyd Goodrich and George D. Culler.
University of California at Los Angeles Art Galleries, Los Angeles, California. *The Gifford and Joann Phillips Collection.* Statement by Gifford Phillips.
Poses Institute of Fine Arts, Brandeis University, Waltham, Massachusetts and Institute of Contemporary Art, Boston, Massachusetts. *American Art Since 1950.* Text by Sam Hunter.
University of California at Los Angeles Art Galleries, Los Angeles, California. *Lithographs from the Tamarind Workshop.*
Corcoran Gallery of Art, Washington, D.C. *28th Biennial.*

1964 Tate Gallery, London, England. *Painting and Sculpture of a Decade.*

Arkansas Art Center, Little Rock, *Six Americans.*

Fisher and Quinn Galleries, University of Southern California, University Park. *New Dimensions in Lithography.*

The Solomon R. Guggenheim Museum, New York. *American Drawings.*

Staempfli Gallery, New York. *Seven California Painters.* Essay by Lawrence Alloway.

The Art Gallery, University of New Mexico, Albuquerque. *Seventy-Fifth Anniversary Alumni Exhibition.*

Fine Arts Gallery, Indiana University, Bloomington. *American Painting 1910-1960: A Special Exhibition Celebrating the 50th Anniversary of the Association of College Unions.* Introduction by Henry R. Hope.

1965 M.H. de Young Memorial Museum, San Francisco, California. *The San Francisco Collector.*

Scottish National Gallery of Modern Art, Edinburgh, Scotland. *Two American Painters, Abstract and Figurative: Sam Francis, Richard Diebenkorn.*

Witte Memorial Museum, San Antonio, Texas. *Selections from the Work of California Artists.*

1966 Austin Art Museum, University of Texas, Austin. *Drawings.* Introduction by Mercedes Matter.

The University Art Gallery, Oakland University, Rochester, Michigan. *A Point of View: Selected Paintings and Drawings from the Richard Brown Baker Collection.*

1967 Henry Art Gallery, University of Washington, Seattle. *Drawings by Americans.* Introduction by Gervais Reed.

Lytton Center of the Visual Arts, Los Angeles, California, *California Art Festival.*

North Carolina Museum of Art, Raleigh. *American Paintings since 1900 from the Permanent Collection.*

Finch College Museum of Art, New York. *Documentation – Sculpture, Paintings, Drawings.* Directed by Elayne H. Varian.

1968 Los Angeles County Museum of Art, Los Angeles, California. *Late Fifties at the Ferus.* Text by James Monte.

Pennsylvania Academy of the Arts, Philadelphia. *163rd Annual.*

San Francisco Museum of Art, San Francisco, California. *"Untitled," 1968.* Introduction by Wesley Chamberlain.

XXXIV Venice Biennale, Italy. *The Figurative Tradition in Recent American Art.* Text by Norman A. Geske.

University of Texas Art Museum, Austin. *Painting as Painting.* Edited by Donald Goodall.

1969 Pasadena Art Museum, Pasadena, California. *West Coast 1945-1969.* Introduction by John Coplans.

Stedelijk van Abbemuseum, Eindhoven, The Netherlands. *Kompas VI – West Coast, U.S.A.* Introduction by Jean Leering.

1970 Crocker-Citizens National Bank, Los Angeles, California. *A Century of California Painting. 1870-1970.*

Museum of Art, Carnegie Institute, Pittsburgh, Pennsylvania. *Pittsburgh International.*

Fondation Maeght, St. Paul de Vence, France. *L'Art Vivant aux Etats-Unis.*

Joslyn Art Museum, Omaha, Nebraska. *Looking West.*

Geneva. *The New Vein: The Human Figure 1967-68.*

San Francisco Museum of Art, San Francisco, California. *1970 National Drawing Exhibition.* Text by Gerald Nordland.

University of California Art Gallery, Berkeley. *Excellence.*

University of California, Santa Barbara. *Trends in XXth Century Art, A Loan Exhibition from the San Francisco Museum of Art.*

1971 Grunwald Graphic Art Foundation Print Gallery, Dickson Art Center, University of California, Los Angeles. *Made in California.*

Hayward Gallery, London, England. *11 Los Angeles Artists.*

Purdue University, Lafayette, Indiana. *Two Directions in American Painting.*

Stanford University Museum of Art, Stanford, California. *A Decade in the West.*

University of Iowa Museum, Iowa City. *Accessions 1970-71.*

1972 Art Institute of Chicago, Chicago, Illinois. *Seventieth American Exhibition.*

Museum of Fine Arts, Boston, Massachusetts. *Abstract Painting in the '70's: A Selection.* Introduction by Kenworth Moffett.

Whitney Museum of American Art, New York. *1972 Annual Exhibition, Contemporary American Paintings.*

1973 Des Moines Art Center, Des Moines, Iowa. *Twenty Five Years of American Painting 1948-1973.*

University of Maryland Art Gallery, College Park. *The Private Collection of Martha Jackson.*

Whitney Museum of American Art, New York. *American Drawings 1963-1973.* Essay by Elke Solomon.

1974 Colorado Springs Fine Arts Center, Colorado Springs, Colorado. *New Accessions USA.*

Fort Worth Art Museum, Fort Worth, Texas. *Twentieth Century Art from Fort Worth and Dallas Collections.*

University of Illinois, Urbana-Champaigne. *Contemporary American Painting and Sculpture 1974.* Introductions by James R. Shipley and Allen S. Weller.

Santa Barbara Museum of Art, Santa Barbara, California. *Fifteen Abstract Artists.*

Virginia Museum, Richmond. *Twelve American Painters.*

1975 Albright-Knox Art Gallery, Buffalo, New York. *The Martha Jackson Collection at the Albright-Knox Art Gallery.* Essay by Linda L. Cathcart.

Brooks Memorial Art Gallery, Memphis, Tennessee. *An Evolution of American Works.*

Corcoran Gallery of Art, Washington, D.C. *34th Biennial of Contemporary American Painting.*

Pennsylvania Academy of Fine Arts, Philadelphia. *Young America.*

University of Texas at Arlington. *Figure and Field in America.*

Yale University Art Gallery, New Haven, Connecticut. *Richard Brown Baker Collects.*

1976 The Toledo Museum of Art, Toledo, Ohio. *Heritage and Horizon: American Painting 1776-1976.*

Gruenebaum Gallery, Ltd., New York, *Three Generations of American Painting: Motherwell, Diebenkorn, Edlich.* Essay by Jeffrey Hoffeld.

Newport Harbor Art Museum, Newport Harbor, California, *The Last Time I Saw Ferus,* Essay by Betty Turnbull.

General References (Books)

Lipman, Jean, and the editors of *Art in America,* compilers. *The Collector in America.* New York: The Viking Press. 1961.

Richardson, E.P. *A Short History of Painting in America.* New York: Thomas Y. Crowell Co. 1963.

Eitner, Lorenz. *Drawings by Richard Diebenkorn.* Stanford: Stanford University Press. Stanford Art Book 2. 1965.

Henning, Edward B. *Fifty Years of Modern Art, 1916-1966.* Cleveland: The Cleveland Museum of Art. 1966.

Pellegrini. *New Tendencies in Art.* New York: Crown Publishers. 1966.

Rose, Barbara. *American Art Since 1960.* New York: Frederick A. Praeger. 1967.

Arnason, H. Harvard. *History of Modern Art: Painting, Sculpture, Architecture.* New York: Harry N. Abrams. 1968.

Geldzahler, Henry. *New York Painting and Sculpture: 1940-1970.* New York: E.P. Dutton & Co. 1969.

Mendelowitz, Daniel M. *A History of American Art.* New York: Holt, Rinehart and Winston. 1970.

Albright-Knox Art Gallery. *Contemporary Art 1942-72: Collection of the Albright-Knox Art Gallery.* New York: Praeger Publishers. 1972.

Feldman, Edmund Burke. *Varieties of Visual Experience.* New York: Harry N. Abrams. 1972.

Wilmerding, John, ed. *The Genius of American Painting.* London: Weidenfeld and Nicholson. 1973.

Boyle, Richard J. *American Impressionism.* Boston: New York Graphic Society. 1974.

We wish to acknowledge the use of the following works used in an historical sense in the essays:

Paul Cézanne
Mont Sainte-Victoire, 1885-87
oil on canvas, 23½" x 28½"
The Phillips Collection, Washington, D.C.

Richard Diebenkorn
Horizon-Ocean View, 1959
oil on canvas, 70" x 63½"
Reader's Digest Art Collection

Richard Diebenkorn
Untitled No. 22, 1948
oil on canvas, 34" x 48"
Norton Simon Museum of Art at Pasadena
Gift of Mr. and Mrs. Paul Kantor

Arshile Gorky
Enigmatic Combat, 1936-37
oil on canvas, 33¾" x 48"
San Francisco Museum of Modern Art
Gift of Jeanne Reynal

Paul Klee
Christmas Picture, 1923
watercolor on paper, 18¾" x 13¾"
Philadelphia Museum of Art
A.E. Gallatin Collection

Henri Matisse
Conversation, 1909
oil on canvas, 69-3/4" x 85-7/16"
Hermitage Museum, Leningrad

Henri Matisse
Entrance to the Kasbah, 1912
oil on canvas, 57⅛" x 31½"
Pushkin Museum, Moscow

Henri Matisse
The French Window, 1914
oil on canvas, 45-11/16" x 34-5/8"
Private Collection, Paris

Henri Matisse
A Glimpse of Notre Dame in the Late Afternoon, 1902
oil on canvas, 28½" x 39⅜"
Albright-Knox Art Gallery
Gift of Seymour H. Knox, 1927

Henri Matisse
Harmony in Red, 1908
oil on canvas, 70⅞" x 86⅝"
Hermitage Museum, Leningrad

Henri Matisse
The Painter's Family, 1911
oil on canvas, 56-5/16" x 76-3/8"
Hermitage Museum, Leningrad

Henri Matisse
The Studio, Quai Saint-Michel, 1916
oil on canvas, 57½" x 45¾"
The Phillips Collection, Washington, D.C.

Henri Matisse (fig. 69a)
View of Notre Dame, 1914
oil on canvas, 57⅞" x 37"
The Museum of Modern Art, New York

Henri Matisse
Zorah on the Terrace, 1912
oil on canvas, 45-11/16" x 39-3/8"
Pushkin Museum, Moscow

Piet Mondrian
Composition London, 1940-42
oil on canvas, 32½" x 28"
Albright-Knox Art Gallery
Room of Contemporary Art Fund

Mark Rothko
Slow Swirl at the Edge of the Sea, 1943
oil on canvas, 76" x 85¼"
The Museum of Modern Art, New York

Photo Credits

Michael Arthur: painting 21. Rudy Bender: painting 47.
Brigdens Studio: painting 34. Geoffrey Clements: paintings
29, 72. Prudence Cuming Associates, Ltd.: works on paper
25, 26. Roger Gass: painting 24. Greenberg, Wrazen & May:
paintings 33, 82. Martha Jackson Gallery: painting 18.
Robert E. Mates: paintings 84, 85, 88; works on paper 58,
61, 62. Robert E. Mates & Gail Stern: painting 78. Robert E.
Mates & Paul Katz: work on paper II. Robert Meneeley:
painting 39. David Preston: painting 35. Nathan Rabin:
painting 57. The St. Louis Art Museum: painting 86©. Hans
J. Schiller: painting 46. Schopplein: work on paper 24. Steven
Sloman: paintings 26, 73, 74; works on paper 28, 29, 33, 45.
Bill Strehorn: painting 67. Joseph Szaszfai: painting 28.
Frank J. Thomas: paintings 5, 12, 17, 70, 71, 89, 90, 91; works
on paper 1-5, 7-10, 12-15, 17-23, 30, 32, 34-44, 46-56, 59, 60.
Whitney Museum of American Art: painting 72©.
Photograph of Richard Diebenkorn by Robert T. Buck, Jr.

36,000 copies of this catalogue were printed on Warren's
Lustro Offset Enamel by Lebanon Valley Offset, Co.,
Annville, Pennsylvania. Typography by Printing Prep Inc.,
Buffalo, New York. Edited by John O'Hern. Designed by
Paul McKenna. November 1976.